WHY VINYL MATTERS

JENNIFER OTTER BICKERDIKE

In Memory of Hunter McPherson.
The way you led your life inspired
me to start truly living mine.
'True is True'.

WHY VINYL MATTERS

JENNIFER OTTER BICKERDIKE

ACC Editions

CONTENTS

PREFACE

A year or so ago, I decided to follow an insane dream and write a book about something I was deeply passionate about. I have dedicated my life to working in and studying music, from heading marketing at a major record label to spending endless hours in the British Library in pursuit of obscure articles for my doctorate on music fandom. I had been devastated by the closure of many of my 'churches': the independent record stores. When people started buying vinyl again, I wanted to rave about what records meant to me and how they have shaped pretty much every aspect of my life, from my clothing choices to the boys I dated. I wanted it to be not just my story, but the story of the heroes and crusaders I admired, loved and have been inspired by, all of whom I encountered one way or another via the vinyl record.

And so I made a list of 'dream' people to interview. Much to my delight, the power of vinyl shone through again, as one person after another agreed to share with me their own personal discoveries, highs, lows and everything else in between that comes with being a vinyl lover.

This book is a series of interviews with those artists, album designers, manufacturers, record store gurus, crusaders and other assorted cognoscenti of vinyl, all extolling the virtues of this almost-discarded format. It tells the tale of the records they love, through the words of those who've kept the medium alive. But above all, this book is a manifesto, proving how identity, friendships, careers and lives are created and shaped by records, a long love letter illustrating *Why Vinyl Matters*.

Jennifer Otter Bickerdike

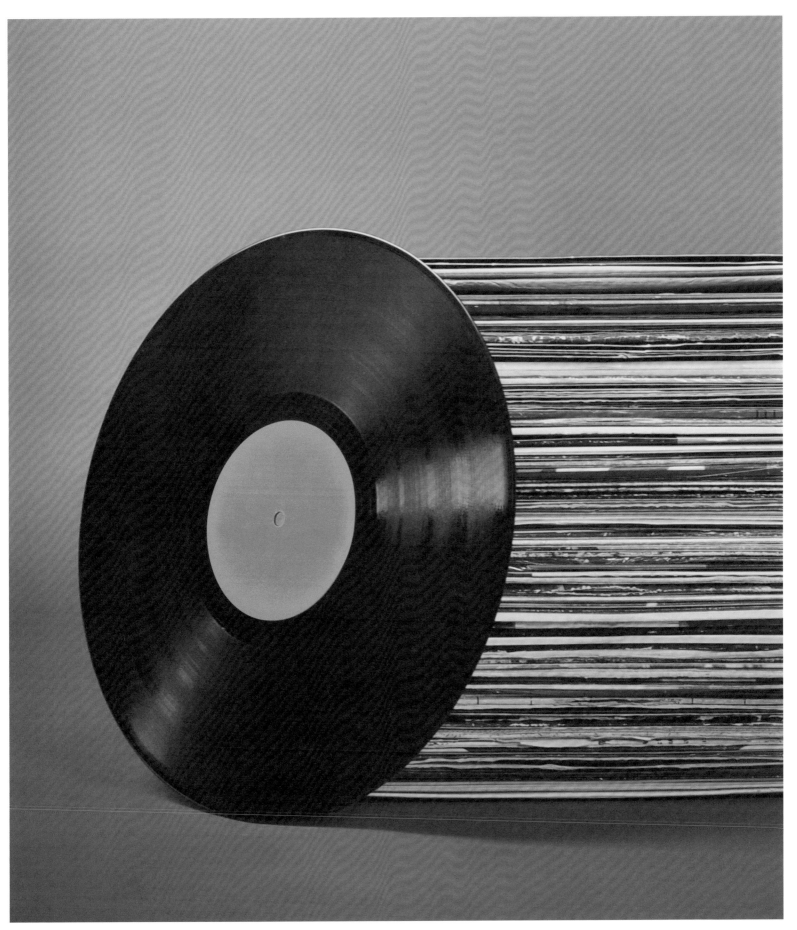

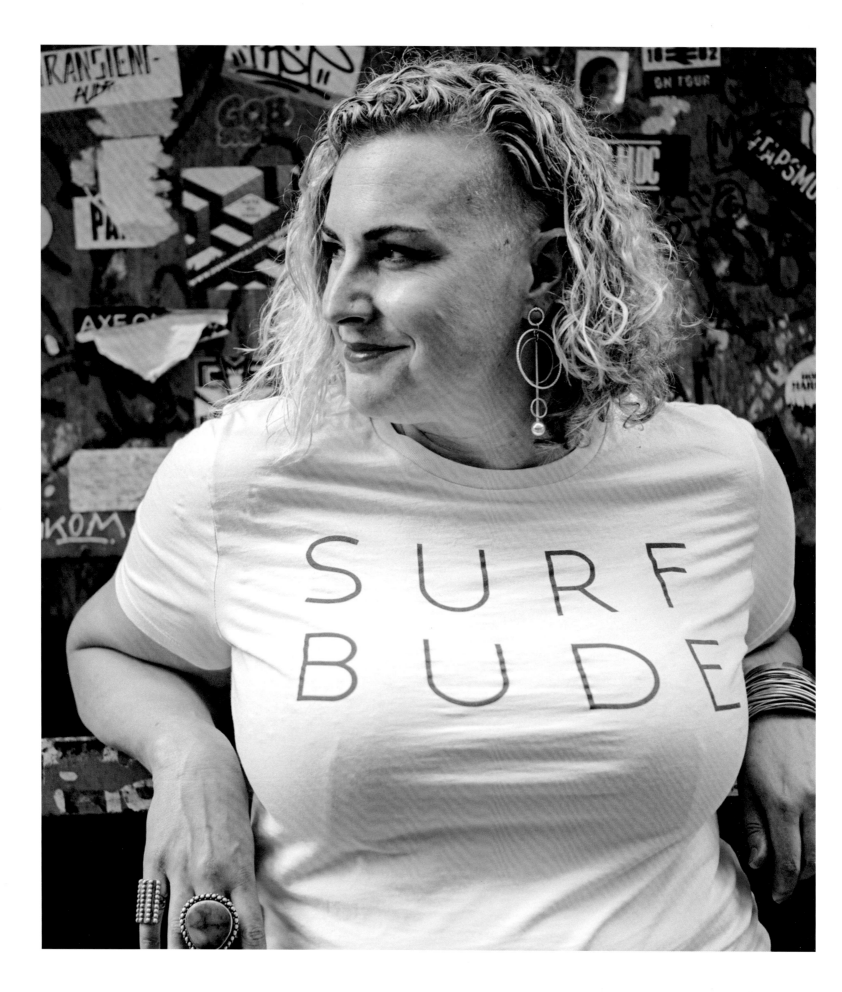

INTRODUCTION

JENNIFER OTTER BICKERDIKE

I grew up surrounded by my parents' burgeoning record collection. This ranged from albums representing my mother's teenage love for musicals, each carefully labelled with 'This Record Belongs to Diane Pucci' so as to not be left behind at a party, to the more recent acquisitions of original Doors, Beatles and Stones records, all on vinyl. However, I didn't have my own first proper LP until I was 12 years old.

It was spring, and there was substantial clean-up to do in our California backyard to get ready for the impending warm months. I was bribed into clearing weeds, bagging branches and mowing grass by the promise of one record of my choice. I started the day already knowing what I was going to get: the Go-Go's 1984 album *Talk Show*. MTV was not yet available in my small beach community of Santa Cruz; my only opportunity to see any music videos was via our family's newly acquired Beta VCR. I would religiously record *Friday Night Videos*, as it was too late for me to stay up and watch. The Go-Go's were one of the only all-girl groups.

Unlike contemporaries Bananarama, who basically sauntered around the sets of their videos in overalls, or the Bangles, who were all short skirts and big hair, the Go-Go's looked normal. Their boobs weren't hanging out, nor were they trying to be overtly cute. Most importantly, they played their own instruments – they were real musicians! This was hugely inspiring and appealing to me. They seemed confident in their looks and talent, so confident that they didn't have to rely on over-the-top, trowelled-on make-up and ratted hair. They were all about the songs, and being strong, independent girls together. I desperately wanted my naturally curly locks to look good in the boyish crew cuts sported by Belinda Carlisle and the gang (however, no amount of Studio Line hair gel could accomplish this impossible task). My favourite Go-

Go was Gina Schock, as I thought she was a badass for being a girl *and* a drummer (I had never seen this combination before). All of the Go-Go's were styled to look effortlessly cool, with a nod to their punk roots. Cut-off sweatshirts, bright yellow jackets and tartan button-downs seemed both exotic but within reach. With the right straightening iron and large hoop earrings, I too could possibly be a Go-Go: part of a dauntless, stylish, sophisticated gang of girls who were in on the joke.

Going to the record store with my dad to buy their album made me feel like I was entering into a new and thrilling territory of teenage possibility, the vinyl disc my communion of initiation. As soon as I got home I ripped off the clear plastic and started my voracious consumption of the liner notes. I studied those lyrics, the band's Thank Yous and their writing credits, as if they provided me with the tools to understand and appreciate the band and the record.

This album was one of the defining moments of my budding personal identity. Having the physical vinyl record was crucial for me to understand not only the Go-Go's, but also myself. The Go-Go's looked cool, wrote cool and sounded cool. The entire package was at once empowering and defining. The full 'experience' of that record – of sitting for hours singing along to the lyrics provided by the album sleeve, trying to capture the effortless punk chic of the band as they appeared on the record cover – provided a guide for my emerging teenage character. I can't imagine a band, and the entire set of subcultures and ideas connected to them, being experienced in any other way. It makes me pause to consider that a 12-year-old today might not ever have the opportunity to experience such a profound and transformative moment, not just through music, but through the all-encompassing sensory immersion provided by the acquisition of a tangible record. I am sorry, but the tiny pixelated 'album art'

on the current downloadable offerings – when it's even available – is not comparable to the *pow* of a 12-inch x 12-inch vinyl cover. However, regardless of how powerful the LP had been for me and my peers, my memory of *Talk Show* and other vinyl favourites from my youth had become the nostalgic meanderings of a Luddite in a technology and convenience driven world. Until recently, that is.

Over the last twenty years, it seemed that it was the fate of the vinyl LP to fade into distant memory. Compact discs (CDs) had made them all but obsolete. Then downloading and streaming crushed the CD market, making music more portable, cheaper (hell, often free), and completely unbound from the traditional consumer experience of dedicated retail outlets, sumptuous packaging, and the elite availability of recording and producing the album itself. Suddenly anyone could make, sell and distribute music from the comfort of their own bedroom. People who preferred the 'old' formats of music, especially vinyl, were viewed as out-of-touch, underlaid nerds, as portrayed by John Cusack in the 2000 movie *High Fidelity* (based on the 1995 Nick Hornby book of the same name).

As downloading and streaming became the most popular means of getting music, a horrible cycle took root in the UK and the US. Record stores experienced epidemic closures, as customers were not coming in to purchase music anymore. Fewer outlets available for selling product meant fewer places for albums to be sold for those who still wanted to participate in the ritual of the traditional shop. All seemed doomed for the physical format of music, and the brick and mortar establishments that traded on them.

Resurrection happened in the most unexpected way – through the humble vinyl album. The personal music collection had become compacted to invisibility, existing only as a title scrolling across a screen. What was missing for the true aficionado was the physical component: the story, the package, the multi-stimulus explosion offered by the record. In 2008, amidst news of further declines in CD sales, an uptick in vinyl purchases was noticed on various charts (even though few artists were offering their music in this format). Slowly but surely retailers began stocking records, and artists started insisting on the LP's return to the available formats for new releases. A re-emergence of the album as art began to take root, as the perception of the vinyl customer shifted from audiophile geek to true connoisseur. Even trendsetting retail outlets like Urban Outfitters began stocking hand-picked vinyl titles alongside their painfully cool home furnishings, suggesting that vinyl albums (and record players) were necessary accessories for any truly hip individual. In 2015, an official chart of vinyl sales was introduced in the UK, heralding the return of the format not solely as a hobbyist pursuit for sound purists, but as a viable commercial product with fiscal impact.

Recent Vinyl Numbers

The UK's Official Charts Company launched two vinyl-specific Top 40s in April 2015 – for the first time in Britain, and right before an unforeseen rush of album purchases. Vinyl sales hit a 25-year high in 2016, as both young and old consumers snapped up the physical format of music. These numbers were up 53 per cent from 2015, with more than 3.2 million LPs crossing record store counters, the highest number since 1991, when Simply Red's *Stars* was the bestselling album. The year 2016 also marked the first time that spending on vinyl outpaced spending on digital downloads.

Customers are almost equally split between the under-35s who are just starting their collections (35.3 per cent of customers) and those who first

discovered music through the format (the over-44s, who make up 36.3 per cent). While the first decade in the 21st century saw independent shops closing with demoralising regularity, the second decade marks a striking surge in high street music outlets, growing from 6,808 in 2010 to 10,391 in 2014. More than 57 per cent of these purchases took place at the late (but possibly once again great) cornerstone of cutting edge culture, the independent record store, while another 36 per cent took place at non-traditional retail outlets like Urban Outfitters. On 1 September 2015, grocery chain Tesco announced that it would start carrying vinyl. Tesco buying manager Michael Mulligan said of the decision, 'In the last year we began selling record decks in our largest stores and initial sales are very encouraging, so giving our customers some new vinyl to play on those decks seems like the logical next step.' [Sourced from British Phonographic Society] In America, the figures are even better. Numbers released in early 2017 by *Billboard* show vinyl sales in the US up for the 11th year in a row. The year 2016 saw vinyl increase 10 per cent from 2015 in consumer purchases, reaching a staggering 13.1 million units sold across the United States. [Sourced from BuzzAngle Music Analysts]

Vinyl is back, and shows no indication of going away.

But does it *really* sound better?

One of the recurring arguments in support of vinyl is that the sound quality is superior to CDs and digital files. Though we immediately 'know' whether what we are hearing is 'good' or 'bad,' the physical science behind this is still not fully understood. The secret to how we interpret specific music as 'pleasing' or 'vile' is unknown, as the ear receives all sounds, Britney to Bach, in a similar manner.

While we don't know the science behind sound and perception, most of the basic mechanics for how we hear have been sketched out. Sounds transmitted to the inner ear are broken down into a spectrum of frequencies, then arranged by the brain on a cerebral piano keyboard, ordered low to high. Vibrations in the air move thousands of tiny hairs located in the inner ear, stimulating nerve cells to send electrical signals from the ear to the base of the brain, then up to the cortex. *Voilà!* We have hearing!

Scientists have found that humans are born with a predisposition to music, which explains why music is found across the globe in all cultures, with specific melodies and rhythms holding particular meanings and associations. This may help in explaining the ongoing argument in regard to sound quality, in the stand-off between CDs and vinyl. Looking just at the fidelity and accuracy achievable in sonic reproductions, the CD runs circles around the trusty vinyl record. It's actually the means for producing and playing vinyl that adds additional sounds to the 'finished' product that we hear. The mechanism of vinyl recording and playback introduces distortion, which creates a harmonic 'warmth' often described as unique to records. This very element, which could be argued to taint the perfection of clear sound, is exactly what many vinyl fans find appealing about the format.

The Rise, the Fall and the Resurgence

It took a journey to the brink of extinction for us to realise how important the physical record is in defining self, community and culture. The story of the album's inception, burst in popularity, decline and rebirth reads like a fantastical version of David and Goliath. Yet this new interest in the old format proves that music is more than just sound, more than a commercial product to be bought, sold, streamed or stolen: it is our identity, our context, our solace and soul.

The humble beginnings of the vinyl record start with the quest for visual representation of an analogue sound wave. In 1857, French printer Édouard-Léon Scott de Martinville created what could be described as the first record player. He wanted to capture what he heard in a form he could see. His experimentation led him to combine a stylus, paper and a vibrating diaphragm to record the pattern made by sound waves. Though he simply wanted to review the outcome from his newfangled gadget for personal interest, his invention unintentionally created the first device able to record sound. In 1877, American inventor Thomas Edison built on this early technology, envisioning a product that could dually replicate and record. The phonograph was born.

Early examples of the phonograph were very basic, building on de Martinville's device. Instead of paper, a tinfoil wrapped cylinder was paired with the vibrating stylus to capture sound waves as the device was rotated by hand. While the recordings could be played back immediately, the sound quality was very poor, relegating it for use solely at funfairs and other 'oddity' attractions. In the 1880s, Alexander Graham Bell's Volta Laboratory tried using a cylinder encased in wax instead of tinfoil, a difference resulting in a vast improvement of sound quality. With this breakthrough, recorded music moved from a sideshow sideline to a sellable commercial product. By 1880, Edison's wax cylinders with analogue sound waves inscribed upon them were widely available, and paramount in establishing the recorded music industry. Wax dominated the marketplace, until the early 20th century when Emile Berliner developed discs cut by lasers in an attempt to usurp the wax format. Berliner's discs, though of poorer quality than their wax counterparts, could crucially hold up to four minutes of recorded sound.

The humble beginnings of the vinyl record started in 1901, when several small companies, including Berliner's, formed the Victor Talking Machine Company, merging into one entity. They began by producing 10-inch vinyl discs, adding the 12-inch format in 1903, making Edison's wax cylinders virtually obsolete. The basic patents for the manufacture of laser-cut disc records expired in 1919, creating the opportunity for other companies to get into the record production business.

The following years saw a myriad of variations on the recorded music theme, particularly in the method of recording production, the speed of the discs and the materials that they were made of. The 1920s saw electrical recording become prominent over acoustic, and the use of shellac for record discs, which were used on the 78rpm speed albums. As manufacturers began experimenting with different speeds of record play, a new material was needed which could sustain more wear and tear from use, yet be lighter in weight than the heavy shellac albums. Through various trials and errors, vinyl records were born and became standard material by the late 1930s.

In 1939, a young Columbia Records executive, Alex Steinweiss, wanted to replace the standard plain paper covers that records came in with original drawings and paintings. His first experiment with this new look came with the already popular and fast-selling *Smash Song Hits* by Richard Rodgers and the Imperial Orchestra. The fresh artwork produced a skyrocketing 800 per cent increase in record sales, following the album's makeover. Steinweiss's idea proved that customers were attracted to the visual packaging of the album as much as the music itself.

Steinweiss's next breakthroughs radically changed the vinyl experience. To coincide with the larger space for art and design provided by the 33⅓ rpm long-playing format, Steinweiss replaced the paper covers with a more durable paperboard package. He also added liner notes to each album, providing

Jennifer Otter Bickerdike
interviewing Tim Burgess,
Liverpool Sound City 2017

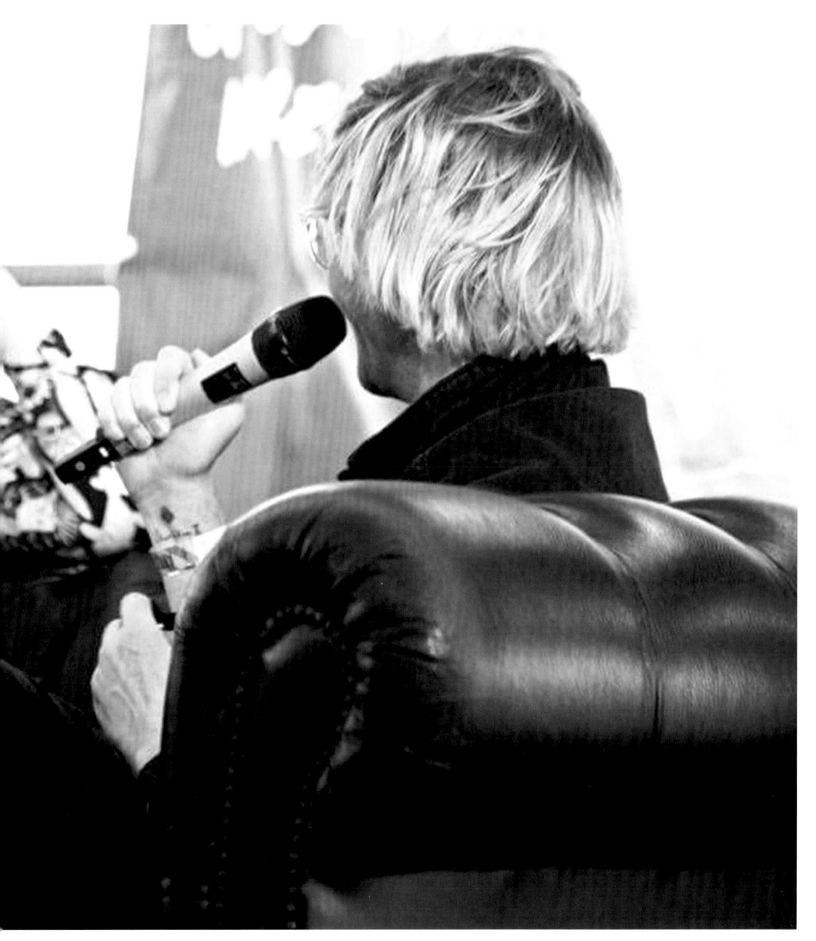

another visual element to the formerly audio-only item. These two innovations became standard for all new vinyl releases.

Steinweiss believed that musical and cultural symbols could stimulate an audience's interest more than a simple portrait of the band. He argued that the cover art and the liner notes set the proverbial stage, conjuring emotion and feeling for the music before a note was heard. This allowed for the creation of an artist as a branded cultural form, and for the album itself to transcend a particular group, becoming a statement, relic and experience unto itself.

As new and improved recording and playback technologies evolved, companies tried to differentiate their products from their competitors'. Individual components – loudspeakers, turntables and amplifiers – hit the market, offering excellent listening experiences via 'high-fidelity' products that promised to provide the 'perfect' reproduction of sound. For the next fifty years, various improvements in vinyl allowed for better sound, longer playback times and improved overall quality. Vinyl seemed primed to stay forever.

Despite the various cultural values provided by the vinyl record, the 1980s saw a new format appear on the market: the compact disc. The CD was cheaper, more portable, seemingly indestructible and could hold a lot more music, due to the CD containing data as opposed to a physical representation of an analogue soundwave. They also took up less space in stores, meaning that more stock could be for sale in the same amount of space. Over the next two decades, vinyl began to disappear from record retailers. Customers were encouraged to 'replace' their record collections with the 'superior' sound and convenience provided by CDs. 'Speed tables' featuring CDs of older albums formerly only released on vinyl dominated record store floors,

often on specially priced deals. Record companies and retailers were double-dipping sales, not just from the profits made on new releases, but the commerce supplied by fans wanting to experience their favourite back-catalogue albums via the supposedly 'superior' sounding format of compact disc.

The early 2000s, however, saw the introduction of the MP3 to the marketplace. This kick-started a growing prevalence of digital download as the favoured manner to experience music. Steinweiss's ingenious album cover, first shrunk to CD size, was now almost indistinguishable on the tiny screens of mobile devices. Music had become completely untethered from a physical commodity, lacking the emotional ties and cultural symbolism formerly provided by the comprehensive package. Suddenly, the displayed record collection, which pointed to one's personal musical taste, had all but disappeared from the home. With this came the invisibility of individuality: our things, our possessions are incredibly crucial in forming and maintaining our sense of self and providing a larger social context for meaning. A room without records was a space lacking an outward and semi-public view of the private persona. The old cliché of knowing someone's world views by what albums were in their record collection (Celine Dion! Not a friend of mine!) became obsolete. This loss of tangibility resulted in a chasm, wherein music history and subculture were lost.

Slowly but surely, aficionados returned to the record store, spurring a renaissance in vinyl sales. Owning a physical album allows for a display of identity and a show of commitment. The record cover provides means for interaction with the disc itself. Each step – from going to the store, to buying the record, to pulling off that shrink wrap and pulling the record out of the slip cover – all turn the experience of listening to music into a ritual. The ceremonial rite

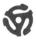

of the record and all its panoply – from liner notes to fold-out posters – has come back into vogue, as the quintessential need to embody, display and own a beloved work of art can't be fulfilled by an MP3 file.

Artists have long heralded the vinyl format as the superior way to experience music. The White Stripes' Jack White founded Third Man Records in 2001, releasing almost all projects on vinyl, as well as creating 'The Vault', a subscription only service where members receive vinyl rarities and merchandise from the label. Iconic artists like the Beastie Boys are putting out remastered deluxe editions of their past albums, featuring special art-work and gatefolds. Even Radiohead, long known for creating trends and bucking conventional music business expectations, are offering 'bundles' of some of their most well-received albums. Record Store Day 2016 saw bands new and old participating in the vinyl renaissance, with LPs and 7-inch discs from over 600 artists. From Bowie to U2, musicians of every genre put out exclusive releases to celebrate the resurgence of independent record stores and the turntable format.

Such support of the humble vinyl album gives me hope that some young girl out there is looking at pictures of Paramore's Hayley Williams, listening to their 12-inch, and knowing she can take on the world – with or without her Studio Line hair gel. The physical albums provide an unparalleled opportunity to understand ourselves, to see the history and heritage of the music family tree, and to continue to invest in music as a lever for cultural change and community. Williams' pink hair is to today's young girl what the buzz cut on Carlisle was to me – a snapshot of a world of possibilities, all supplied by the 12-inch x 12-inch of the album. Long live the vinyl record, to have and to hold.

Completely non-scientific information gathered while writing this book

Most mentioned album:
Fleetwood Mac's *Rumours*

Most mentioned favourite artist:
New Order

Most mentioned favourite album:
The Clash, *London Calling*

Number of records bought by author in the name of 'research':
108

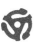

LARS ULRICH

DRUMMER

Lars Ulrich was born in Denmark in 1963. After seeing his first concert at age ten, he became enamoured with the drums. His family moved to Los Angeles when he was 16, where Ulrich met James Hetfield. The two founded the legendary Grammy award-winning band Metallica.

In the 1990s, Ulrich opposed Napster and testified before a Senate Judiciary Committee about copyright infringement. In 2009, Metallica was inducted into the Rock & Roll Hall of Fame, making Ulrich the first Dane to receive the honour.

What was the very first record you bought, and what did it mean to you?

When I was nine years old, in 1973, my dad took me to see Deep Purple in Copenhagen. The next day after school, as I was biking home, I stopped off at the record store. It was out in the suburbs where I lived, a run-of-the-mill local chain. I asked what Deep Purple records they had. They had *Fireball* – so I bought *Fireball*. And that was the beginning of it. Over the next couple years, as I was growing up in Copenhagen, I bought a lot of Sweet, Slade, Status Quo, Deep Purple... A lot of singles, a lot of 45s... This was 1974-1977. A few years later, I started migrating more towards hard rock: Thin Lizzy, Rainbow, Judas Priest – that kind of stuff.

What place does the brick and mortar record store have in today's culture?

Probably a significantly different one than when I was running to record stores on a daily basis. The record store at that time, for me, was not just a place where you bought records. It was the place where you browsed through records; it was the place where you first encountered records; it was a place of social significance. It was a place where you heard from the knowledgeable store clerks what was coming out, what was going on. That was in the pre-Internet days. Living in a place like Copenhagen, Denmark, we didn't get a lot of English or American periodicals, so the record store clerks were a key source of information. It was a place of great importance for a 12, 13, 14, 15-year-old snot-nosed kid like myself at the time. It was the centre of my music universe. My store was a three-level place called Bristol Music Centre. Of course, the hard rock department was down in the basement – duh! There were two or three fellows running it. One was a guy named Ken Anthony. A highlight of my teenager years was when Ken

invited me back to his apartment in the southern outskirts of Copenhagen to look through his private record collection. I thought I had died and gone to music heaven.

When I moved to America in 1980, it was right at the height of the new wave of British heavy metal. It was hard rock's answer to the do-it-yourself punk attitude a few years earlier: independent records, people releasing 7-inches out of their basements. At the height of this – which was sort of 1979-81 – I used to get all of these 7-inches and 12-inches sent to me. There was a mail-order company in England called Bullet Records. They specialised in hard rock. The bands would press up to 500 copies of some 7-inches and 450 of them would go to Bullet Records because that was the place where the hard rock mail-order community lived. I would get all these records sent to Newport Beach, which is where I moved to in America. Also, my guy Ken Anthony, he would send me records of stuff he was getting his hands on. There were very few records stores in Southern California that stocked hard rock. I would drive up to Hollywood; there was one place in Long Beach, there was a place in Costa Mesa called the Music Market. They were very, very few and far between. If they ever got anything in, they would only get one copy. So I had a lot of it sent to me.

Do you still talk to Ken Anthony?

Ken Anthony has played a role in Metallica's career! When we came to Copenhagen in 1984 to record our second album, *Ride the Lightning*, penniless and starving – the usual sob story – we ended up staying in Ken Anthony's apartment, the very same apartment I visited three or four years earlier as a snot-nosed 14-year-old. We came – the whole band, all four members of Metallica – and stayed in his apartment for two months in the spring of 1984 when we were recording. There you go: full circle.

What is the joy of the album release for you?

It's the ritual element of it. It's running your finger down the side to try to open the plastic wrap, and usually cutting that part under your nail. Then pulling it out, and seeing if there's an inner sleeve, and hoping for a gatefold. Nowadays, you just walk over to your computer, you click three times, and you have 140,000 songs at your fingertips. It was just a different kind of thing – and it still is. I still have all of my old records. I still occasionally take them out. I would be lying to you if I said there was no nostalgic undertone to the whole thing. It's just nice to be able to sit down and listen to music for no other reason than to sit down and listen to music. When you're in your car, music is an afterthought. You put some music on when you're cooking in the kitchen, or when you're sitting on an airplane and staring out the window, bored. It's a background function to some other activity. You used to put a record on for no other reason than to sit down and completely immerse yourself in the music, the lyric sheet and the pictures; sit there and dream your life away. It was pretty cool.

For every fad, there are a significant number of people who run in the opposite direction. So, for everything that is popular, there are people who seek out alternative ways to the mainstream. That's the nature of pop culture, that is the nature of human beings and humanity in general. Now that most people experience music through compressed MP3s – in subways, in airplanes – I think there are a lot of people who seek out alternative ways just because. So vinyl's resurgence is, in part, the anti-MP3. I think people are looking for better sound quality, looking for a more physical relationship to music, and probably a more one-on-one relationship with music rather than it being just a background element. I am not knocking it; I am

just saying an increasing amount of people seem to want to experience music in a way that has a different depth.

I have three boys. The oldest one enjoys walking to Amoeba Music up here in San Francisco on the Haight and looking at records; but also looking at books, looking at DVDs, looking at paraphernalia, looking at posters. Maybe it's a broader experience than it was for me, when it was purely records. Most music that comes out now, especially by popular artists, enjoys a limited edition run of vinyl which is a huge collector's item. It feels like it's not only back again, but it's probably not going to go away. I don't think it's going to come and go and come and go. Whether it's going to keep increasing its presence or just level off at some point in the next few years, I don't think it's going to dip much. I do think there are a fair few people who enjoy the contrary elements of going to the store, buying the physical record, and dealing with the sleeves. Listening to vinyl is an experience that often has a social interaction attached to it. But more so than anything else, it involves a non-mobile, stationary requirement in the fact that you are not in a motor vehicle, you are not in an airplane, you are not in a subway. It's an experience that requires more effort from you. It demands more attention. Obviously, there are an increased number of people who are falling back in love with this and embracing it once again. I can certainly see this in my 17-year-old. The last two Christmases and birthdays, he has asked for particular favourite records of his on vinyl. He has a little shitty $50 record player in his room. Occasionally, when I walk in there, I would say one out of 15, 20 visits, it's actually a Radiohead or Arctic Monkeys or a Miles Davis on vinyl that's playing, which certainly warms his dad's nostalgic heart. So there is hope!

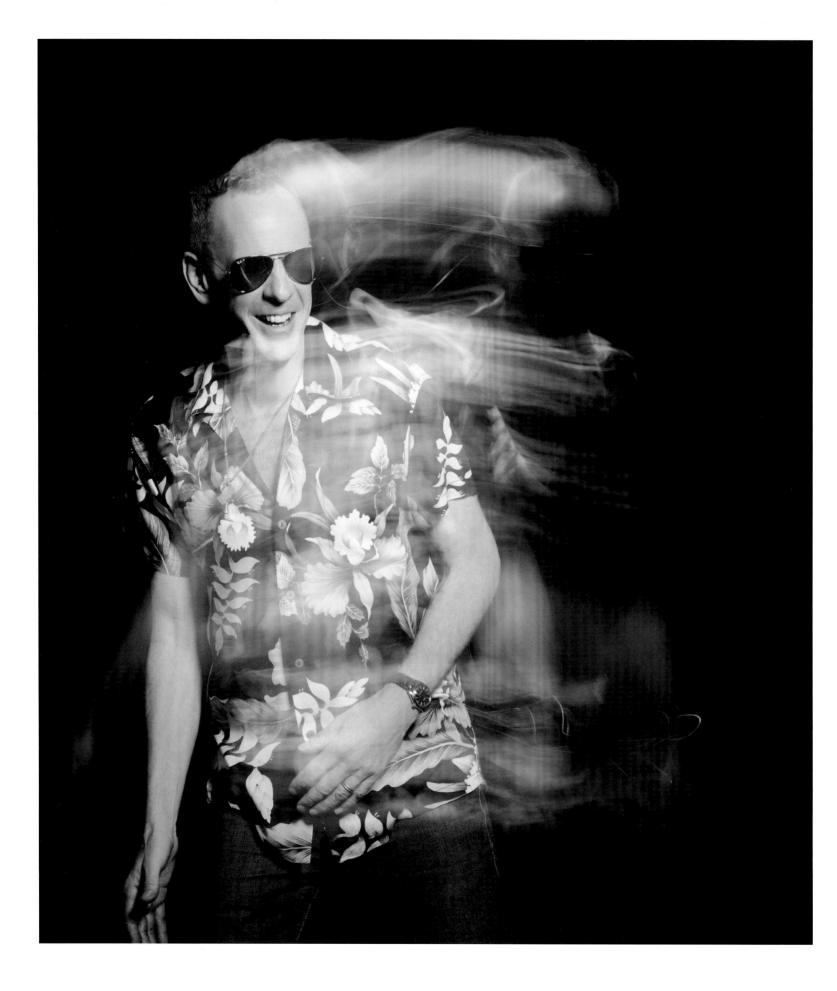

FATBOY SLIM

DJ / MUSICIAN / RECORD PRODUCER

Norman Cook, better known by his stage name Fatboy Slim, is an English DJ, musician and record producer/mixer. Cook first rose to fame in the 1980s as the bassist in indie rock band The Housemartins, known for their hits 'Happy Hour' and their UK #1, a cover of Isley Jasper Isley's 'Caravan of Love.' After the band split, Cook formed Beats International, whose debut album spawned their signature hit, 'Dub Be Good to Me,' also a UK #1. Cook adopted the Fatboy Slim moniker in 1996 and released *Better Living Through Chemistry* to critical acclaim. His subsequent albums, *You've Come A Long Way, Baby* and *Halfway Between the Gutter and the Stars*, as well as their associated singles, including 'The Rockafeller Skank', 'Praise You', 'Right Here Right Now', and 'Weapon of Choice', also met with both commercial success and critical praise. In 2012, Fatboy Slim performed a remix of 'The Rockafeller Skank' at the closing ceremony of the London Olympics. He is the only artist to have played at 18 consecutive Glastonbury Festivals.

My husband and I once read that you have a turntable in every room of the house. Is this still the case and if so, why?

I did used to, yes, but not every room – not the bathroom! We had one in the kitchen, one in the lounge, and one in my studio, because that was how I consumed music. Sadly, I only have one turntable for reference these days, because everything I do now is on sound files rather than vinyl. We did have the Technics deck set up here experimentally [motions to the family room]. Sadly, it doesn't get used, or the kids destroy our record collection.

Why is vinyl important?

That's an interesting question. Is it 'why vinyl matters?' or 'why vinyl *mattered*?' Because when it was the primary way that we consumed our music, it became more than just a piece of plastic or vinyl. It became part of the pop culture, part of the growing up process, part of the whole cult mentality. It was the centre of the music business. Then that changed to CD. People did not feel the same love and warmth about CDs as they did about vinyl. Then you got MP3s – they were a hard thing to love. Now with streaming, we are at the exact opposite end of how we consume music. You don't have to make any sacrifice or invest anything into the music to listen to it. You just consume. It's just there; it's all there if you want it. There is no sense of character or rarity, or buying into the cult of the band that you enjoy. Music has pretty much become disposable, which is a shame because vinyl was never disposable. Even if you got bored with your records, you put them in a charity shop and someone else would buy them. Digital music doesn't have that iconic status; it's not the central object of desire, translated from the people who make the music to the people who listen to it.

First vinyl memory?

Trawling through my parents record collection, which I have to say was not the coolest record collection that anyone could have, considering it was the mid-1960s. There was The Beatles, which I latched onto. Later, I also liked the Carpenters. There was an awful lot of Kenny Ball and his Jazzmen. There was an awful lot of Peter, Paul and Mary. My parents were not that hip. The Beatles records I loved; and just the idea of going through the record collection, finding little bits that you might like, here and there.

What was your first vinyl purchase and what did it mean to you?

The first record I bought with my own money was a single, 'Devil Gate Drive' by Suzi Quatro. It was brilliant. That and 'Tiger Feet' by Mud were the two biggest tunes of the moment, when my pocket money had been upped so I could actually afford to buy records. 'Devil Gate Drive' was a great, rebellious, sexy record that I still possess to this day. It got me invited to parties because people wanted to dance to it. It's quite bizarre to explain to my children now the concept that if you didn't have a record, you couldn't hear it.

I became a DJ because I was the vinyl junkie who had all the records, and would get invited to parties as a result.

So you started DJ'ing to become more popular?

Initially, yes. But at teenage parties, your records always ended up on the floor, or covered in fag ends and vomit. So I started worrying about that. I also started thinking that I was only getting invited to parties because I had the records, not because people actually liked me. Strangers would invite

me to their parties. 'You *are* going to bring your records, aren't you?' One day, somebody I didn't know that well invited me over to a party. I said, 'I would love to come, but I am not bringing my records because they got trashed last time I took them to a party.' And she was all, 'Oh.' I said, 'Were you only inviting me because of my records?' And she said, 'Sort of, yeah.' And then she came back to me and said, 'What if my dad hires out these twin record players, like a DJ console thing, and you are in charge of the records because you are the DJ?' I said, 'Yeah, all right.' So she did, and I thoroughly enjoyed it. There was a crowd; it suddenly became a performance. The joy of sharing my record collection in that manner, rather than just leaving them in the corner of the room to be explored by partygoers, I thoroughly enjoyed it. That was what launched my DJ career. I wonder if she remembers that she gave me my first gig! In those days, DJs weren't hired for their mixing skills; it was for the fact that we knew what the good records were and we had them to play.

Your face lit up when you were talking about that. You have probably told that story a million times, but it still makes you happy.

Yeah, it does make me happy. One good thing about being on our side of the cultural and age divide is that we can roughly understand what is going on with technology, but people are still making reference to what we grew up with. We can sit here and say, 'Oh, it's not like the old days.' But kids growing up, they have no idea what the 'old days' were like. Music sounds the same; it's just consumed in a different way. My nephew wanted to become a DJ. I said I would give him some mentoring and lessons. I gave him a load of records, and was trying to go through the basics. He was getting the records out of the sleeves like this [very slowly and gingerly removes an imaginary record from a cover]. I just looked at him and said, 'When you're DJ'ing, you don't have time to do that. You don't just put your finger on the lines, you put it on the label and on the edge; you have to do it quicker than that. You have to flip it.' And he said, 'Yeah, I am just a little bit freaked out. I have never touched a record before.'

Really?

Yeah! He was 15 years old, and he had never touched a record; his mum would never let him. He had grown up in the CD generation. Now he might be one of these people who is buying records but never playing them. That's the kind of thing that I find most interesting about vinyl's history. Everyone is saying, 'vinyl sales are up again!' Everyone is buying these 180-gram collectors' editions. Brilliant! But nobody is actually unwrapping them and playing them. They are just taking the free download card out. That really freaks me out. That is right decision, wrong motivation. They are buying into vinyl, but not *getting* the thing that they are buying into.

You aren't sympathetic to these kids, then?

No. It's pure nostalgia for something they weren't even around for. But at the same time, if you buy into vinyl you are saying 'I am making a commitment, spending money. In return, I can show my friends. I can put these sleeves on the wall. I am actually buying into this.' It is kind of half right.

Thoughts on DJs who have never used vinyl and have only learned how to DJ via the computer/Serato [DJ software which emulates the sounds of vinyl]?

That's like asking about people who can't operate a pony and trap because the internal combustion engine was invented. There are skills that you don't need to know. I don't need to know how to use a mule to draw water from a well, because my water comes out of a tap. Vinyl was a very interesting part of music's culture – dance music especially – but now you can do your own edits and downloads, going back to it [vinyl] is kind of beyond nostalgic – it's archaic.

How does the vinyl experience both live and in the studio differ for you and how you want your music to be perceived? How do the 'mistakes and fuck ups' make or break a performance?

I still have all of my vinyl, but I use it more as a vault – a reference library vault – than a working, living collection. It doesn't really figure in making new music. Every now and then, there will be a tune I want to sample that I can't find as an MP3 or a WAV. Then I may go and dig the vinyl out so I can sample it off that. Beyond that, about once a year, I DJ at a party or an event where they want me to play vinyl. It's quite fun, but it's like watching someone ride a penny-farthing around the room.

Most cherished piece of vinyl you own and why?

A Disconet copy – a legal Disconet copy – of Double Dee and Steinski's *Lesson 2*. It was a hip-hop party cut-up that couldn't be released back in those days [the 1980s] because it was James Brown-goes-into-'Planet-Rock' [by Soulsonic Force] goes-into-everything. It was the first time I had ever spent two weeks' wages on a record. But I was the only person in the whole of the South of England, as far as I knew, who had that piece of vinyl. It got bootlegged about six months later, but I had it six months before. Even after it was bootlegged, when I played it, other DJs would come up and go, 'Oh that's not the bootleg, that's the original.' It was great. It's a wonderful piece of musical history because Double Dee and Steinski were the pioneers of cut-up. Musically, it inspired me. Also, as a DJ, to invest that amount of money in one piece of vinyl, and to have it pay off, was great. The second most cherished piece of vinyl would probably be my copy of *London Calling* by The Clash. It's very dear in my heart. Sampling the 'Guns of Brixton' for 'Dub Be Good to Me' – it launched a whole career for me. Again, a very sound investment, that record.

Can the same thing happen today? Can you get the same cachet and credibility from a rare record, or a trend?

I don't know. Yes, that record gave you the credibility; but it was practical as well. It was like a really cool leather jacket: not only did it make you look really cool, but it kept you warm as well. I don't know that there is a parallel today; I can't see anything that kids really latch onto. I sometimes bemoan the lack of cult fashions and tribes. When I grew up, there was a new tribe seemingly every five months. During my teenage years, there were punks, skinheads, suede heads, rude boys, mods,

rockers, rockabillys, psychobillys, goths; which one did you get on with? It was like, I will ride the next few out and get on *that* one. Kids just don't dress up and join cults anymore. There is a theory that online cults come and go before you have time to invest in a whole new wardrobe! Like Pokémon Go: it had a shelf life of what, five weeks? Things happen so quickly on the Internet, there isn't time to invest in changing your hairstyle and buying a whole new wardrobe of clothes.

Every generation had its soundtrack and its cult religions or tribes. As fashion has become more disposable, people have become less passionate about belonging to a tribe. They don't want to throw themselves whole-heartedly into it. The only people who really do seem to be the scooter boys. They come through here [Brighton] on their way to the Isle of Wight. They still keep the faith. I bet you they are still spending extraordinary amounts of money on Northern Soul records; I bet they still play vinyl.

Is vinyl's return to vogue simply a trend, or will it be more long-lived?

I think it is a bit of a fashion, a bit of a trend. It came along around the same time as the hipster beard. I don't know why I associate the two! I think they are both funny; in a few years, people will look back, and think, 'What were we doing?'

I would love to think that this is the way it will go. But there has to be another way that people buy into the cults, the gangs, that is more suited to the 21st century. I suppose it's like following someone on Twitter. It's about the level of commitment you make. People used to come up and ask me for an autograph in the street – rather than a selfie. And as I was signing the autograph, they would say, 'I have all your records.' i.e. 'I haven't just recognised you in the street, and I don't just know your big hits;

I *really am* a fan.' You can't even say that these days. Because everyone can say, 'I have access to all of your records.' Nobody can buy into that anymore; they only thing you can really say to tell people you are a true fan is, 'I follow your every Tweet!'

Is the resurgence of vinyl about nostalgia?

Whenever I use vinyl, it's for nostalgic reasons. Either I am trying to relive my childhood or educate my kids as to what I used to listen to. Or playing a party or a set at a club for people who want the DJ to use vinyl. Like I said before, it's like knowing how to ride a penny-farthing when you have a smart car.

Every six months or so, we would say, 'Look, we should play our kids some proper records and go through our record collections with them, and say, "Have you heard this?"' We get the turntable out and we do it. Then you remember that you have to get up to change the record. It's like when they first invented TV remotes: you were like, 'How lazy must you be to not to get up from your sofa and walk over to change the channel; how lazy must you be?' Roll on six months and you would sit and watch the wrong programme because you couldn't find the remote. You just get into bad habits. The idea of sitting there by the record player and putting 45s on every two and half, three minutes – it's not convenient at all.

Is there any piece of vinyl you are still chasing and why?

The other day, I found a copy of *Carpenters: Greatest Hits*, sung by The Sessions Singers, on eBay. That was the Carpenters record I grew up with – this is how uncool my parents were! They did not even buy the original *Carpenters: Greatest Hits*, they bought one of those Ronco 'Sounds Like' things

– I think it was called *Sounds Like The Carpenters*. I was listening to 'This Masquerade', and, actually, I preferred the cover version. I remembered it was by The Session Singers. So one day, I looked for it and found it on eBay! It cost about ten pence. That was a piece of nostalgia, because my parents' copy got lost somehow over the years. To have that exact version, and remembering how I fell in love with all those Carpenters songs on vinyl... I think that was the last one on my bucket list.

How does vinyl play into the ethos and values of record shop culture?

It was totally important; it was vital to it. But it got replaced. There was a whole connection of communication based around knowing what the records were and seeking them out in these really small pockets – like in one column in one music magazine that concentrated on dance music. Or just hanging out all afternoon in record shops. The DJs would be there a lot, going through all the new releases, and they'd see what other people came in to buy. When another kind of DJ came in, you would compare notes. It was a whole world of social interaction. But that would involve spending three hours in a record shop. You could do the same amount of research now in about ten minutes on the Internet. Consuming music the way we do, and with the Internet making all of that information and music available, it means that the record shops are gone; it means that the DJs now communicate through forums.

DJs don't hang out together at airports anymore. Before, you would see another DJ sitting there with a record box, looking bored. You would look at the stickers on their box, trying to figure out who they were, and then you struck up a conversation. In the old days, you would always have tons of stories to share. You were in the minority, in the one per cent of people who were vinyl junkies and who travelled the world playing their records for everybody else. It's a different scene now. DJs probably wouldn't recognise each other at the airports anymore; today they just carry a memory stick. There isn't the same kind of commentary. At the same time, DJs now get treated like superstars, whereas before we were treated like part of the furniture.

I think people will be surprised that you have made such a big transition away from using vinyl.

I had to! It wasn't my choice. Technology dragged me kicking and screaming into this world where I now have to play sound files. I am still really, really vehemently against streaming. I think it could be the last nail in the music-business coffin. If you think home taping on cassette was bad, if you think CD was bad, if you think Napster was bad, with streaming, you might as well just say music is free from now on. If you want to be a musician, it has to be a hobby, not a career, unless you have a really good live set. Because streaming removes any sort of allure or investment; music becomes like cornflakes. You're not even pretending that there is any magic, any grooves.

Why did it take you a while to move from vinyl to digital? Why the hesitation?

Some call me a late adopter; some call me a Luddite. I guess I am a nostalgic kind of person. I also had a distrust of computers and technology. Early technology always went wrong, and when you are a DJ, you don't want things to go wrong. Also, I learned my craft with two Technics 1200s; I knew them inside out. I knew exactly how the pitch change worked, I knew how much to nudge it to keep it in time. I spent years learning that craft, 30 years learning how to do this. Now you want me to throw it all away, and trust a machine to do it for

me? No. I held out as long as I could. But once I did make the change, like with the TV remote, it was like, 'How did I ever survive without this?' I am glad that I stuck it out a few years longer than everybody else, until the bitter end. But once I did turn to the dark side, there was no turning back, sadly.

What does the growth in the popularity of vinyl say about the place and space of music in our lives?

It's another little pleasure that is gone. They used to say that you could read someone by what they kept in the medicine cabinet, but I always thought their record collection offered a more reliable account. If you go back to someone's house, and they go off to make coffee, have a look at their record collection and you'll get a good idea of what sort of person they are.

How many records do you have currently?

I think it's about 8,000. I put a cap on it, in terms of a certain amount of wall space, when I measured how many inches 100 records was. From there on, I was thinking, I will get rid of the second copies. As a DJ, you always had two copies of everything, especially for the breakbeats. Any tune that you want to mess about with, you need two copies. At one point in my life, I had three copies of everything: I had two copies to scratch on and play out; and when they

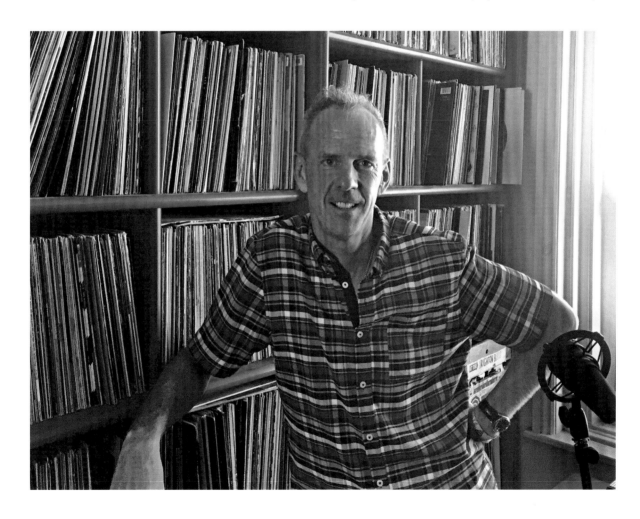

would get knackered, I had a clean copy if I wanted to sample that break. The first thing I did was start culling those extra copies.

Crucial release to have in your collection because it just sounds so much better on vinyl?

It's The Clash records for me. When I hear them on CD or MP3, they never sound as ballsy. But that may be nostalgia because I still hear them with my 16-year-old ears, when it was the most powerful noise I had ever heard. When you play them on these little mini speakers, they never pack quite the same wallop. Technically, they should sound alike, but there's so much magic contained in the grooves of vinyl; it's still there for me.

What was it like, growing up a vinyl geek?

Remember the days when you used to go around to a mate's house, just to listen to records? Kids wouldn't understand that today. They would think, 'Is that like Netflix and chill? Are we going around to just listen to records?' Yes! We would just go around there and compare each other's collections. I remember one game we used to play: people used to play 'Spot the intro' with me. They would play me my own records. They would say, 'You have so many records, do you really know them all?' I would say, 'Pretty much, yeah.' The idea was for them to play it, and for me to identify what record it is, what label it is, stuff like that. Real train-spotty stuff. Some of the records, I actually got before the music started, because I knew the clicks of the vinyl. I knew the noise of each individual one when you put the needle down on the record. I was pretty deep as a vinyl junkie.

I lived through a golden age of music. The golden age of watching dance music grow, come out of the clubs. I grew up as a vinyl junkie, when vinyl was

king. I started my career in the '80s, when musicians were getting paid instead of getting ripped off by managers and record companies. I have lived through so many golden ages of music, and I am very thankful for that. But I wouldn't want to be a musician trying to start out now. Today, you would need to get 22 million steams of your single to get the same revenue as you used to get for selling 1,000 12-inch singles, which wasn't that difficult if it was a half-way decent dance record.

Oh my God. How much do you even get for a stream? Like .0001 pence per stream?

I think there is a few more zeros actually.

Streaming may have helped artists, in that kids will go and buy the record as the last 'step' in becoming a fan.

But where are they going to buy the record from, unless it happens to have been re-released as a 180-gram boxset that is going to cost them a fortune? I don't see a lot of kids trolling around second-hand record shops.

Here's an interesting thing: I spent a lot of time looking through charity shops for vinyl. Every now and then, you would find a good seam of records in a charity shop. On the whole, it was Val Doonican records, marching bands, and Mantovani. Now, how many people do you think in the last ten years have thought, you know what, I am going to get rid of my vinyl collection, because I have the CD or I can get the music on my phone? Those records have not gone into the charity shops. The charity shops are still full of Mantovani.

I don't know where all the rest have gone. I don't know if people just chucked them in the bin, or

> **"** Remember the days when you used to go around to a mate's house, just to listen to records? Kids wouldn't understand that today. **"**

somebody is storing them in some vault. I know that [the website] Discogs has all those dealers. But there still has to be thousands – millions – of records floating around. I don't just know where they are!

The concept of a B-side: try explaining that to a teenager now. It just happened to be on the other side of the record; it had to be there. It wasn't very important, but it *could* be very important. If you did not like the A-side, you still had the B-side; you still got value. As the artist, if you wanted to have a track that wasn't on the album, or that didn't fit on the album, you could put it on the B-side. If you thought, 'Oh shit, we need a B-side. Let's go into the studio and do something off the wall!', sometimes you would come up with something absolutely genius. Some of the world's greatest records started as B-sides. There was a whole culture of B-sides. I saw an old Northern Soul sew-on patch recently. It said, 'Always Check the B-Side'. The whole concept of B-side is gone. The whole concept of writing things in the run-out grooves – gone.

How has that changed you in terms of being an artist making something?

Once you finish a thing, you don't think, 'Oh, right, OK, I have a day to make a B-Side and have a laugh, and possibly come up with something better than the A-side.' There is no part of the creative process where you are completely absolved of

any commercial responsibility. On the plus side, hopefully you don't get the album 'filler'. You won't have those last three tracks on an LP that should have been B-sides. People won't bother purchasing those kinds of albums anymore.

Are you still going to put your records out on vinyl?

Probably not the new ones. We are just re-releasing *Better Living Through Chemistry* – it's twenty years old!

What collection within your whole collection are you still most excited about?

All of it, and the fact that it is all still there. At one point in my life, I had to collect the first 100 releases on Stiff Records, 65 per cent of which were really good records. I had to buy a few turkeys, but I had to have the whole Stiff collection. Unfortunately, I was always three short. Eventually they were repackaged and the first 20 were reissued as a boxset. But I could tell the original ones from the reissues because of the ribbed plastic on the run-out groove. Imagine the look on my son's face when he inherits the collection and goes, 'What the fuck do I do with this? I know it meant a lot to Dad, but it takes up half a room.' Hopefully, by then, it will go into a museum!

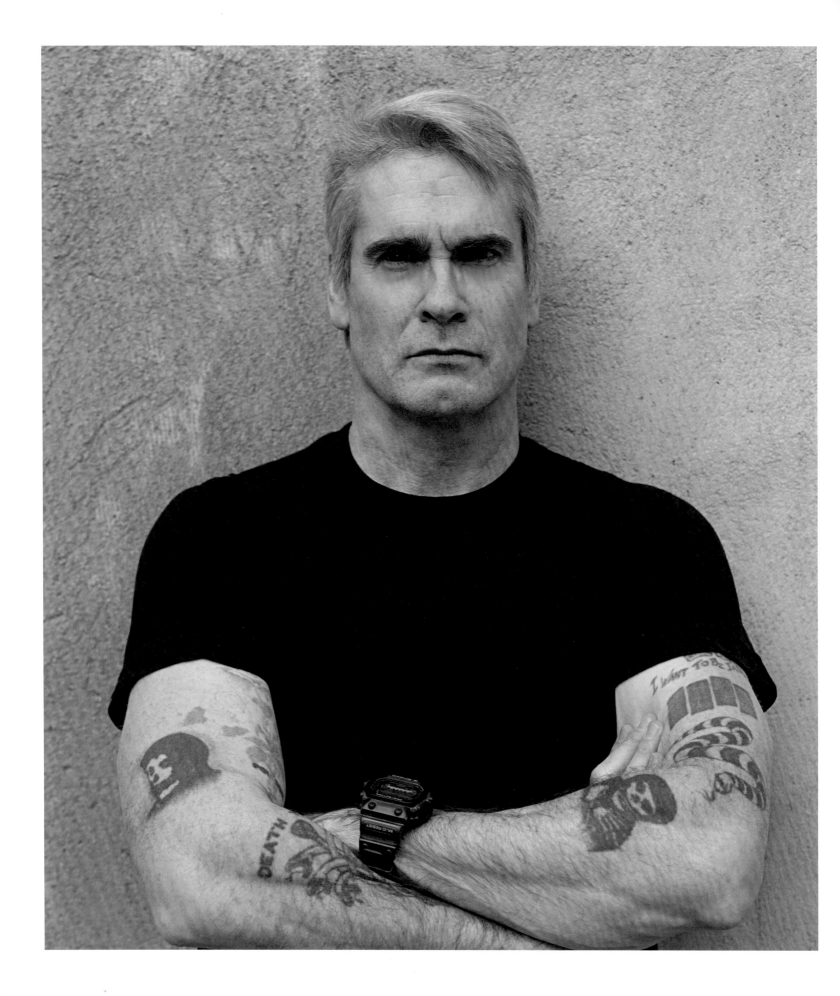

HENRY ROLLINS

MUSICIAN / WRITER / RADIO AND TELEVISION PRESENTER / SPOKEN WORD ARTIST / ACTOR

Henry Rollins was barely out of his teens when he joined the legendary punk band Black Flag. Since parting from the band in 1986, Rollins has found success as a spoken word artist, author, actor, and television and radio presenter. He currently hosts a weekly radio show on KCRW, and is a regular columnist for *LA Weekly* and *Rolling Stone Australia*.

Is vinyl important? And if so, why?

I can only answer for myself. Vinyl is important to me because what's on it is real. It is what the musicians wanted you to hear. Whether what is on the record is to your liking doesn't matter. They were able to tell you their truth, and you are able to evaluate it on a level playing field. There is no such thing as 'digital music'. Digital technology can emulate music and that technology is getting better, but there is no Led Zeppelin on a Led Zeppelin CD. There isn't a nanosecond of music on any music streaming service.

What does a record provide that other formats do not?

Full frequency. There's a reason records sound better. There is simply more on them.

Why did vinyl fade as a format during the time of CDs?

Many reasons. I am sure more than I know of, but here are a few that come to mind.

There was a newness about CDs that was persuasive and attractive. Many people had less-than-great playback on their analogue set-ups, which didn't treat their vinyl all that well and led to a lot of surface noise. In contrast, CDs were mastered loud, and to the untrained ear, louder is better. One of the initial selling points was that the source was 'digitally remastered'. Of course it was! This meaningless phrase led the consumer to believe that through this great leap in technology (from a 7-inch vinyl to a 5-inch disc of data) an almost magic process had taken place, one which would reveal the true majesty of the music that vinyl had deprived them of. The truth is that the blood of the music was being squeezed out in the process,

leaving the listener in an icy, tinny, music-free wasteland of digital information. How many people do you think actually compared their vinyl to CD? I remember doing it with the first CDs I bought in late 1986. The vinyl was much better. Technically, I didn't understand why but my ears could hear the difference.

Another reason is that in terms of sheer portability, digital is an efficient medium to listen to the music it tries to imitate. CDs were smaller and lighter, thus far more convenient for someone moving from home to dorm to apartment, etc. Record stores could carry a lot more product with CDs instead of vinyl. The consumer could consume in his or her car, at home, wherever. On that level, digital is good. On the road, I am in a digital environment for weeks at a time. I do the best I can to make it sound better with good headphones and speaker systems – but it is what it is.

Why has vinyl returned?

Perhaps these are some of the many reasons.

Someone heard their friend's system, was given the sermon, or had the chance to hear something besides digital. They were duly impressed, and they sought out their own analogue playback environments.

People read or heard interviews with bands they liked who extolled the virtues of vinyl and were thus inspired to check it out.

Many bands, when they signed to major labels at the height of the CD, insisted that their music get a vinyl release. Also, bands kept going into studios and recording on tape, which became ever more expensive. Musicians standing up for music is definitely one of the reasons that vinyl has returned.

> **" Vinyl is important to me because what's on it is real. It is what the musicians wanted you to hear. "**

On a personal note, there is something great about getting the record out of its sleeve, putting it on the turntable, getting up, turning it over, etc. I have always enjoyed the physicality of listening to records. When you think to yourself, 'That has to be the last song', and prepare to get up, only to hear another song start and finding it difficult to enjoy it because you know that you will be getting up to turn the record over or put it away; I like all that. Also, if you have good playback, you will never want to hear anything but analogue.

Artwork on albums and singles, colored vinyl, limited editions, different picture sleeves for different territories, Record Store Day – these things make music fun. I am nearing 60 years of age and like a lot of adults, I have a lot of 'real world' concerns and obligations. It's great to still worry if I'm going to score the limited edition of a record.

Will vinyl continue to be in vogue or is the recent interest just a trend which will pass?

I have no idea what humanity will get up to next. I see a lot of young people pumping music from their phones through a crap pair of headphones, so that might be where it all ends up. Bad-sounding music from a cloud. I think there will always be enough people who want something else. Right now, Record Store Day is going from strength to strength – but I have no idea if people regard this as a thing they are into for life, or just what they are into right now.

Is vinyl a nostalgia item then?

Only if you consider music to be a nostalgia item. What we're talking about basically is a music-delivery medium. There have been different mediums over the years. I think newer generations value portability. Many don't have landlines and perhaps think of them as relics. Not having the sheer bulk of vinyl to haul around might be very appealing to a lot of people. Perhaps the question is if vinyl will become an elitist/luxury item.

How does vinyl play into the ethos and values of punk?

Punk and digital, to me at least, are antithetical. I can only project my own perception – but for me, punk is vinyl and cassette. It is the picture sleeves, the noise on the vinyl, the way you know the next song on the cassette because you have carried it with you and played it so many times. Punk is analogue. It is real. Would you rather hear the first album by The Clash on LP or CD? One is real, the other is, at best, somewhat trite. On the other hand, do you really want a Beyoncé LP? Why? What do you hope to get when you pull the album out from its sleeve, a coupon for a free Pepsi? Some music is merely an advertisement for what music can be. It never escapes the enclosure of its commercial goals, nor does it seek to. The people who appreciate this music are happy with their streaming or other wretched sound-delivery systems. Punk, like rock, is an analogue, real-life experience, so you want analogue playback.

What does the return of vinyl in popularity say about the place and space of music in our lives?

Vinyl requires you to be where a record player is. Time, place, ritual, etc. The area around the system is your temple – all are welcome. The system – the sermon. The record – a ladder extending from the Parliament *Mothership*, Sun Ra's barely perceptible nod from Saturn... I can't explain to you how important this is to me. When I listen to an album sitting alone, it's great. When I listen to that same album with my best friend Ian MacKaye, suddenly we're together, listening to an album we have been playing since we were teenagers. Now, it's more than music. It's our lives coming through the speakers. This is the place and space music has in my life. Sometimes, when I visit where I come from, I walk by houses and apartments where I would hang out with others and listen to records. Those places have a lot of meaning to me. Vinyl speaks to that more than any digital rendering of music ever will.

First vinyl memory?

I remember walking a long way through the snow to buy *Physical Graffiti* [by Led Zeppelin]. At age 14, I think it was, there was a jock guy at my school listening to music on a one-speaker tape deck. I asked him who it was. He looked at me like I was stupid and said, 'Ted Nugent!' I went to the record store that night and bought the first Ted Nugent album. There were a lot of generic instances like that but I never connected with vinyl as a thing until punk rock. I remember distinctly buying a single of a local DC band. Besides liking the music, the fact that it was from a small band that was in my city suddenly made the music real to me. I don't know if this will make sense but there is an anonymous consumer/product factor to buying a big band's album. It's not that the record isn't great, it's just that interaction lacks poignancy and actualisation

to me. I am not saying that every band has to know that I bought their record but punk rock was so real and personal by comparison, there was something different about getting a small band's record. I guess what I am trying to say is that I felt that mattered. When I bought the aforementioned single, or, when I bought the first Cramps single from a Cramps roadie when they played a local bar, when I bought the Stimulators single from the band's guitarist after seeing them open for the Cramps at Irving Plaza in NYC, when the Bad Brains gave me copies of their first single in return for loaning them my car so they could drive back to DC, when Ian MacKaye put five copies of The Teen Idles' *Minor Disturbance* EP on consignment at a record store down the street from where I worked and on my lunch hour, I went down and bought all of them to lend support... There was a reality to these exchanges, even if it was just in my young mind, that resonated mightily with me.

What was your first vinyl purchase and what did it mean to you?

I honestly don't remember. I would listen to my mother's records. If I really liked one, she would give it to me and get another. Isaac Hayes' *Hot Buttered Soul* was one of my favourites. Her copy of the first Doors album was a big one. I would guess that my first purchases with money from my minimum wage jobs were big rock bands like Zeppelin, Aerosmith. When I started buying punk rock singles, that was when it all took off for me. The Damned, The Adverts, Buzzcocks, U.K. Subs, the Ruts, bands like that made me value the medium. Before then, a record was just a thing I put on my very bad record player. This is also when I started taking much better care of my records and when I started to understand how much music was a part of my life. I always knew it but when I got it, I really got it. When Ian MacKaye and I became best friends, when we were about 12, music was our connective tissue.

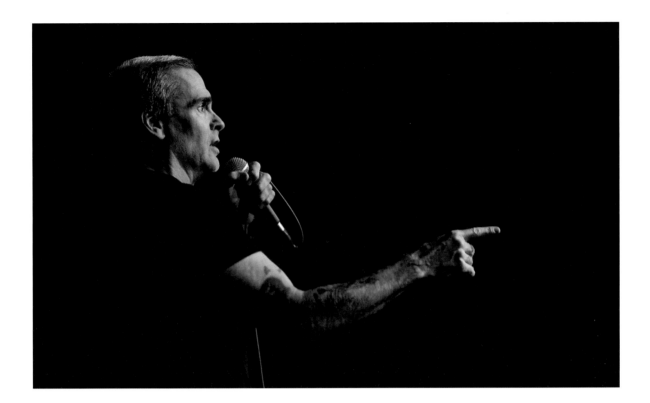

How many records do you have currently?

No real idea. A lot. I have seen collections that dwarf mine as far as volume. I never thought of my collection in terms of amount as much as scarcity of the pieces. It's not all that hard to acquire records. I usually buy one to three a day. I have a lot of acetates, test pressings and other small-run items that I value more than merely having a lot of records. Sometimes I write on the inner sleeve when and where I got the record, any interesting information about the acquisition and then I sign and date it. I think the next owner should know a little about where the record came from.

Crucial release for any audiophile to have in their collection because it just sounds so much better on vinyl?

That's a huge question. Older rock albums would be good – Bowie, Queen, Zeppelin, etc. Jazz giants like Miles and Coltrane. There are thousands of must-haves. I think every record I own is a must-have. I wouldn't have them otherwise.

Any other last words of Rollins wisdom?

Buy records. Whenever possible, get them directly from the label or artist. Listening to music makes you a better person, so listen as often as you can. Duke Ellington would sell out venues in big cities but after the show, no hotel would let him and his band stay because of the colour of their skin. He was all in. You should learn some of these stories and hear the music these people made. There are bands playing in small rooms all over the world, putting their entire lives into their music. You should go to their shows.

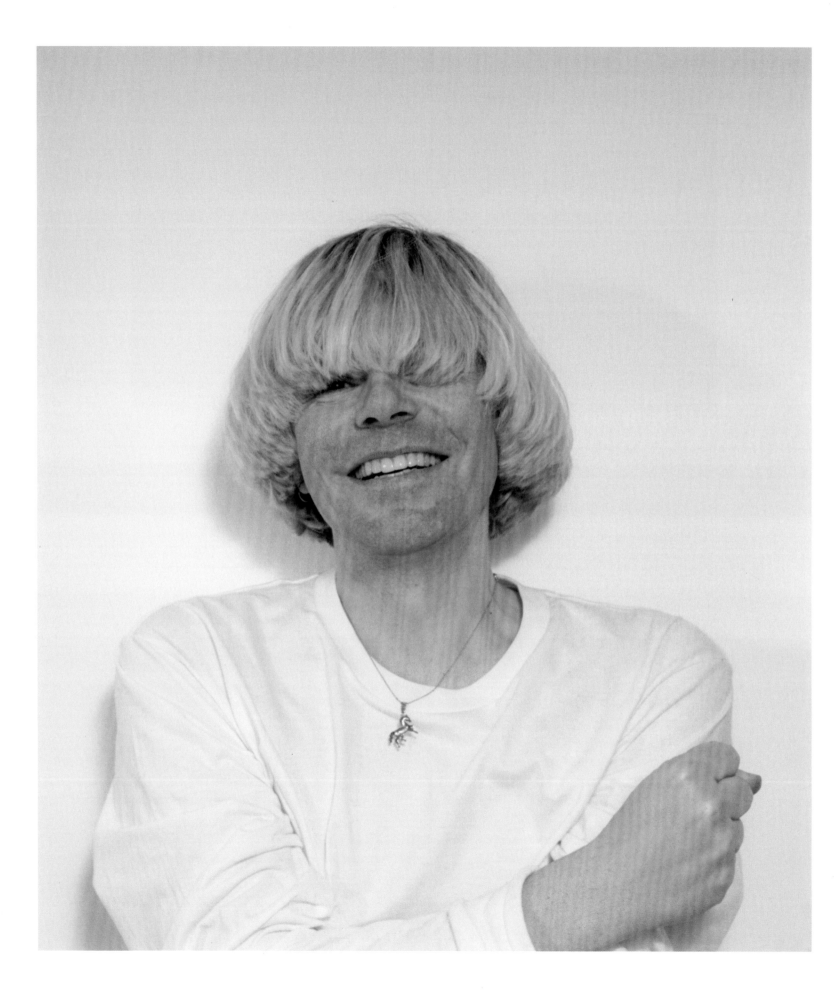

TIM BURGESS

SINGER / SONGWRITER / LABEL OWNER, O GENESIS

Tim was born in Salford but grew up in a village near Northwich, Cheshire. Leaving school at 16 to work at ICI, his real love was music. Soon afterwards he was invited to join a new band, The Charlatans. They have gone on to have three #1 albums and 17 top 30 singles. Burgess started his own record label, O Genesis, in 2011. For 12 years, Burgess lived in Los Angeles, but now resides back in the UK.

Is vinyl important and why?

It most definitely is. It's not a transient format like MiniDisc or Betamax. It was the format that rock 'n' roll was born on and grew up with. The 12-inch and 7-inch covers became gallery spaces for artists like Peter Blake and Peter Saville (see page 110). Even the label in the middle of the vinyl would proudly introduce us to the world of Island Records, I.R.S., Virgin Records and Small Wonder – with logos and colours that invited us in. The downsizing of CDs meant Hipgnosis masterpieces and independent label designs were shrunk and relegated to make them harder to appreciate. All that and we've not even mentioned the sound: the thump of the arm and needle meeting the record. No skipping, no shuffling. Can you tell that I like vinyl?

First vinyl memory?

We had a record player at home; but a six-year-old and a delicate piece of precision equipment didn't go together well. There was a real reverence towards the record player and the shelf of albums beside it. I remember my mum listening to *The Planets* by Holst, and Dad's favourites were Bobby Darin and Bix Beiderbecke; the soundtrack of the house was governed by those black discs. I remember Disney's *Snow White and the Seven Dwarves* album playing at home too. Those records showed how much magic there was in music.

What was your first vinyl purchase and what did it mean to you?

My first record was *Long Haired Lover from Liverpool* by 'Little' Jimmy Osmond, which I got when I was five, in 1972. I saw the power that records had when the Bay City Rollers broke big – they had an effect on girls that boys had to take note of. Those records may have been entry-level stuff but

the whole world they were from looked appealing. Not to say I even knew what to do to become part of that world – but I knew it looked exciting.

Most surprising thing you learned while researching and writing *Tim Book Two: Vinyl Adventures from Istanbul to San Francisco?*

However much you try to keep up, there will be records that pass you by and then knock you off your feet when you find them. An album like *Colour Green* by Sibylle Baier, which was recommended by Kim Gordon – such a beautiful collection of songs that I never knew even existed. Moments after hearing it, it was one of my favourite albums.

Most cherished piece of vinyl you own and why?

New Order were the band I fell head over heels in love with. I have dutifully taken my copy of *Power, Corruption & Lies* to each of them as I have worked with them – it now has all their signatures, though it has been over 30 years since I first bought it.

Piece of vinyl you are still chasing and why?

I always have an ongoing list from what I hear on the radio or that friends recommend; there's no one holy grail-style album that I'm after. There was when I was writing my book – *Fireside Favourites* by Fad Gadget. A few days before I handed in the finished draft, I tracked down a copy in a shop in Southend.

Why has vinyl returned?

For many, vinyl never went away. I think it has a mythical property for kids. Streaming music makes a lot of sense in terms of convenience, but what are

"For many, vinyl never went away."

these black slabs of plastic that only have 11 songs on them? How are there still shops that sell nothing but vinyl? It's like showing a commitment to music, so lots of kids now have record players. I went to Piccadilly Records in Manchester on Record Store Day a couple of years ago. There were so many kids buying vinyl. It was so good to see.

Will vinyl continue to be in vogue or is the recent interest just a trend that will pass?

Maybe it'll go in waves. Some kids will fall out of love with vinyl, but record shops are fighting back. There are so many fantastic second-hand shops; it's an amazing world to dive into.

Serato or vinyl when DJ'ing and why?

Not sure how to break this to you but I use CDs – wait, come back, I can explain!

Often my DJ sets are at festivals or after Charlatans gigs; taking my treasured vinyl collection to a potentially hugely muddy field or on and off a tour bus would be too much for me to take. Don't get me wrong, if a Northern Soul club asks me to DJ, then it's 7-inch vinyl all the way! But it's mostly CDs I've put together – plus lots of venues just don't have record decks. Am I forgiven?

How important is vinyl to O Genesis Recordings?

Very. It would be easy to start a label that only did downloads and CDs. But bands want to make a real record on real vinyl that gets into real record shops; in fact, the lure of vinyl has served us well. I became friends with Ian Rankin through a shared love of music. When I wrote my first book (2013's *Telling Stories*), I felt a real thrill to be part of the world of authors, publishing and bookshops. It got me thinking that Ian might love to be part of the vinyl and record shop world. He loved the idea, so we made a record together. We've released records by The Vaccines, R. Stevie Moore and Professor Tim O' Brien. They just wouldn't make sense without being able to see them on vinyl.

How many records do you have currently?

I think it's around 3,000.

Crucial release for any audiophile to have in their collection because it just sounds so much better on vinyl?

20 Jazz Funk Greats by Throbbing Gristle.

Any other last words of Tim wisdom?

Not sure it's wisdom, but vinyl is pretty much the only recorded format that seems to give back, that is more than recordings just being in their most convenient format. I love the fact that people write about it, cherish it and the fact it's seeing a renaissance. So my words of wisdom are: buy more records!

57

58

59

60

44

JULIA RUZICKA

BASSIST / LABEL CO-OWNER, PRESCRIPTIONS

Having made a name for herself as the bassist in the cult post-hardcore London-based band Million Dead, Australian-born Julia Ruzicka joined noise rock band Future of the Left in 2010, after providing bass duties for various other artists. She released her own album in 2016 under the project name *This Becomes Us* (featuring multiple vocalists, including Pixies frontman Frank Black). Ruzicka co-owns and runs the label Prescriptions with Andrew Falkous. Since moving to London in 1999 from Melbourne, she has worked for various record labels and currently resides in both Cardiff and London.

> **"**The advances in technology have been great for music's convenience and distribution, but I think people like having something tangible. Nostalgia is also a powerful drug, and a top seller.**"**

Why is vinyl important?

A better question might be: who is vinyl important to? I think it means different things to different groups. Music lovers, collectors, artists – to these people, it's a passion, an extended artistic representation of the music they have purchased or created. It's an object of beauty, but it's also a vehicle that carries the music they love, and at the end of the day that explains why it's so important to them. It's a way of transporting the substance – the music – in a pleasing package. It feels nice, looks nice, even smells nice. The advances in technology have been great for music's convenience and distribution, but I think people like having something tangible. Nostalgia is also a powerful drug, and a top seller.

In terms of the music consumer market, vinyl has seen a resurgence over the last five to ten years. That means that music retail, labels, and artists are making money again, like they were in the pre-digital age. In this context, it's extremely important for bands like mine, because when we hit the road in some areas, especially in certain parts of Europe and the US, fans go mental over buying our vinyl at the merch stand. That's our main earner on some tours! It feels great to hand over a record; I feel like I'm giving our audiences something of real value. So hooray for vinyl! It's saving a lot of smaller bands financially when they're on the road.

What is your first vinyl memory?

My parents' record collection. I was fascinated by it as a kid. The pictures, the turntable, how it worked – all of that was absolutely intriguing to me. At that age, you're just flummoxed by it. You're thinking: 'How does this black round flat thing with lines on it produce all that sound?' My mum has a really great '50s and '60s record collection: Buddy Holly, The Beatles, rare blues artists… I would love to go home and raid her collection again, as I'm sure I'll find some absolute gems that will mean more to me as an adult. Fascinatingly enough, mum also had a lot of comedy on vinyl, especially by this one Hungarian comedian called Hofi. God knows if he was any good. I couldn't understand it myself, being an English-speaking child. My parents lived in Australia, but my father was from Czechoslovakia and my mother is Hungarian; hence the Hungarian comedy. Back then I suppose it was common for comedians to release material on vinyl, as it was one of the only ways to distribute their act. I'm a huge fan of Bill Burr and recently he talked about releasing some vinyl of his podcast, which would be great to hear. While that's a really nice thought, vinyl probably won't become a huge commodity within comedy; it's relatively expensive to produce, and nowadays comedy has a multitude of platforms to be available on. It's a nice idea though, as a one-off.

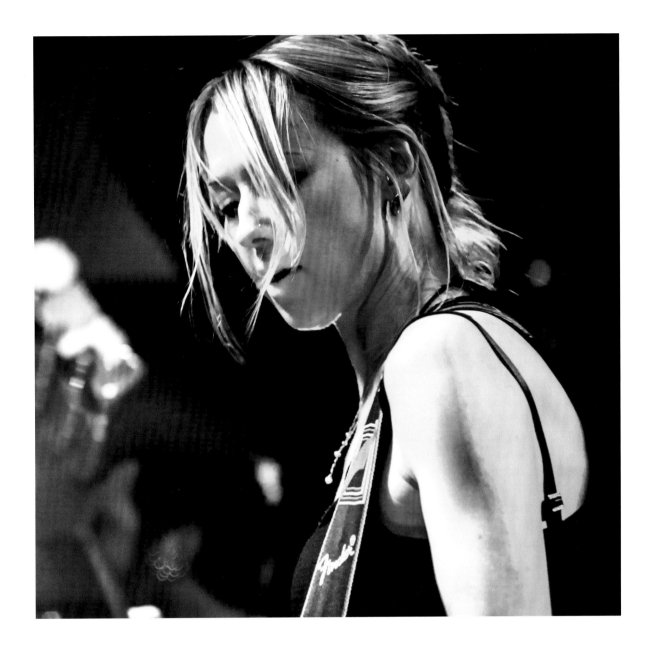

When I was old enough to obtain my own music, I was growing up during the age of the cassette. However, on birthdays, when I asked for music I asked for it on vinyl. Vinyl was a special birthday gift, as cassettes were cheaper – so it was up to the parents to buy me vinyl! I think Michael Jackson's *Thriller* was my first album. Who can forget that centre spread, with the baby tiger climbing over Michael's white suit?

What was your first vinyl purchase and what did it mean to you?

My first vinyl purchase with my own money was quite a few years and bike paper rounds later. I'm pretty sure it was Metallica's *Ride the Lightning* – by then, my musical tastes had changed from commercial pop. After that I went back and bought *Kill 'Em All*. I'm proud to still have those first

> **"** For some people their vinyl collection is their pride and joy, it's a centrepiece in the house, an ice-breaker, a talking point, a world they can escape into. **"**

pressings, from when Metallica were good, raw and exciting. Vinyl is such a great way to listen to *Master of Puppets*; the production on that record really lends itself to the format. And then it went from there to Slayer, Obituary, Morbid Angel... I went through a bit of a metal phase, as you can see! Afterwards, I moved on to punk and alternative rock. These bands, on vinyl – they just felt really exciting and special. You could peruse the artwork and the text within the record sleeve for hours. As teenagers, we would replicate the artwork, learn how to draw the logos, memorise the lyrics... We even studied the thanks lists and the credits, all as we listened to the music play. I remember buying a record by a band called Death. Me and my friends from high school, we were really into them – we would sit there reproducing the artwork from the covers, redrawing it on school desks and books. We obviously felt we were quite edgy, drawing the word 'Death' with skulls in it and the like. It's really funny when you look back!

I'm sure this resonates with a lot of people who bought vinyl as a teenager, or even as an adult. Back then, pre-Internet, the information you were given on the vinyl packaging, a lot of the time, was the only way you would get information on the band, so vinyl brought you so much more than just music. It fed your fascination, it made you want to know more about the band or artist.

Where I went to high school in Australia it tended to be the weirder kids or the oddballs – basically the non-sporty kids! – who had the insane vinyl collections. I remember being really impressed by that. You'd go to a friend's house and spend hours and hours just going through their collection and listening to records. You'd have them all spread out everywhere and just geek out.

What does the return in popularity say about the place and space of music in our lives?

As mentioned earlier, nostalgia is big business, and I still think people like to 'collect'. I'm just hypothesising here, but the return in popularity for vinyl may be the want and need for something beautiful to keep and hold that contains the music you love as well as a throw back to simpler times. For some people, owning vinyl might act as some validation or signpost to signify that they are serious about music. In some cases, they may also feel it's a more reputable and valuable way of supporting the band or artist. It's all positive really. Except for when you move house! That's when vinyl sucks. How many vinyl collectors regret not switching to digital then?

There's certainly an aspect of identity. For some people their vinyl collection is their pride and joy, it's a centrepiece in the house, an ice-breaker, a talking point, a world they can escape into. When we were growing up, people would have their vinyl on show, as many do now – they want you to know what they're into. It's a flag, looking for connection through something fun and artistic.

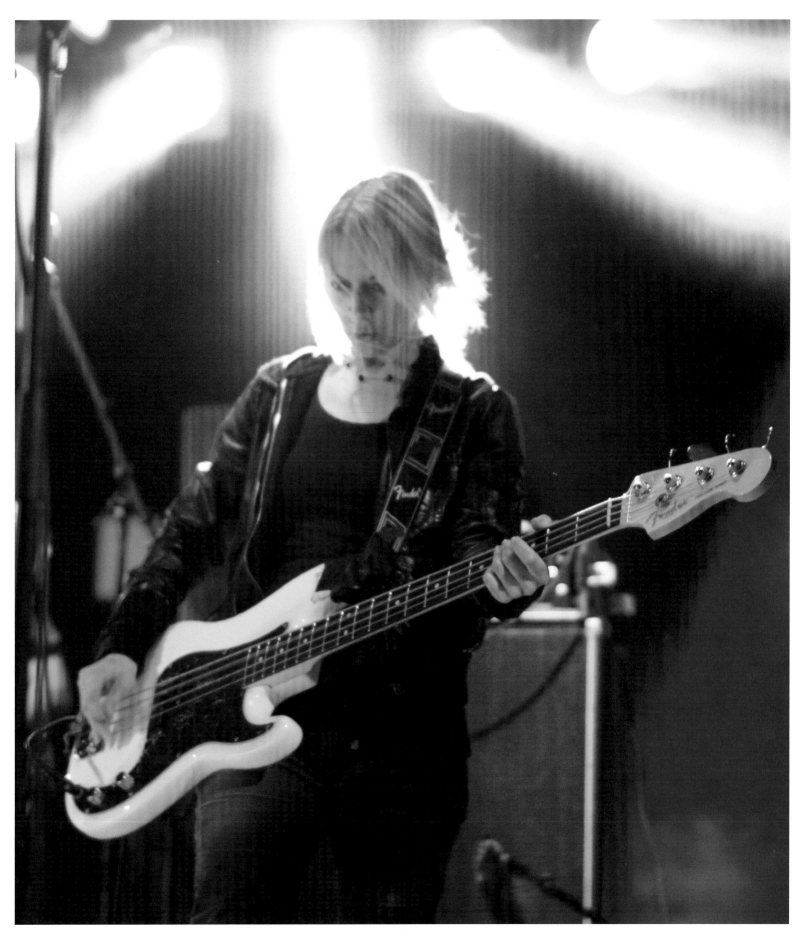

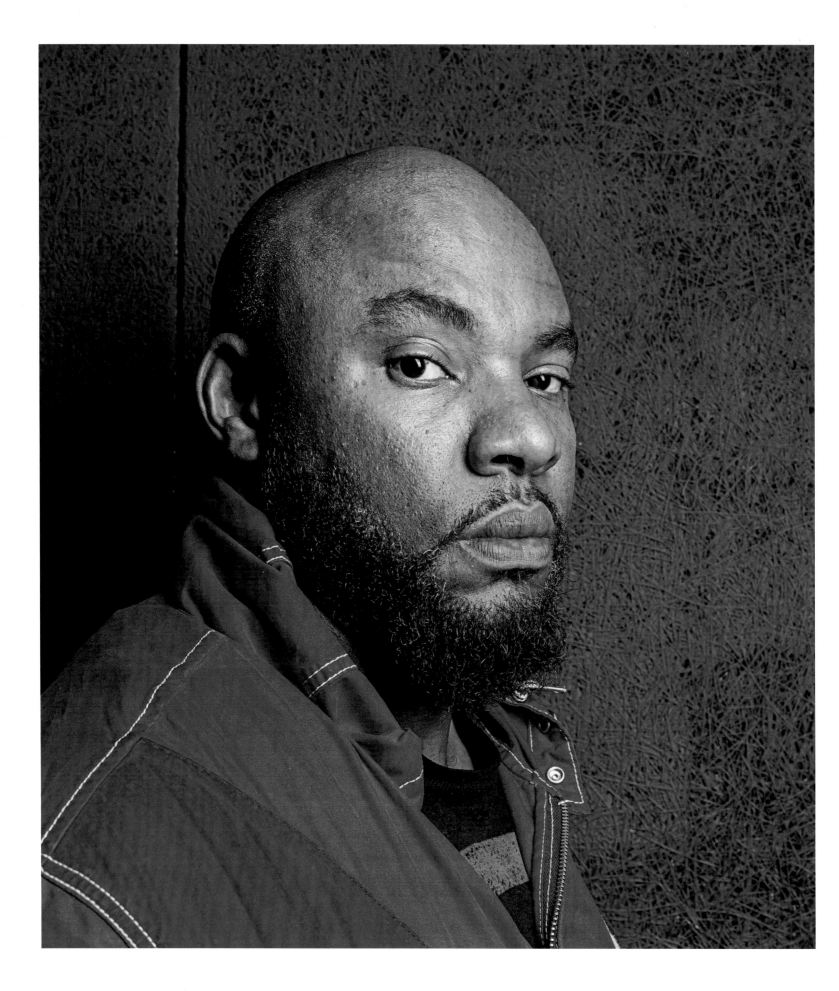

CHIEF XCEL

DJ / PRODUCER

Xavier Mosley, aka Chief Xcel, is half of Blackalicious, a hip-hop duo from California. Xcel is the DJ/producer while rapper Gift of Gab, known for his tongue-twisting complicated rap style, fronts the band. The pair have released four full-length albums, and are founders of the acclaimed Quannum Projects, an independent record label and cooperative. Like a few other West Coast rap acts, including the Pharcyde and Jurassic 5, Blackalicious has generally favoured what hip-hoppers call the 'positive tip'; in other words, their lyrics have often been spiritual and uplifting rather than violent or misogynous. Xcel has worked with a variety of iconic artists, including Gil Scott-Heron, Zach de la Rocha (Rage Against the Machine) and Questlove of the Roots.

Is vinyl important to you, personally?

Once vinyl's in you, it's in you forever. You can always switch to Serato – most of us have, myself included – but there will never be a day when I'm no longer digging for new vinyl. I dig differently nowadays. I go through record collectors and dealers, who I have developed relationships with over the last few decades. I buy a lot of stuff online as well – stores don't exist like they used to. But I still go through the 'archaeological' process and find that one guy who has a collection in his garage in Houston or in Toronto, or I stumble upon this record collection in the very north of Canada, or somewhere else completely random – wherever. I'll never stop doing that. That's all part of it for me.

First vinyl memory?

My first vinyl memories are of going to Leopold's Records on Telegraph Avenue, Berkeley, California on Saturdays. That's where my dad would go to buy his records. I went with him and got all of the obvious stuff – Earth, Wind & Fire; Parliament; James Brown. I was also heavy into jazz – so John Coltrane, Ornette Coleman, all the Blue Note stuff, the Prestige stuff, Black Jazz.

My dad would be embarrassed because whenever we went into the record store, I was always fascinated by the KISS covers. This was when they had their own TV show, and all of that shit. I hated the music, but I loved the covers, so I would make him buy me those records. I would never even listen to them! Those are my earliest memories.

What was your first vinyl purchase and what did it mean to you?

It was probably Parliament's *Uncle Jam Wants You*. That's the first one I remember. I always had access to records – a lot of parents wouldn't let their kids touch their records, but mine weren't like that. In my house, as long as you put the records back in the right sleeves, you were good. If you didn't put them back in the right sleeves, it would be a problem!

For me, it was like, 'yeah cool, I got money; now I can buy my own vinyl'. But at that age, I wasn't consciously collecting records. I was probably younger than my son is now – and he's ten. When I started *collecting*-collecting, I was about 11 or 12 – because that's when I started DJ'ing. We would go to Tower Records on Broadway [in Sacramento, California], which was actually the original Tower Records. That's where I started buying 12-inch records. On any given weekend, I would get stuff like Dr. Funkenstein's 'Scratchin' to the Funk' and Schoolly D's 'P.S.K. (What Does It Mean?)'.

How did vinyl influence your interest in DJ'ing?

I had always been fascinated by production. When I heard what producer Prince Paul did with De La Soul's 1989 debut, *3 Feet High and Rising*, everything changed. Because at that point, it wasn't just about looking for breakbeats in one genre of music; everything was fair game. It was like if you'd only seen ten colours in your life, and then all of a sudden you were exposed to this world of technicolour – it's like *wow*. From that point on, I went from buying hip-hop records every weekend to just buying records, period. I always tell people that I had a head start because my father collected so many different genres of music – I was already up on a lot of stuff – but in terms of taking these samples from all different genres of music and creating a collage, a new portrait on a blank canvas, that made my mind unravel. It exposed me to a whole new world.

"Once vinyl's in you, it's in you forever."

Have you always released Blackalicious records on vinyl? If so, why?

Every record we have ever done has been on vinyl. It's what we do! I can't imagine creating something that *isn't* available in that format. As a record collector, I'm a big fan of the analogue aesthetic, and the physical nature of everything vinyl. I'm also a fan of how technology has increased my workflow and my productivity; but for me, I love the process of making a vinyl record more than I could ever love digital production. I love the endless back-and-forth creative sessions with Brent Rawlins, our artistic director who has overseen all of Blackalicious's records from *Melodica*, Blackalicious's 1994 debut EP, to *Imani Vol. 1*, our 2015 release. There's nothing quite like sending him the music, having him hear it, and seeing how his mind interprets it, and how he synthesises that music into visual form.

Do you just send Brent Rawlins the music? You don't send him a mood board or anything like that?

Everything starts with us. With *Nia*, our 1999 album, we went to Brent and said, 'We want to make all of our album covers pieces of art in their own right.' We wanted them to be things that people would hang on their wall at home. At the same time, we wanted them to be a comprehensive body of work, in the same way that if you looked at the Earth, Wind & Fire covers, you could make a collage where they all fit together as one piece. If you look at our record covers, you can connect the dots. They all have a similar feel and a similar vibe for a very, very distinct reason. And that has been intentional since day one.

So Brent just listens to the music and goes with the legacy of what you have already done? It sounds like it's an evolving process...

It totally is. He will come and put options in front of us, saying: 'These are the things I am seeing.' Case in point: when we did the *Nia* cover, I spent about a week with him at the Schomburg Center for Research in Black Culture, Harlem. There was an artist from the Harlem Renaissance of the 1920s and '30s, Aaron Douglas, whose work was displayed there at that time. I wanted something that was texturally and tonally inspired by his work. With that in mind, Brent worked it over. He came up with the idea of the kids on the cover for *Nia*. Then we took it a step further: what if each one of those kids represented somebody from Quannum Projects [the hip-hop collective that includes Blackalicious]? If you look at that cover closely, you can say 'This person is Lyrics Born, this person is DJ Shadow, this person is Lateef the Truthspeaker, this person is Joyo, this person is Aaron and Ova.' There is a lot of subtext in our record covers. That couldn't be achieved if we just put out a CD – and it certainly wouldn't be achieved if we just put it out digitally. You have to have the vinyl to be able to feel that extension of the art.

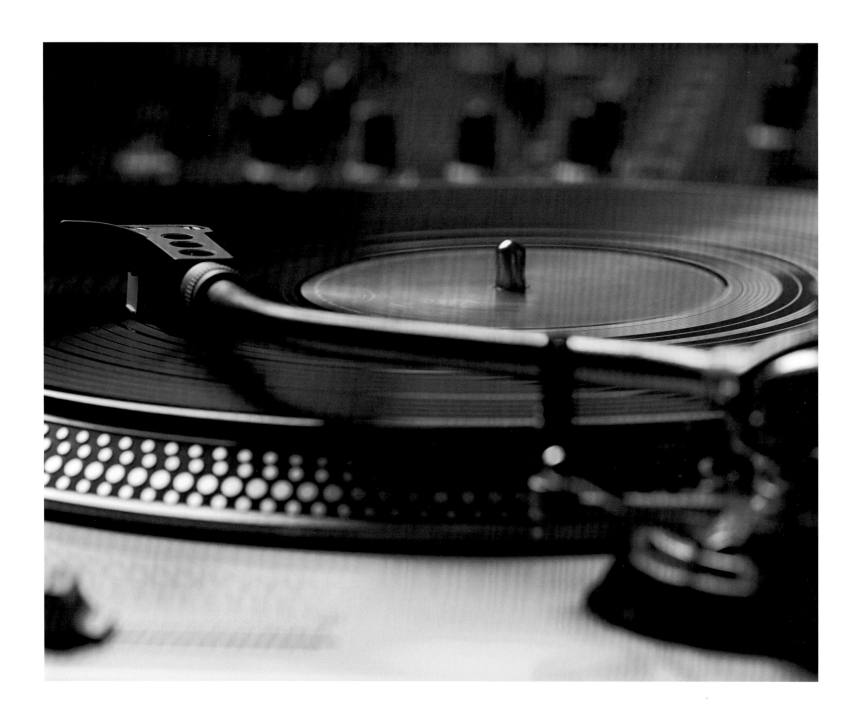

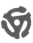

> **❝** No matter what happens with technology, there will always be a record that you do not have. **❞**

Do you still use vinyl when you make a record?

Yeah, I do. Even if it's to go into the studio and to have reference points of a certain direction I want to go in. A lot of times, I go into the studio with my musicians and I will just play records for them. It could be a Turkish jazz record; then that's the direction of the day. We may go from Turkey to Brazil to some sort of Japanimation '70s soundtrack thing. The record crates are always the heartbeat of the sound for me.

Crucial release that sounds so much better on vinyl than any other format?

I really dig listening to *Off the Wall* by Michael Jackson on vinyl. Those mixes sound really, really dope to me. I love listening to the Public Enemy records and hearing the Bomb Squad production,

and knowing how ahead of their time they were. That sort of music maintains its timeless nature. Ask me tomorrow though, and it'll be a completely different set of records!

Tomorrow, KISS will be on the list?

You can quote me on this: I was never digging the music! The record covers just looked wild to me.

Last bit of Xcel wisdom?

No matter what happens with technology, there will always be a record that you do not have. I can go to a warehouse somewhere in Florida and go, 'Damn, this church made this private pressing of 200 records just for their congregation.' For me, that's what drives the thrill of discovery. It's finding those things that never got gobbled up by the conglomerates.

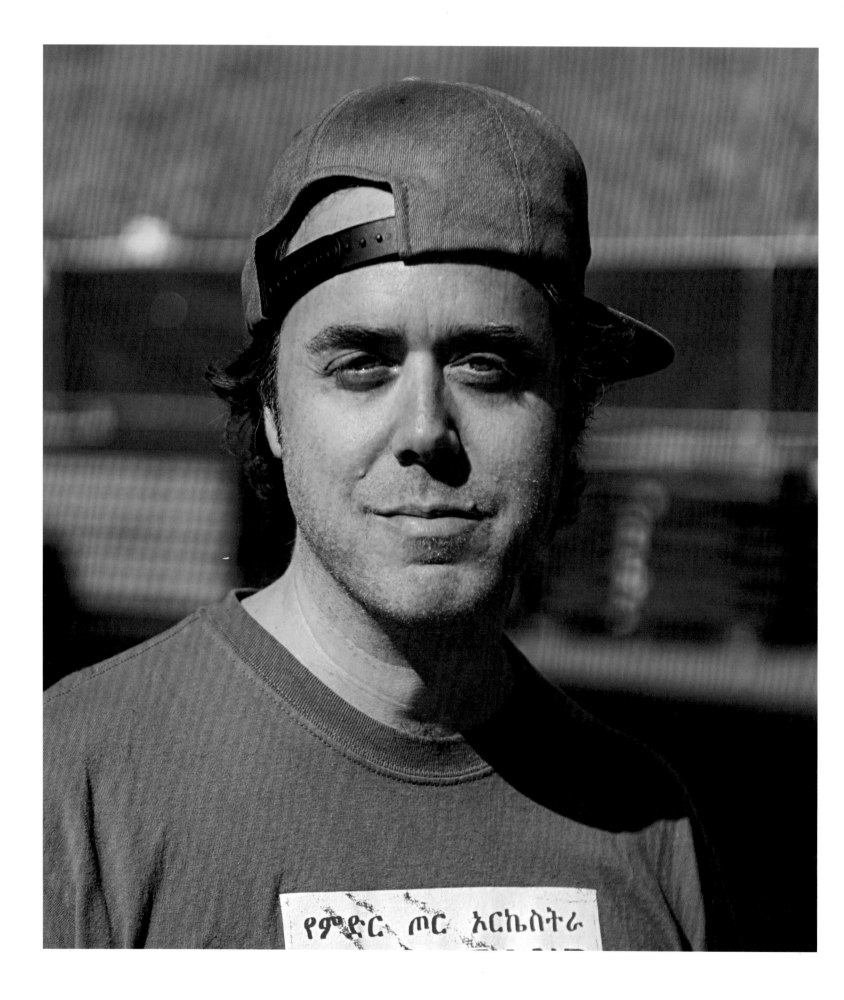

CUT CHEMIST

DJ / PRODUCER

Cut Chemist, born Lucas MacFadden, is a founding member of both the rap group Jurassic 5 and the Grammy award-winning Latin funk outfit, Ozomatli. He has collaborated with fellow turntablist DJ Shadow on a number of projects, including one of the world's most sought-after mix CDs, *Brainfreeze*, and its sequel, *Product Placement*. Cut Chemist has been recording and performing for over twenty years. He began DJ'ing in 1984, aged 11. By the age of 14, Cut was recording with his friends, including Chali 2na, who would later perform as part of the six-man line-up for Jurassic 5.

Is vinyl important?

Vinyl is still the best way to archive music: the best way to preserve music. When stored properly, it doesn't deteriorate like digital or tape. Because the tape is magnetic, the magnetic portion loses its power over time, and the music can disappear from it. With vinyl, the music is cut into the surface. It can't deteriorate unless you leave it out in the sun, break it or scratch it. It's the only medium that can preserve music forever.

First vinyl memory

My parents gave me a choice: 'Do you want the 45rpm for the *Star Wars* theme, or do you want the whole LP?' I thought to myself, 'Are you kidding me? I want the LP!' You get the booklet, you get all these pictures, you get two records – versus the 45rpm, where you get some stupid paper stock sleeve and two songs. And the 45rpm is small – no thanks. That was 1977. That's my first vinyl experience that I really remember.

What does a record provide that other formats do not?

The natural compression of vinyl is a warmer sound. There is something lost in digital because digital code can only add certain things whereas vinyl can capture everything between the ones and the zeros; it can capture the subtleties.

Why did vinyl fade as a format during the rise of CDs?

Every generation has their format of choice. During the '90s, CDs were that generation's medium of choice. They were more disposable, but they were marketed as something superior because they did not scratch – which we all know is bullshit. The thing about CDs was that you could advance the tracks very quickly. You wouldn't have to rewind and wait. Things were quicker; society was moving faster; people were becoming more 'ADD' [Attention Deficit Disorder]. The CD fit this: forward, forward, forward, skip skip skip. Whereas with the tape, you had to listen to the whole thing. You wouldn't want to fast forward for 30 minutes just to hear the last track.

Why has vinyl returned?

It has and it hasn't. If you're talking about vinyl as a mainstream medium, it hasn't. How much of the population still buys vinyl versus downloads? A fraction? I know vinyl sales are bigger than they have been since vinyl was the main medium, but they're still not even close to what they were in the golden days. Who are these people buying vinyl? Why? People buy it because they think it is hip. This generation is all about laptops. If you want things to progress, you can't hold onto old technology. If that was the case, I would be DJ'ing on cylinders. Vinyl has had its day. It's the superior format; I do agree with that. But it doesn't fit into today's society. This is not a superior society. This is a society all about disposability and quick turnaround. It's not about quality. Of course the laptop is the way to do it. I'm not going to deny that; I use a laptop for my own shows. You think I'm going to go around the world with records? TSA [Transportation Security Administration] would charge my ass if I had four crates of records going through airports!

Why did you feel it was important to release your albums on vinyl, even when it was not a popular format? What does this say about ethos and values?

CDs or files can be deleted. I think it's always important to put your work out on vinyl. When

you care this much, you need to have something released in a physical format that you love, that you can hold. Records are the best way to do that; they aren't going to delete themselves. A CD's information can be wiped. I have some CDs that won't play anymore, even though I stored them well. Digital information just fades away after a while. But not records!

What does the return of vinyl in popularity say about the place and space of music in our lives?

It says a few things. It says that people still like the classics, which is great. People still want to hold tangible art – that's important. Every day, it seems like the tactile world is being taken away from us and everything is becoming more virtual. I think it's a fight – people are fighting to hold onto something through records. That's awesome, that is amazing. I think people should always fight for what you can touch.

I think one of the reasons people are losing their minds is because there are less and less things to touch. Without touching things, you cannot be grounded. It's hard to love something that you cannot touch. So, when you download a song and you say, 'I love that song'; do I think that you love it as much as someone who bought it on vinyl? No, absolutely not. Because that person can touch that song, they can hold it, they can see it, they can listen to it. With a file, it's like, 'Yeah I love it.' Then you forget about it. 'Oh yeah, I had that in my hard drive! Wait, that was three hard drives ago.'

Will vinyl continue to be in vogue?

I think it will stay in vogue. When did it start? In the '30s, '20s? Even though it took a brief hiatus in the 1990s, people were still collecting records. We are

talking about a medium that hasn't gone away in 100 years. I think that says a lot. I think it is always going to be here in one form or another.

What was your first vinyl purchase and what did it mean to you?

The K-Tel *Dancer* compilation from 1979. 'Celebrate' by Kool and the Gang was the reason I bought it. It had all the jams: 'He's So Shy' by the Pointer Sisters, 'Double Dutch Bus'. I knew I wanted to be a DJ, even back then. I was listening to the Mighty 690, which was an AM pop station which broadcast out of Mexico. We got it here in Los Angeles. I realised that I wanted to play records for my friends, make them dance and have a good time. So when I saw this compilation, I thought, 'Shit I don't have to buy *all these* records, I just have to buy this one! They're all here on this one record.' I was seven, eight years old. It was $4.99 at Music Plus. I bought it with my own money, and I wore that thing out. I still own it.

I started buying all these K-Tel compilations. *Dimensions*, *Certified Gold*, *Neon Nights*. I started buying James Bond soundtracks shortly after. That was probably in 1980. I saw the movie *Moonraker*, and I liked it so much that I started collecting the music: they were the first things I consciously collected. When I saw a James Bond soundtrack, and realised that it wasn't from the *exact* film I liked, I would buy it anyways. Then I'd see another one, and buy that too. I was trying to get to that *Moonraker* soundtrack, but I never found it. I always found these other ones instead, and eventually I decided it would be cool to have them all. That was the first time I felt like I wanted to complete a series. And then finally – *Moonraker*. I saw it and I bought it!

How many records do you currently have?

Probably about 40,000.

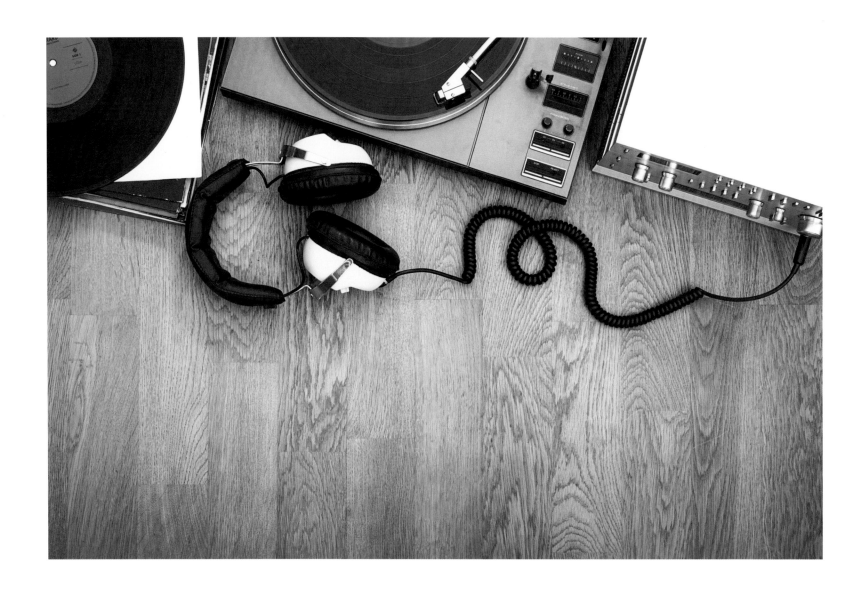

> " It's fun to talk to people about music, about what they know, what they don't know, what I can share. "

Of your various micro-collections within your overall collection, what is your favourite?

It changes, but I think I'm most proud of my hip-hop collection, because it's the most thorough.

Are you still digging around in crates hoping for an insane vinyl find?

A lot less than I was, because my taste is more refined. I look for all kinds of stuff; I look for funk, hip-hop, soul and jazz, African. There are specific pieces that I want. Do I go out there searching for things that I can learn about? It's harder nowadays, because everyone is an expert with the Internet. The record shops will withhold obscure things, because they need to know more about them so that they can flog them online. It's a drag to deal with people like that – we call them 'grippers', because they grip too hard onto their shit. Thanks to people like that, it's actually become easier to buy online. Not to say that I buy

online exclusively. I do it a lot more now than I used to, partly as I have a lot less time to hit the pavement. Diminishing returns are staggering. More and more people are buying records. More and more people are experts. More and more people are selling records. That makes it harder to find the gems.

Do you still enjoy going to the record store?

I do when the record store owner is cool; knowledgeable, easy going, somebody I can talk to. I don't *need* to go to the record store to buy records. But if people are willing to share information, and I can share information, if sharing is reciprocated – I love that. I love going to Groove Merchant in San Francisco and hanging out with my friend Cool Chris. It's the best thing ever. I don't even need to walk out of there with any records; if I do, it's a bonus. It's fun to talk to people about music, about what they know, what they don't know, what I can share.

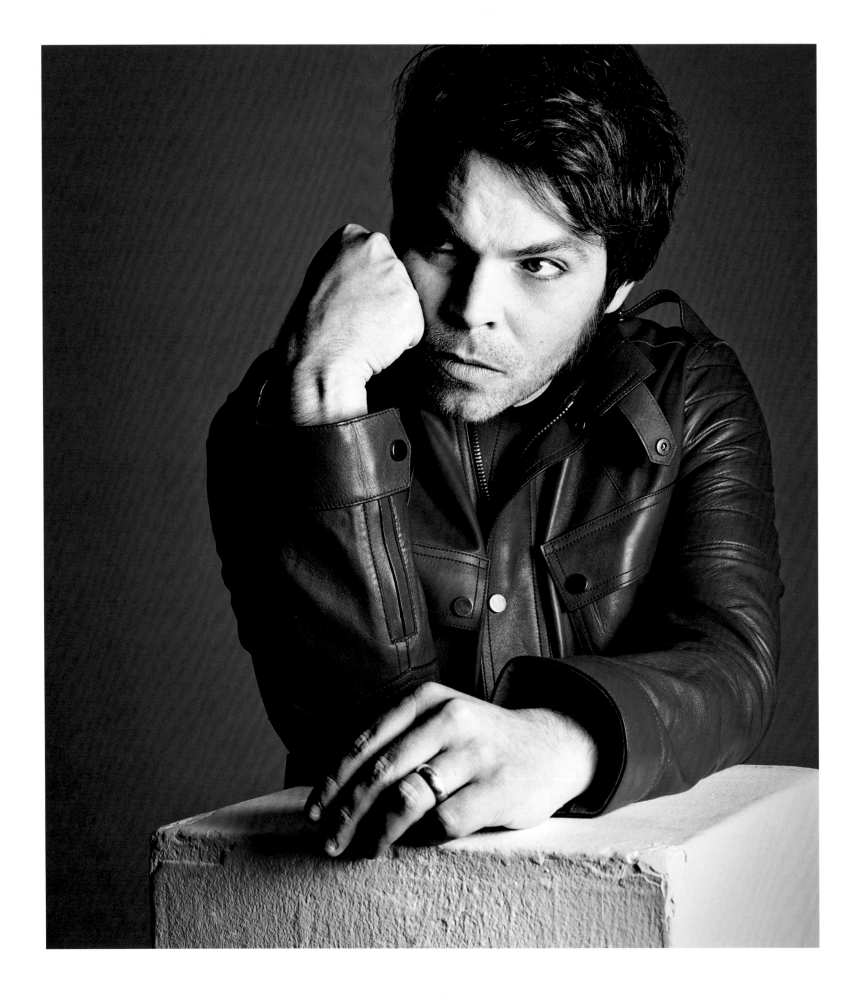

GAZ COOMBES

SINGER / SONGWRITER

Gaz Coombes is an English singer, songwriter, Ivor Novello and BRIT award winner, who signed his first record deal aged 15, and is best known for fronting the group Supergrass. He is responsible for 11 top 20 singles and 7 top 20 albums, beginning with Supergrass' *I Should Coco*, Parlophone's fastest selling debut since The Beatles' *Please Please Me*, through to his recent solo album, *Matador*, which was shortlisted for a Mercury Prize and the Ivor Novello album of the year.

> ❝ When I got older, I would find things on vinyl that I couldn't on any other format. It was another doorway to music. ❞

Why is vinyl important?

It's the number one way for a lot of people to listen to music. It may have had dips, but it's still going strong. I've always been a fan of what it does sonically for records, for guitar bands especially. I love how it brings out the mid-range guitar. When I look at stuff during mixing, I can tell which tracks will have an edge or come into their own on vinyl. It's very sensitive to certain things. It's great! Nothing else has quite matched it. There's just something about it that seems to surpass any other format. Yes, streaming is a big part of how we consume music; but it's still not what I necessarily do at home. My record player is the first port of call, all the time.

Right now you're in the middle of making a new album. Do you use records for inspiration, or as a jumping-off point for new work?

Yeah, in my studio at home, I've had my decks set up for the last month or so... partly because I threw a party at New Year, and haven't taken them down. DJ'ing with vinyl is so hard! I'm terrible as well; I'm a beginner with eyes for bigger things. I'm just messing around with it. It's fun. When it's not dance music, it can be kind of weird, too. When you are going from 'Love is the Drug' [by Roxy Music] to 'Sure 'Nuff 'N' Yes I Do' by Captain Beefheart and his Magic Band, they are not very mixable. It's out from one and into another. But it's cool. It's like old-school radio DJ'ing. Now that I am working on

a new project, when I get a bit of a mental block or hit a wall I just go over to the records, finger through them and find something to mix.

First vinyl memory?

They used to sell 7-inch singles in the supermarket when I was a kid, which was always really cool. At the time, it was considered normal. It would be strange now. I remember going down there, I must have been about seven or eight years old, and I had a little bit of pocket money. I bought 'Into the Groove' by Madonna. I had a crazy fascination with Madonna.

Is that gone now or is it still there?

It's still there, a little bit; in a reminiscent kind of way. I remember being so into Madonna. And the film *Desperately Seeking Susan* as well. She just looks amazing.

What did it mean to you to get that Madonna vinyl record?

It was very exciting getting it back home and playing it on my Alba Midi System. I was probably killing my records by playing them with that horrific needle. When I got older, I would find things on vinyl that I couldn't on any other format. It was another doorway to music, as I was getting into weirder things and looking for new things to be inspired by. Sometimes you will find different versions of a record on vinyl; it

has been remastered, or there are different versions to what was originally available, or on the CD.

Going around America on tour, I would search out record stores when we arrived at each stop. I remember finding a lot of weird supergroup records, featuring people like Al Kooper, Stephen Stills, someone else and someone else. It would be a one-off. There was probably not a demand for it to be reissued once other formats had been invented.

I also loved American in-store performances, like at Amoeba Music. It was half about doing the in-stores, and half about having the store give you credit to buy albums as a thank you: 'You've got $100.' It was like *Supermarket Sweep*. I would wander that store for three hours!

Vinyl is still magical. At Christmas, my wife got me *Scott 3* [third solo album by Scott Walker] on vinyl. I had *Scott 4*, but I had been looking for the track 'Copenhagen' which is on *Scott 3*. I had heard it before, but had recently heard it again. I had forgotten about that song. It is utterly beautiful. I just love that record so much. I played it so much over Christmas; it was my Christmas record. It has these beautiful orchestral things on it; it's a magical record. I just love this piece; it is just different listening to it on vinyl compared to any other way.

How did vinyl influence your decision to become a musician?

I think it was a part of the whole birth of our band, really. We were doing what kids were doing anyway, whether they were in bands or not. Being over at each other's houses, we would go through records, in between jamming together. Then someone would find a Muppets album. People think I'm taking the piss, but the Muppets album, the Cheech and Chong record, a lot of those weird comedy music albums were inspiring. On the Muppets album, Animal had a song that was really mental. It was him drumming, and making all of these noises! The Monty Python records were massive too. Just weird records that would pull you all together to laugh at, or you'd say, 'Oh yeah, we should do something like that.' Just listening to music; but the fact that it was vinyl and the scope of what we had is just different to what you could get on a cassette or CD at the time. It was more likely to raise an interesting conversation or inspire something in a different way.

Do you have a most cherished piece of vinyl that you own? If so, what is it and why?

I've got a really cool version of *The Man Who Sold the World* [David Bowie], the one with the cowboy cover. That's pretty rare. I remember when I was living in Brighton, I'd go to the Brighton Centre and attend all the vinyl swap meets. I went through a phase where I would hunt down the weirdest and rarest things I could find.

Are you still chasing any vinyl?

Not particularly. There is nothing that I have my eye on. Six or seven years ago, I was trying to hunt down Dennis Wilson's record *Pacific Ocean Blue*. That was a tough one to find. I think they actually reissued it, which is a bit of a cop-out, but that was the only way I could get hold of one. *On the Beach* by Neil Young was another one that was quite hard to find, but I ended up getting an original one of those. I think I found it online.

Do you play it, even though it's so rare?

Yes. To be honest, the only thing I wouldn't play are my mum's Beatles records. She's got a few originals.

They're a bit fucked, so they may not be worth a great deal, but they are the first pressings. She also has the original *Space Oddity*. The cover is really faded, but it is quite cool.

Why do you think vinyl has returned?

I think it fits with the idea of things becoming more collectable. Maybe people get the same buzz as they did when we bought vinyl originally. It's a tricky one. It's a really cool product. It has the potential to show off a great bit of artwork, and I think kids still appreciate that; they can see that it's a more creative way to buy and keep their music. Whether or not sonic positives are understood or are a part of it, I have no idea. It just works. That's why we keep coming back to it. It's a great invention. However, the record players they're pushing on people are fucking awful; they're crap. I really highly advise people not to buy them. They look kind of cute, but they're not very good.

Have you introduced your kids to vinyl?

Yes. They are eight and twelve years old. I've given them a crash course. There's nothing worse than someone fumbling around and scratching up your vinyl, not putting it on or putting it away properly. The kids really like it. They think it's cool.

I love the cover for *Matador* [Gaz's second solo album]. You look fantastic. You have a David Bowie vibe going on it.

It is because I had an amazing photographer, and great lighting. I am not going to deny, Bowie was a bit of an influence. More the out-takes frames from that Bowie shoot [Masayoshi Sukita's images, from Bowie's 1977 *Heroes* record cover sitting]. It was an amazing shoot, and I really enjoyed it. It was an honour to work with Rankin [photographer for the *Matador* cover]. It felt like a special album cover, in an old-school way, harking back to the days when the cover shoot was a huge affair. The album before was more a piece of artwork that was created, which was really cool. I love that one as well.

Favorite album cover you have done and why?

I always liked the *In It For The Money* cover [Supergrass' 1997 album]. It's the three of us busking. The cover after that, the *Supergrass* X-ray image [from the band's 1999 album] was a mad one. I remember breaking into a hospital – a friend of ours had keys, so we didn't *really* break in – but we got in and got this guy to switch on the machine. The cover image is a proper MRI scan of our heads! I think as we were taking the X-ray someone asked, 'Is this safe?' But it was like, 'Fuck it, let's do it anyway!' It was mad; we had scans of our skulls and superimposed our faces onto it.

What is your favorite album cover?

That's quite hard. I think you might've stumped me on that one. I don't think I have a genuine favourite, although I've always liked the cover for The Beach Boys' *Holland*. It's this faded old photo that just works on the scale of a 12-inch x 12-inch album cover. *Innervisions* by Stevie Wonder is a good image. I just don't really have a favourite. *The Man Who Sold the World* by Bowie is a great one, the black and white image with him and his guitar mid-pose. I've got some amazing Elvis albums. I have some odd, quite strange pictures of Elvis around our house.

Have you seen how much some of your Supergrass vinyl sells for on Amazon?

Yeah. It's the original pressings, I suppose.

The starting bid is £205.

I've got like 12 in my house. If anyone wants a copy, please get in touch!

The Supergrass self-titled album is going for £200. You guys could do a massive reissue.

The last reissue we did was for *I Should Coco*'s 20th anniversary. It was good to get that out. A lot of people were asking about where they could get it on vinyl. That was great to reissue. We spent a lot of time and effort on it. I remember going to the vinyl press. We weren't allowed to smoke near it. It was a bit of an event, going and cutting the acetate and leaving little notes on the run-outs, like 'Fuck off'. I just got a great message that there is a copy of the Iggy Pop performance at the Albert Hall [in London with Josh Homme] from 2016 on vinyl for me. It was a gig I went to. I think it may possibly be the best gig I've ever been to. It was really mental. Really good. Iggy was just great. I have seen him a few times, but he was better than I have ever seen him before. It was brilliant.

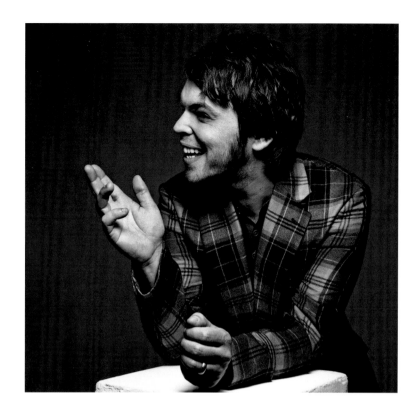

How many records do you have currently?

I don't know. I've never really thought of counting them. Seven or eight racks.

A lot, but it's not obscene?

No. I haven't gone crazy. I don't really have time to maintain a collection as large as one of my friends'. He has an entire room. Mine have just been gradually building up.

Will you put your next album out on vinyl?

Yep. That's always the part I wait for. I'm very much into releasing the album in different ways and making

the most of as many formats as possible. I'm pretty open about how it's consumed. But for me, the vinyl is still the one I'm excited to open when I receive it.

Crucial release for any audiophile to have in a collection, because it sounds so much better on vinyl?

I would say Iggy Pop's *New Values* works better on vinyl than on CD. It's mastered at quite a low level, which is cool because everything is mastered way too loud nowadays. Vinyl picks out the guitars; they sound great on that record. It's a really well-produced album as well. Somehow the frequencies and the needle are brought out more on vinyl.

Any last words of Gaz wisdom?

Steer clear of those portable record players! And I think it's always great to choose the vinyl option first.

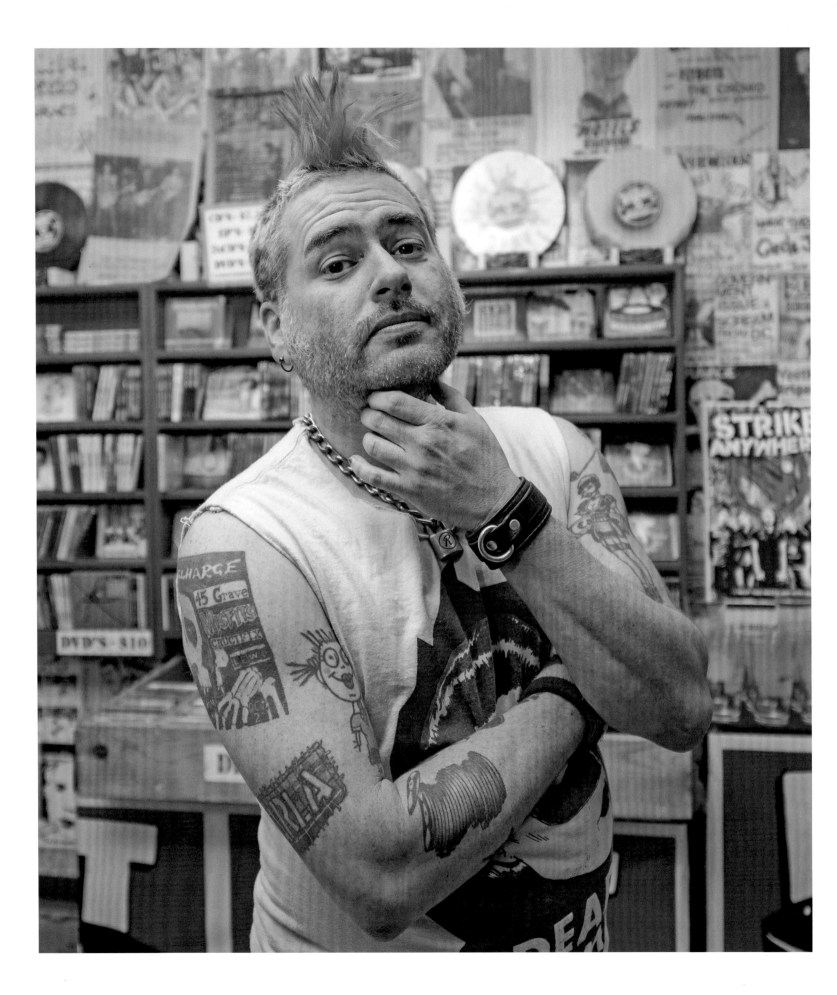

FAT MIKE

VOCALIST / BASSIST
LABEL OWNER, FOUNDER, FAT WRECK CHORDS

Fat Mike, born Mike Burkett, is the owner and founder of Fat Wreck Chords, one of the biggest independent labels in North America. He has been creating music since he was in high school, when he played in a band called False Alarm. Today, he is best known for his roles in the punk rock group NOFX, and the supergroup Me First and the Gimme Gimmes.

> **"People miss being able to identify with their own tribe. That's one reason vinyl is making a comeback."**

Why is vinyl important?

Punk rock sounds better on vinyl. That's a fact.

In my personal life, we have a family rule: when we are eating our dinner, I play records. We have a record player and speakers in the dining room. I'll ask them: 'What do you guys want to hear? The Beatles, Louis Armstrong, Herb Alpert...?' It's a family tradition. The thing I like about it is that you have to get up and change the record.

First vinyl memory?

My parents weren't music listeners or music lovers. I didn't grow up in a house with music. Not in the car, not at home. It was embarrassing. They had a stereo, but they only had two records: one Barbra Streisand, one Herb Alpert. That was it. When they had people over, they would play those tracks, but they wouldn't listen to music at any other time. I had heard The Beatles before, but I didn't learn about any of their 'deep' tracks until I was in college. I was such a music illiterate! So discovering music has been fun for me.

First record you bought for yourself?

I was at summer camp. Joe Escalante from The Vandals went to the same camp, although he was a year older than me. I heard him play 'Beat on the Brat'. I got home, I went to Rhino Records in Los Angeles, and I asked the guy in the shop: 'Have you heard the song "Beat on the Brat with a Baseball Bat"?' He said,

'Yeah, it's the Ramones, kid', and he showed me the cassette. So that was the first thing I ever bought.

How did you go from buying one cassette to becoming a vinyl aficionado?

Back then you couldn't get cassettes of Minor Threat or the Misfits or Agnostic Front. It was only on vinyl. My mom was a manicurist, and my dad was a travelling shoe salesman; they didn't give me shit. I got a job. When I was 16, I worked at McDonalds. I saved up, I got a record player, and then I started buying records. *Urgh! A Music War* was my first record. *Never Mind the Bollocks, Here's the Sex Pistols* was my second record. I remember going from two records to five records and thinking to myself: 'Wow, I have *five* records now!' After that it pretty quickly became: 'Oh My God, I have *ten* records now!' Collecting was a huge thing for me.

What's your most valuable record?

That would be one of the recent purchases. All of my 7-inches and LPs are worth a lot of money, although I just paid record store prices. I am a collector, but I never pay a lot for a record. The most I have paid is for *Multiplication Rock*. Do you know what that is?

Is that like 'Conjunction, Junction, what's your function?'

Yeah, yeah, yeah – that's it! But it's the multiplication one. That was like $40 at a used record store. 'Three is a Magic Number'? What a fucking song that is.

The most expensive record I own is the first pressing of the Reagan Youth record. There's a bit of a story behind it: NOFX had played our third show with Reagan Youth at Cathay de Grande in Hollywood. They had nowhere to stay, so they stayed at my house. The next day, they said, 'We have to go and master our record.' So I drove them to Capitol Records, Los Angeles. It was an eight song record. They told the guy, 'Can you put it in mono?' And the guy was like, 'What?' And they said, 'Yeah, we want it to be mastered in mono.' And the guy said, 'Well, I've never mastered a record in mono. We have been doing stereo since the '60s.' And the band said, 'We have a lot of friends in New York whose ghetto blasters only have one speaker. We would like them to hear everything. We want people that have broken stereos to be able to hear everything in full.' So the first Reagan Youth record is mastered in mono – and you know what? It sounds so fucking good.

I mentioned to my wife that I didn't have a copy of it, but she forgot whether it was Reagan Youth or Wasted Youth. So she got me the first pressings of both of those records for my birthday. She had to get them from France or something, and they were like $80 or $100 apiece. So those are the most expensive records I own. I play them for people sometimes.

Was there any particular record cover or album art that you looked to for inspiration?

What pops into my mind is the Plasmatics' *Beyond the Valley of 1984* record cover – if only because I used to jerk off to it when I was 14 or 15!

The aesthetic of punk records changed everything for me. The back of the Wasted Youth album *Reagan's In*, with the guy doing a stage dive, was amazing. Or Agnostic Front's 7-inch *United Blood*. I loved covers that just showed you the band and what was going on. Punk rock was so beautifully ugly. The crowds were gross, all packed together and sweaty. Whenever I saw album art like that, I thought, 'That's a scene I want to be a part of.' The more graphic the cover, the more I liked it.

What does the return of vinyl's popularity say about the place and space of music in our lives?

People miss being able to identify with their own tribe. That's one reason vinyl is making a comeback. That was what was so special about my childhood. When I first got into punk rock, I had a few records; I didn't really know what to buy, because back then you couldn't just look on your computer and figure out what people liked. I remember this girl at my school – she had a Misfits shirt on. I was like, 'Oh, she's a punk rocker.' So I went to the used record store and found Misfits' *Walk Among Us*. That was how you got new music. I got this record, and thought, 'This is my new favourite band, this is so awesome.' They were *my* band that nobody at my school knew about – except for the girl punk rocker. It was *my* band because *I* found them. You feel like you are part of something. I ended up getting all of the Misfits 7-inch – I paid $2 for them each through the mail order. So now I had a relationship with the band, because Glenn Danzig, the Misfits' lead singer, filled all the orders personally. This was my band; I wrote them letters and bought all their 7-inch. How cool was that? There's nothing like that anymore.

But there are still people who like to collect things, and who want to feel like they're supporting the band. They need something in their room. Just like people like to have home libraries, places where they can store their books, rather than Kindles. It's having a piece of

art on your wall versus having it on your computer. You want something to be with you, if it means a lot to you. The few records there are that are perfect records, you don't want them to be in cyberspace. You want to own them. You want to own *Never Mind the Bollocks*. You want to own *Ziggy Stardust* – because they are perfect albums. When people just listen to the one-hit song off an album, they don't have a connection when they go see them play. But when you find a perfect album – and I am a total stickler, I can only name them on one hand – you want to have it.

What are these 'perfect albums'?

Misfits: *Walk Among Us*
David Bowie: *The Rise and Fall of Ziggy Stardust and the Spiders from Mars*
Sex Pistols: *Never Mind the Bollocks*
I have two *Rocky Horror Picture Show* soundtracks – those are both worn out.
Bad Religion: *How Could Hell Be Any Worse?*

Since Fat Wreck Chords started, have you always released everything on vinyl?

We didn't release *Fat Music for Fat People* – the label compilations – on vinyl originally because we would give those away for free at shows. We ended up putting them on vinyl eventually, but to start with they were more for promotion. For every record though, we have always released vinyl from the very beginning. It used to be under five per cent of sales. But it didn't matter. Because every guy or girl – every person in a band – wants the vinyl record. Everyone wants to put out a real record.

Why is that?

Because it's tangible. CDs – who knows where CDs go? No one has their CDs anymore. All the older bands, the original bands – they do vinyl. That's what

we did. We all collected vinyl. We would all go into used record stores. We try to be Buddhist, but the fact of the matter is, people like to own things. When you buy something, it's nice to actually have it. These days, when you buy a movie online you think, 'I'm buying it? You're just saying I can watch it a few times.' That movie still lives in cyberspace somewhere. Songs and records I have bought on iTunes – they just disappear. I will be in a different country, and my computer or iPod will say, 'You can't access this record right now, because this country doesn't offer the right service.' It's crazy.

Five or six years ago, I was shopping for some old jazz. I got this Louis Armstrong boxset. You can't get that shit anywhere else but on vinyl. The only place it exists is at the used record store. They don't make those albums anymore; they're not online. So as a result, I have all these songs that I've never heard before! Not only does the music sound cooler, but some artists only live on vinyl.

How important has the vinyl format been for creating the Fat brand?

That's where the Fat Wreck Chords logo is the biggest: on the Fat Wreck Chords vinyl! Vinyl has been a part of what we do since the early days, because punk rock is all about vinyl. When CDs first came out, sometimes we would only make 500 copies of vinyl for a band. It cost $2,000 just to get it mastered and have the artwork laid out. You would lose money on it – that happened a lot! But it wouldn't matter because you still got to make the vinyl. Now most of our profit comes from vinyl, from the record store and from mail order. Did you know that Fat Wreck Chords has its own record store?

No! Where? That is so exciting!

We have an actual store you can walk into. I came up with this idea five years ago. We moved offices,

> " Keep buying records. They're good for the soul. "

into this cool place that used to be a tile showroom. There's a big space in the front. I thought: 'Why don't we turn this into a record store?' We have this room – it's about 15 by 15 feet. And every inch is chock full of records and old fliers. We only open once every two weeks on a Friday between four and six p.m. That's right – two hours every two weeks! We give out free beer to anyone that comes in. It's totally legal to give out beers so long as everyone is over 21. We have a community now. Everyone comes. Bands play, local kids, bands from out of town who drive in. Everyone makes sure to show up at Fat Wreck Chords on a Friday afternoon. It's fucking great.

What neighbourhood is this in?

In San Francisco's Bayshore neighbourhood. It's an industrial area, but there's a little record store tucked away there. It does surprisingly well – we've had days of over $10,000 in business, which is crazy. We make 100 copies of every record we put out, and those versions are especially for the store. The label is different. The colour is different. You can only buy it there. People show up when we have a new release because there's such a limited quantity, and depending on what it is, it goes for $40 or $50.

Some classic Fat releases are selling for huge amounts online. What are your feelings on this?

I think it's cool. The first 7-inch I put out by myself was *The P.M.R.C. Can Suck On This* (1987). We made 500 copies. We hand-drew all the labels in Sharpie. I did that because I wanted every one to be a collector's item. Even back then, I was thinking about making stuff unique, rather than making money.

Let's talk record covers. You've had some notable ones – like *Heavy Petting Zoo* (1996). Do you still like this cover years on?

I still like it. A lot of stuff I came up with years ago, I just can't believe. Some of the lyrics I wrote are just like '*Holy Shit*'. My wife is a dominatrix, but I played her 'Louise' and she said, 'Oh my God, you're a fucking pervert!' *Heavy Petting Zoo* is just some idea I had. I thought 'let's do three different versions', so the cassette, the CD and the vinyl all have different artwork. A record store in France got shut down because of that record cover. They put a poster in the window, and the city shut them down for showing pornography!

Any last words of Fat Mike Wisdom?

Keep buying records. They're good for the soul.

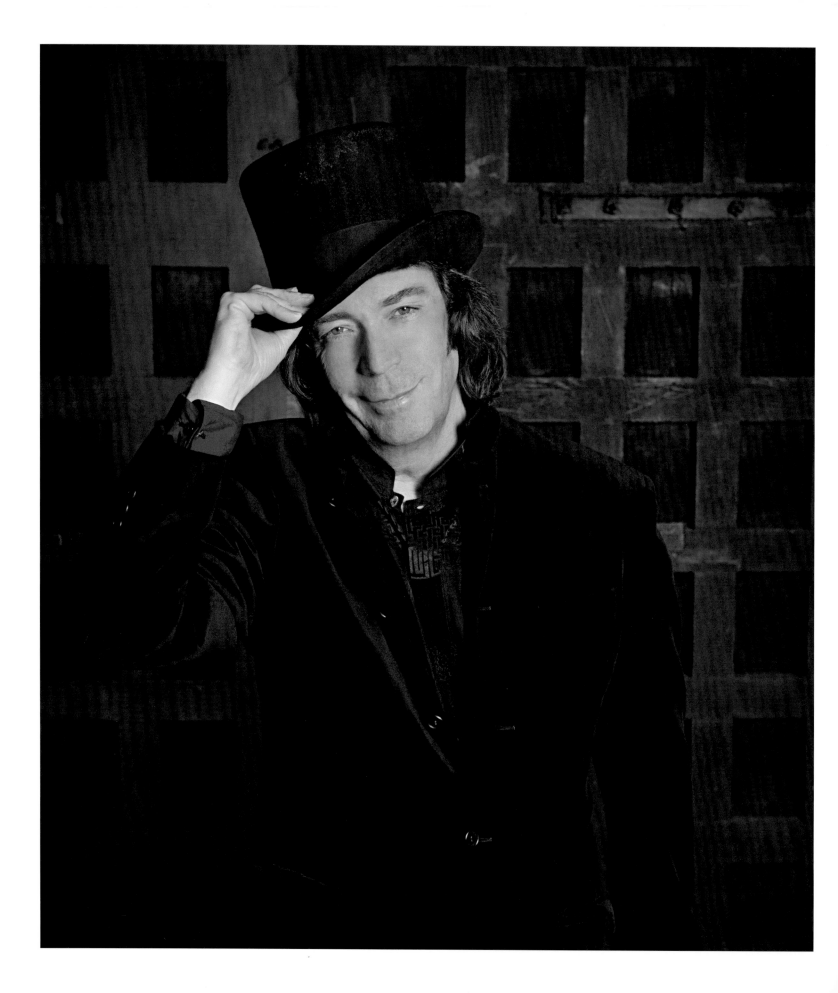

STEVE HACKETT

MUSICIAN / SONGWRITER

Steve Hackett is an English musician, singer and songwriter. He is best known as the lead guitarist of Genesis. He joined Genesis in 1970, leaving in 1977, and has performed as a solo artist ever since. The band was inducted into the Rock & Roll Hall of Fame in 2010.

What is your first vinyl memory?

I would probably go back to when records were being pressed on 78rpm. I'm trying to remember what material it was that they used – shellac, was it? I remember listening to those from an early age, trying to put a record on by myself when I was about three years old, and missing the bit at the beginning – the bit before it goes into the spirals. The head was going around on the rubber turntable and making this God-awful noise. I thought the thing was haunted! It scared the life out of me as a kid. It was a frightening enough record in the first place: *Three Little Pigs and the Big Bad Wolf*. But it got even more frightening after that! From then on, I thought it best to leave the record player to my parents.

The first record I bought myself was The Shadows single, 'Man of Mystery'. That was in 1959. There will be someone out there who will say, 'Actually, that record did not come out until 1960' [it was released in 1959], but *my* memory is that I was buying stuff when I was nine. It all started then. I bought a few singles after that, usually guitar instrumentals. The first album I bought was Ravel's *Bolero*. Everyone thinks I bought it because of the semi-naked woman on the cover. Actually, I bought it for the music.

I'm sure you did!

Yeah. It has someone on the cover who looks like a belly dancer, with symbols over her breasts. A friend of mine still claims to have that record and says he will give it back to me. I sold it to him to get money for a guitar, way back. I had this conversation with Roger King – he's my engineer and keyboard player. He said he thinks the reason that people are attracted to the sound of vinyl is that you get extra compression and distortion as part of the package. Now those are things that are desirable for rock and pop. They can make them a lot more powerful. With classical music, we have pauses, and tacit sections, and quiet bits – vinyl doesn't do much for that. So for people who have quite wide tastes, and listen to things other than Motörhead, perhaps vinyl isn't the best for you, not when the pristine quality of CDs better suits other music genres. Personally, I'm very pro-choice; if someone loves vinyl, I have no problem with that. I love vinyl myself. Over and above that, I try to sell my stuff in all formats. Of course, full-size albums with full-size artwork, no one is going to argue that those are amazing. It's a throwback to the days of sticking album covers on your wall, like interior decorating from the 1960s. Who needs wallpaper when you can hang your favourite album art and paint the walls orange?

What has kept vinyl alive?

If you could get a classical pressing back in the old days, chances were that the quality was going to be better and the crackle was going to be less. Jump ahead to today, plants are finding it hard to keep up with the demand, and it's that same distinctive sound that has been vinyl's saving grace. It's the single factor that has allowed record stores to survive, or even come back from the grave. A while back, I did a short acoustic set at the HMV on Oxford Street, London, and signed a few things. I met the owner of HMV. He said that's the reason they have managed to survive. The 'back to vinyl' idea. Right now, there's a whole new generation who never rejected vinyl in the first place, but are discovering it for the first time. It's a strange thing, isn't it? It's not just old vinyl fetishists who love it. It's young people who think, 'Oh, the music sounds bigger because the record is bigger. It must sound better.'

> **"** If you could get a classical pressing back in the old days, chances were that the quality was going to be better and the crackle was going to be less. **"**

How many records do you currently have right now?

I went through a divorce a while back, and I lost my entire vinyl collection. I am vinyl-less at the moment. I'm not asking fans to start sending me care packages; I will choose them myself as and when. I have one or two – and it really is just one or two! I did have rather a lot, but I have lost houses, never mind record collections! There are so many of those records that I would love to go and listen to now, but you know, time will heal, and I will acquire them all again.

Do you think that vinyl will continue to be in vogue?

I think so, I think it will. Formats will change, but I think what we will find is that we have the past, present and future all running concurrently. We won't have to delve into memory. We will just have to delve into choice. I see no reason why vinyl shouldn't survive for forever and a day. The fact that it has already been around once and is now coming around again just goes to show you that vinyl is like certain genres of music. Whoever tries to kill jazz, good luck – it will always come around again! Good luck to whoever tries to kill records, because they will keep coming back too. Whatever media does to polarise opinion, at the end of the day we are living in a democracy. What's important is that you listen to music. It doesn't really matter how it happens.

But I do think people are missing out on the experience of walking down the high street, wandering into that record shop, and browsing. Music is a browser's medium. I remember ages ago, I heard this piece of music and I went around singing it, and saying to people 'Do you know what this piece of music is?' It was that arcane – it was when they were selling records in shops that sold refrigerators and washing machines! In these brown paper boxes, in no particular order, you would find music being sold wholesale. One day, as I was digging through the boxes in one of these stores, I saw an interesting looking cover. I thought, 'that one's coming home'. And I found the very piece of music I was looking for! It was Erik Satie – *Gymnopédie No.1*. Satie is a minimalist French composer from the early 20th century. The *Gymnopédie* I found was an especially beautiful arrangement, which I subsequently recorded with my brother. But that's what I think of as 'the vinyl experience'. You had this whole process of discovery. You knew that somewhere, amongst all the bric-a-brac, you would find a little music.

What record sounds amazing on vinyl?

Duane Eddy's 'Because They're Young' sounds absolutely wonderful on vinyl. I heard it on CD; even though it was perfect and pristine, note for note, it did not have the same *bam!* about it. There was something about that early single. It's a perfect record. The mixture of drums and guitar and strings sounds so great – but only on vinyl. I have never heard it sound as good on CD.

> **"** Most of my fans want to buy either CD or vinyl. They want to own physical product. I understand that. **"**

Why have you continued to release albums on vinyl, even when it wasn't in fashion?

Because I'm pro-choice! There are people who prefer vinyl. My brother prefers vinyl, in fact – although I was surprised to hear him say that, as he makes a lot of classical music. I think he likes the power, the compression, the distortion aspect of it. I'm not so keen, as a classical fan: I was listening to *Segovia Plays Bach* on record a while back, and I think it had been transferred from various different mediums. There was this one bit when he was laying into his guitar; it sounded like he was playing through a fuzzbox. I didn't mind in the least back in the day. I thought it sounded absolutely pristine. What did I know?

I think it's up to everyone individually. Luckily, unlike politics, we don't make one decision then have to live with it. Most of my fans want to buy either CD or vinyl. They want to own physical product. I understand that. I want to own a book. The idea of a Kindle – watching a screen – does not really appeal to me. I think I like the idea of ownership – I think this is why I'm such a vinyl advocate. But there are many young people who don't know what I'm talking about. To them, music is something on a cloud; it's something you walk around with; you don't share it with other people. It's for your headphones only. Remember that James Bond movie? *For Your Ears Only*!

Any words of wisdom for people just getting into vinyl?

I am sorry to say that in the 1960s, I lent my then-girlfriend my prized Andrés Segovia record. She had a cat. She did not put the record away – in fact, she had it on the floor. The cat, shall we say, 'redecorated' the vinyl. I think that's the single biggest reason I broke up with her! It was a cardinal sin, I'm afraid. With time we mellow, but back in the day, you did not mess with my vinyl. I learned that lesson, and so did she – God bless her.

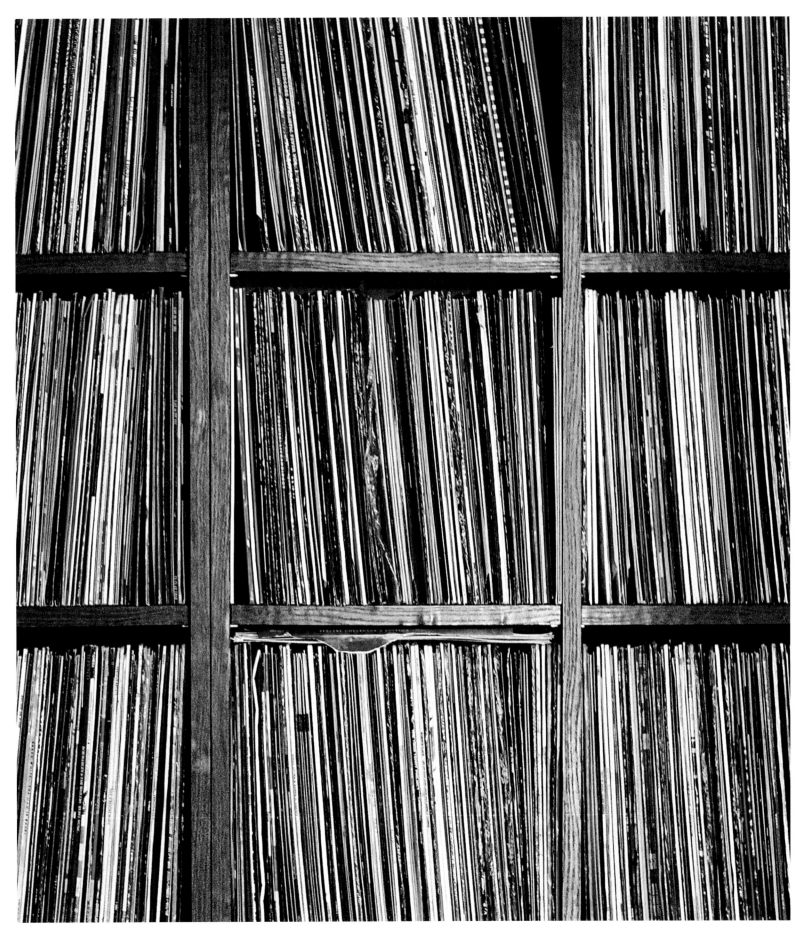

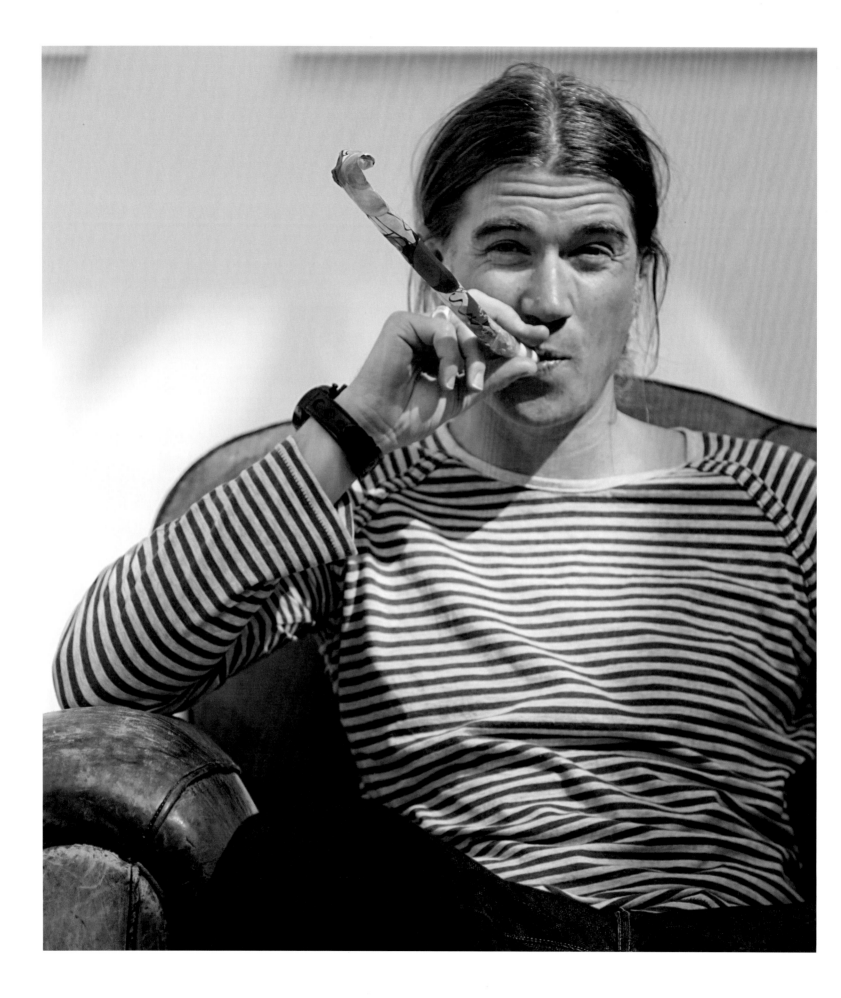

ROB DA BANK

DJ / FILM COMPOSER / EARWORM MUSIC / FOUNDER, BESTIVAL

Robert Gorham, better known as Rob da Bank, is a nationally beloved music curator. His club night Sunday Best, founded in 1995, has spawned a record label and three multi-award-winning music festivals: Bestival, Camp Bestival and Common People. Rob co-founded the award-winning supervision and licensing company Earworm, which sources music for films, games and TV shows, allowing him to rediscover his writing and producing side as a film composer.

Why is vinyl important?

When I started DJ'ing at 15, I had my first Technics. I saved up for months for these amazing decks, the first real object that I owned myself. And records were the thing that I played. We had cassettes, we had the radio, but records were what DJs played and that's what I wanted to be. Vinyl was king. It didn't matter that I only had about 25 records to start with; the collection just kept growing. I would carry that small box of records around to my mate's house to practise DJ'ing with. It could have been just two records, just mixing together. Records had a much bigger importance than that to the whole world, but personally that's where my own vinyl addiction started.

For anyone growing up in the '80s, and probably a bit of the '90s, that was the craze. It wasn't just if you wanted to be a DJ. If your mate had a pair of decks, he was the party man, he was the guy with the music collection. Nowadays, everyone has a phone, everyone has Spotify, everyone has Beats, or iTunes – everyone can access it. Back then – and it wasn't that long ago! – it was one person who had the vinyl collection, one person who had those decks, one person who had those Technics. The equipment was the key to controlling the music.

Do you use vinyl now?

I do. I always have done, but for the last ten to fifteen years, as it has slowly been fading away in the background, I have kept my whole collection in various lock-ups and storage places. As of a few months ago, I have actively started buying records again, and going to record shops in London, which I haven't done for years. I think it's partially from leaving Radio 1, where I DJ'd for years, because suddenly I don't have to play everything off an MP3 anymore; partially because I am re-exploring

my record collection. It's amazing how many people are pressing records with a very diverse range of stuff. People are not scared of pressing something that may only sell a couple hundred copies. Previously, that had kind of faded out, and the record-pressing business had been getting into the souvenir vinyl market, where people were just pressing things that were going to be put on someone's mantelpiece.

Has the resurgence of vinyl affected Bestival?

Some DJs request vinyl decks. Jamie xx plays vinyl off record decks. This year I decided to do a Vinyl Only tent. It's a hark back to those '90s days when we started Sunday Best, which went on to become Bestival. It is a celebration of that era. It's all about trying to get people to play vinyl. It doesn't have to be particularly old-school or vintage vinyl; it could be brand new stuff. It's a bit of a challenge to us all! But there is so much good stuff out there on vinyl. I would love to play a Vinyl Only set. That used to be me three times a week; I'd be playing Vinyl Only sets. You get out of the habit of it. Last year, I played a Vinyl Only set again. It was really refreshing. You forget about all the things you can do with vinyl records.

It's very interesting, seeing my kids pressing play on an iTunes account, or pressing play on a CD in the car. But actually, they love watching the record go around like I do. They love flipping through the sleeves. They are just about allowed to drop the needle onto the record without scratching it! I want them to grow up having the record player in the house as much as the new technology, so it's not some weird 'gramophone' type of affair. Records should not be looked at as dusty things. And they aren't, looking at current popular culture. Young people *do* know what a record player is; they know

> **" Even if you're 16 and are just getting into music, even if you've learned how to DJ on a computer, give it a go on vinyl. "**

what vinyl is. It hasn't faded away like we thought it might. It's making a resurgence. Hopefully it will be around forever.

Some people may enjoy sitting down and listening to 45 minutes of one side of a record, and flipping it over. For other people, that culture has died and they're onto a Spotify playlist and that kind of quicker fix. To be honest, I have Spotify playlists, I do Apple Music – I'm on everything. But I am not that technologically advanced. I flick in and out of stuff. My kids know how to work some technology better than me. I can listen to a cassette, I can listen to vinyl, I can listen to a DAT or a MiniDisc if I want to. I have all the different gear from the '80s onward. I found my Walkman the other day! It's great that I can dip in and out of all these mediums – but vinyl is definitely my favourite.

First vinyl memory?

I was born in '73, so by 1980, I was listening to pop music. My mates and my sister were playing the Pet Shop Boys and Adam Ant. The first record I bought was the theme tune to *ET the Extra Terrestrial* by John Williams; I still have that 7-inch. When people get asked in trendy magazines what their first record was, and they say the Sex Pistols or The Clash or whatever, I'm always a bit ashamed that my first was the theme tune to *ET*. Now that I've started composing film scores myself, I am much more into that world. I'm now sort of proud of that, as my first foray into music.

How many records do you have currently?

I really don't know! I was a music journalist for seven or eight years, and I got sent ridiculous amounts of records, which I hoarded. I thought I needed every single one for evermore – even all the white labels, which had nothing printed on them so I never knew what they were. I had a big clear-out and got rid of about a third. I still own around 10,000, but I haven't counted them recently.

Crucial release that sounds so much better on vinyl...

Too many things! Off the top of my head – David Bowie's *Low*. I'm just thinking of records I have seen recently in my collection. There are atmospheres in it that you can only really pick up on the record.

Any last words of Rob da Bank wisdom?

Explore vinyl. It's an amazing world of sound. I'm not a vinyl snob or an audiophile; I have friends who spend £5000 on an amplifier or £500 on a needle for their stylus. I use the bog-standard Technics 1210, which I've had 25 years. I just buy cartridges off Amazon when it runs out and gets scratchy. I think it's an amazing way to engage with music. Even if you're 16 and are just getting into music, even if you've learned how to DJ on a computer, give it a go on vinyl. It's not quite as easy, but it's much more rewarding.

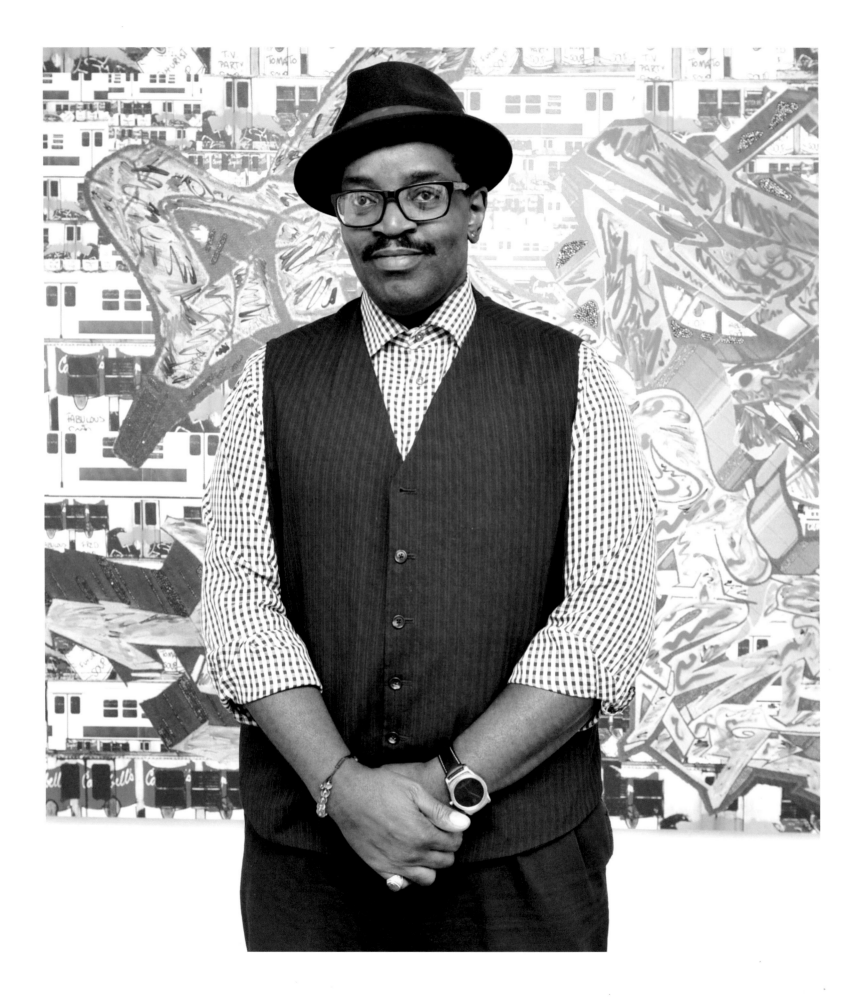

FAB 5 FREDDY

ARTIST / FILM-MAKER / RAPPER

Fred Brathwaite, stage name Fab 5 Freddy, is a key figure in the American street-art scene. He collaborated with close friends and contemporaries Keith Haring and Jean Michele Basquiat, among others, to prove to the world that New York graffiti was spawning an art movement – one which is now of global relevance. Musically, he is celebrated for his work as a rapper, and as a pioneer of the hip-hop genre. Fab was the host of the first ever internationally televised music video show dedicated solely to hip-hop music, *Yo! MTV Raps*, from the late 1980s. His name gained worldwide recognition thanks to the 1981 Blondie hit 'Rapture', which features Debbie Harry rapping 'Fab 5 Freddy told me everybody's fly'. Today, Fab focuses on making visual art.

> **"**My first vinyl memory was my parents' record collection, which I probably destroyed a lot of as a little boy! **"**

Why is vinyl important?

Vinyl was important because it was the means by which we got to hear great music. For the past 80 years or so, the main technology was vinyl, and it was great while it lasted.

First vinyl memory?

My first vinyl memory was my parents' record collection, which I probably destroyed a lot of as a little boy! I would just hold the albums and look at them for ages. Some of my earliest memories of photography and art are from jazz albums. A lot of those artists decorated their covers with the contemporary art of the time: expressionism, that type of thing, as well as great black and white photography. Max Roach, my godfather, was a great jazz drummer. Him and my dad grew up together. My dad was a big jazz fan and had tons of albums. I would play with them, try to build houses out of them – those are my earliest vinyl memories.

Favourite cover art?

There's so much stuff! I don't have a particular favourite off the top of my head. Maybe Max Roach's 1960 album *We Insist! Max Roach's Freedom Now Suite*. The image on the cover is a black and white photograph of several black men sitting at a lunch counter. I don't know if it was a re-creation or an actual photo of a lunch counter protest. I remember the picture was very disturbing to me as

a little kid. I would ask my parents, 'What was this about?' They would explain it, but it wasn't until many years later that I was old enough to understand. When you look at the history of that record, it's one of the first protest records. Even though it was an instrumental jazz record, it was all about black folks rising up and fighting racism and oppression, at the beginning of the Civil Rights Movement.

That's pretty powerful. Did you ever consider going into cover design?

I did lend a painting for a friend's album cover many years ago. It was a punk band and I did the cover. The artist's name was Thelonious Monster. The album was 1993's *Baby... You're Bummin' My Life out in a Supreme Fashion*. The main guy was a friend of mine back in the '80s. We all had mutual friends in Los Angeles, and he liked my work. That's the only time I ever got into the album artwork design. It was a happenstance thing; it wasn't something I was pursuing. I was all about showing my work and exhibiting in galleries, but I happened to meet this guy. We were all hanging out, he liked the work, he asked me if he could use it, I said sure – and that's it. History.

How has the role of vinyl changed in hip-hop in the last twenty years?

DJs don't have to haul around crates and crates of vinyl to every gig anymore. All they need is a hard drive, a computer and Serato, although most still have the two Technics turntables. There's a lot of

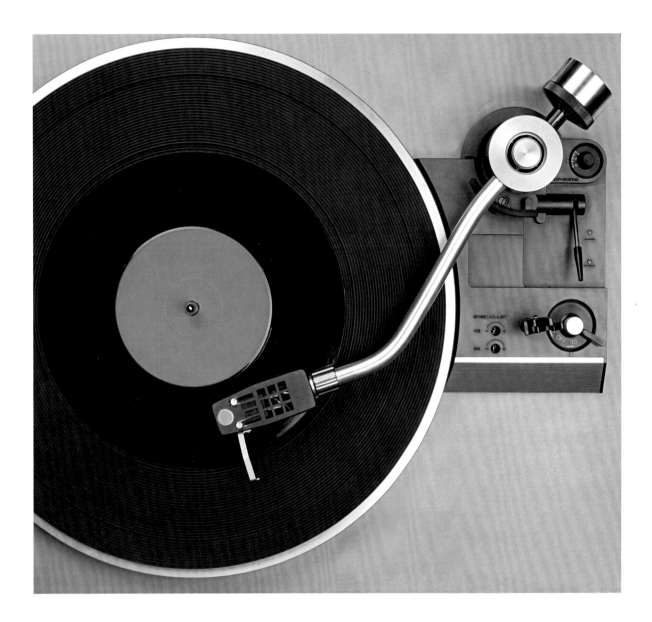

digital tech out there; people can do it from their laptops, getting the mixing, the cutting and the scratching effects. Digital has just replicated the whole experience. A lot of my DJ friends talk about how reluctant they were to leave vinyl, but the ease of moving around has been a transformative thing for them. Eventually it crossed over, because it's easier to transport a laptop than it is to lug crates of records to a party on the third or fourth floor. You don't have to do that now.

Digital has gobbled up a lot of the platforms that we were once comfortable with: books, music, films. People sometimes want to hang onto those things that are near and dear to them, but it's the changing of the times.

For myself, it was more about cassettes and a boom box. That was how I listened to most of my music growing up, as a kid raised in a hip-hop culture. Those things have a history too.

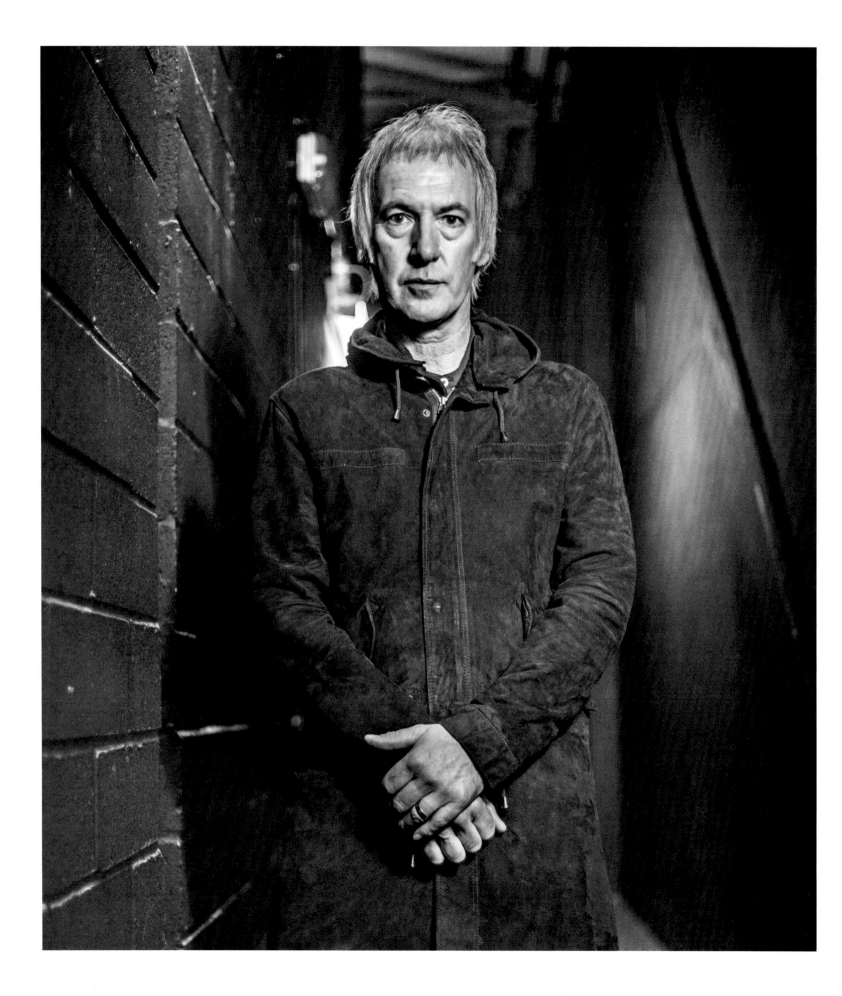

CLINT BOON

**KEYBOARDIST / VOCALIST /
SONGWRITER / PRESENTER / DJ**

Clint Boon is a member of Manchester indie band, Inspiral Carpets. He is also known through his work as a radio presenter on Xfm Manchester, Radio X, and BBC Radio Manchester. Clint set up a mobile disco business in 1975 at the age of 15, and has worked as a DJ ever since.

Why is vinyl important?

To me, it's the definitive music medium. It's as important as oil paint on canvas. Like a lot of music consumers, I use MP3s, I use CDs; but what I feel I have to get a fix of every day is to sit down with a record player, put a piece of vinyl on, and listen to it. That's something I do even now. I'm fifty-seven and a half years old, and every night I have to put at least one or two songs on the record player, just so I can hear vinyl talking to me... singing to me.

You listen to something on vinyl every single day?

Yeah, pretty much. Last night, we were ready for bed and I said to Charlie, my wife, that I just needed to listen to some vinyl. So I sat down and put on a Jon and Vangelis album that I've not listened to for 30 years. The music was only part of the beauty of the moment. The nicest part is getting the record out, putting it on, showing the kids where the stylus goes, dropping the needle into the groove and watching it play. It's the whole ceremony of it; it's still a beautiful thing. It's like the difference between visiting your grandmother, actually going over and sitting with her and having a cup of tea, or just phoning her up or sending a postcard. It's a different experience. Listening to an MP3 isn't the same as sitting down and listening to an entire side of the first Velvet Underground album. Even though I love everything that Steve Jobs and Bill Gates gave to us, I love the fact that I have every record I ever bought for the last 45 years even more.

How many records do you think you have in total?

You know, I've never counted. I'm not one of these people who has walls and walls and walls of vinyl, but I've certainly got half a wall...

That's a lot.

Yeah, I'm guessing, in terms of albums, I've maybe got 1,000 albums. I've got hundreds and hundreds and hundreds of singles. I've pretty much kept every single record I ever purchased. I've got them all here. My vinyl collection is still one of my prized possessions. I'm not really a materialistic kind of guy, but if anybody sold my records, I'd be a bit pissed off.

I'm so jealous. I can't imagine if I had kept everything from when I started collecting records as a pre-teen.

When I was a kid, my mum and dad worked in cotton mills. Then they opened a store; we were the local corner shop in the community. They bought a little stereo radiogram made of wood in about 1966 or 1967. They had a Beach Boys album, a Tom Jones album, some Shirley Bassey, The Beatles... I don't remember there being any Rolling Stones in there. Diana Ross and The Supremes, *Porgy and Bess: The Musical, Carmen: The Musical...* All these records, which they played every day, influenced the way I listen to music now. I've always had a very diverse taste. I've always been able to listen to reggae one moment, classical the next, country and western, hip-hop, grime. I think that all started because of that very diverse but small collection of albums that my mum and dad had back in the 1960s. Now I actually own those 25-or-so albums, because my mum gave them to me a few years ago. I own the first record I ever heard in my life. I own the albums that inspired me as a toddler, because there were only two TV channels back in those days, so the radio and the record player were the world. The fascination, even back then, of putting a record on and putting the needle in, was a big thing for the family. It meant that you listened to the same album two or three times in a day sometimes. It's just nice to own those actual albums that formed my taste as a toddler.

Is listening to records in the corner shop your first vinyl memory?

Yeah, first vinyl memories would've definitely been my mum and dad putting on their favourites. There was this one record by Gary Lewis and The Playboys; there's an American comedian called Jerry Lewis who died a few years ago, and he had a son called Gary. Gary Lewis and The Playboys were very much inspired by The Beach Boys. I always remembered that album being one of my favourite things that my dad used to play. The other one was Neil Sedaka. It was just a collection of Neil Sedaka's '60s songs. Listening to that or listening to him doing 'Oh! Carol' and 'Breaking Up is Hard to Do' – it was beautiful stuff.

So, what was the first vinyl you went and bought with your own money?

There were actually two albums; I can't remember which came first. There was Elvis Presley, a very cheap compilation of his gospel songs called *You'll Never Walk Alone*, purchased at Woolworths in Shaw. It was like 75p. About the same time, I bought a copy of Bill Haley's *Rock Around the Clock* from the same shop.

Both good choices.

Yeah. The first single I went and bought with my own money cost 50p, it was 'ABC' by the Jackson 5. I bought that from Oldham market. I can still remember the market stall, and the lady who sold it to me. She was called Mar Dobson. She owned a local record shop and the stall. By that point, I already had a record collection because we lived in the shop and my mum and dad used to sell 7-inch records behind the counter. I think some of them had come out of old jukeboxes, some of them were unwanted chart returns. I was allowed to go through them every week and pick a couple out and keep them. So I had a really nice little collection. In fact,

Paul Anka's 'Diana' was one of the first singles that I fell in love with and saved; there were the Faces too, and a couple of early Rod Stewart tracks.

I wanted to make records, not just be in a band – but I didn't know how the music was made. I was 15 to 16 in 1975 when punk hit me in a big way. It was only then that I really began breaking down what I was listening to, like, 'Oh, that's a bass line and that's the cymbals on the drum kit, and that's a 12-string guitar instead of a six-string guitar.' By that point, I just wanted to make these fucking records like all of the people who excited me. *Top of the Pops* was a big show in the early '70s. I'd be watching that every Thursday night thinking, 'Fucking hell man.' I was really inspired by the '70s glam scene in the UK. A lot of those bands were emulating the rock 'n' roll music of the '50s, but in a glam style. You had bands like Mud, Sweet, The Rubettes, Matchbox and Mott The Hoople. They were all coming from the '50s inspired rock 'n' roll background, but they were wearing platform shoes and sequin trousers. I was very inspired by what I saw on telly. The two things came together: I wanted to make records and I wanted to be in a band. Then in '76, I saw the Sex Pistols in Manchester.

You didn't go to *that* show, did you?

No, I wasn't at the Lesser Free Trade Hall; a few months after, they came to the Electric Circus in Collyhurst, Manchester. I think it was 7 December 1976. I went down there with all my friends from art college. I was 16 or 17. Until then, to be in the kinds of bands I was seeing on the TV, you had to be a great musician. Working-class people didn't seem to end up in Led Zeppelin and Cream and Pink Floyd. Then suddenly with punk, it was like: 'fucking hell, these bands are made up of kids from corner shops in London or Glasgow'. More importantly, my friend's brother was in The Buzzcocks. Phil Diggle

was at art college with me, and his brother Steve was up there on stage supporting the Sex Pistols at the Electric Circus. So I'm thinking, 'That's it, kids like me can do it, we can be in bands.' I dropped out of college immediately and got on with doing whatever I needed to do to be in a band. The rest is history.

Do you use vinyl when you DJ?

Usually, I'll DJ from the MacBook. I do one event called Suits & Vinyl, which is a bi monthly event in Manchester where people come to network. We encourage them to bring vinyl and wear a suit. It's about celebrating vinyl. I DJ entirely from vinyl on those events. People bring their favourite records and I'll play them as part of the event. Most of the time, though, with the DJ'ing that I do – I play music from the last 60 years from every genre – the most accessible way to get music is from the MacBook with the MP3s on it. When it comes to DJ'ing, I've got about 20,000 to 30,000 tunes waiting at the touch of the button. I can flick through a 1950s doo-wop set, to dubstep, to reggae. It's like I hop from genre to genre. I like doing that, because that's the way I've always listened to music.

What do you think about DJs who have never used vinyl, and have only learnt how to DJ via the computer?

I've got really good memories of when the only format you could DJ from was vinyl. I started DJ'ing 41 years ago – in 1975, almost before punk happened. I set up a mobile disco with a friend. I DJ'd from vinyl for a couple of decades, then eventually moved over to CDs because I was getting so many CDs sent to me in the 1990s to early 2000s for work. For a while, I carried CDs to DJ gigs. Eventually I made the switch over to MacBook and I've not looked back. Like I said, it's easy to access any tune with a click of a button. Some purist DJs would think that DJ'ing from a MacBook is a cop-out, but I like the accessibility. A

lot of the time when I'm DJ'ing, people come and talk to me. With the MacBook, you can be getting tunes ready and chatting to people without having to pull CDs out and put CDs back.

Most cherished piece of vinyl and why?

I've got a few. I've always collected records that were made for kids, like children's nursery rhymes, things like that. I've actually got one of the rarest records in the world. It's a 6-inch 78rpm on thick, bright yellow plastic. It's a set of nursery rhymes in a pictured sleeve from the '40s. It's very rare. It excites me when I look at it, because it's probably the only one in the world. I've got one thing that somebody has given me; it's not worth a lot in terms of monetary value, but it's from one of my favourite bands ever, Doves. Before Doves they were called Sub Sub. Back in the early '90s, they made a single called 'Space Face'. It wasn't a successful chart record, but it was a big rave record. Over the years, I've talked about this record a lot on the radio. One time, Jimi Goodwin [lead singer of Doves / member of Sub Sub] visited Xfm when I worked there. I wasn't in that day, but he left this record on my desk. It's a 12-inch white label test pressing of 'Space Face' by Sub Sub with a Post-it note saying, 'Lots of love Clint from Jimi and the Dives', rather than the Doves. It's such a special record to me; I love it. 'Pounding' by Doves is one of my favourite records of all time. I'm sat on stuff like that. You don't want to give it away because it's a fucking treasure. For Jimi Goodwin to give me his actual test press in white label of 'Space Face' by Sub Sub - that's my favourite piece of vinyl in my collection.

Why do you think vinyl has returned?

I think it's because of the culture of people getting back to their roots, back to reality. A big part of how we live has become digital over the years, and I don't think we've realised it. Home-made cakes are very fashionable now; there's been a massive revolution in the last few years. My wife started a

> **"** I've always said 'Follow what your soul tells you to do, rather than what your bank needs you to do'. I still would really. Just try to make your corner of the world a little bit better than it was when you arrived. **"**

business in 2006, Mrs Boon's Cakes, and at that time, people just weren't interested – but suddenly there's been a massive revolution. That's the thing: people are returning to their roots, their reality and their heritage. Vinyl is about going back to this music that was invented to play on vinyl discs. You put a needle in there and it reads the stereo sound.

I think MP3s are an amazing thing, Spotify is an amazing thing; but let's not forget that when David Bowie made his *Ziggy Stardust* album, he got his test pressing of it and he put it on a turntable in his house. He sat watching it go around while the needle bobbed up and down a little bit. This is how these artists wanted it to be. You're going through this mechanical procedure that he or she would've gone through. You're getting the record, taking it out of its sleeve, taking it out of the inner sleeve. You put it on, set the speed, drop the stylus onto it and there you go: you're having the same experience David Bowie had when he first played his record.

Piece of vinyl you're still chasing, and why?

Not in terms of rarities. There are a few classic albums I've decided I need – I've actually started a little list on my phone! There's a couple of Pink Floyd albums that aren't in my collection, and I wanna get Richard Ashcroft solo albums because I only have his latest one, *These People,* which is beautiful. In fact, that's a perfect vinyl listening experience. It made me think I wanna get his previous albums on vinyl, because some music

sounds better on vinyl than others. When you have a bit of space around the music, it's a different experience to listen to. I want to hear the depth of Ashcroft's album. It's only 10 or 11 tracks, but it's split across two pieces of vinyl. You've got two tracks, two songs on each side of the vinyl, so it's cut really loud and really deep. The sonic feeling you get when it's on in the room is fucking incredible. It's my new favourite album.

Crucial release to have on vinyl because the vinyl experience is so much better.

I think the big one is *Dark Side of the Moon,* but there's a lot of hidden gems that people might not know about. *Pet Sounds* by The Beach Boys. Leonard Cohen. Moby, the *Play* album... Actually, I've made a note to get those too – I don't yet have them on vinyl.

Last bit of Clint Boon advice to offer the reader...

I've always said, 'Follow what your soul tells you to do, rather than what your bank needs you to do.' I still would really. Just try to make your corner of the world a little bit better than it was when you arrived. I think that's a good way to live; you don't have to be rich to do that. Whether that's knocking on the old lady next door, asking if everything's alright or to tidy her garden; it can be as little as that, or it can be as big as making a fucking beautiful album like these people who make the world a bit brighter with their music. Use that. Make your corner better than it was when you arrived.

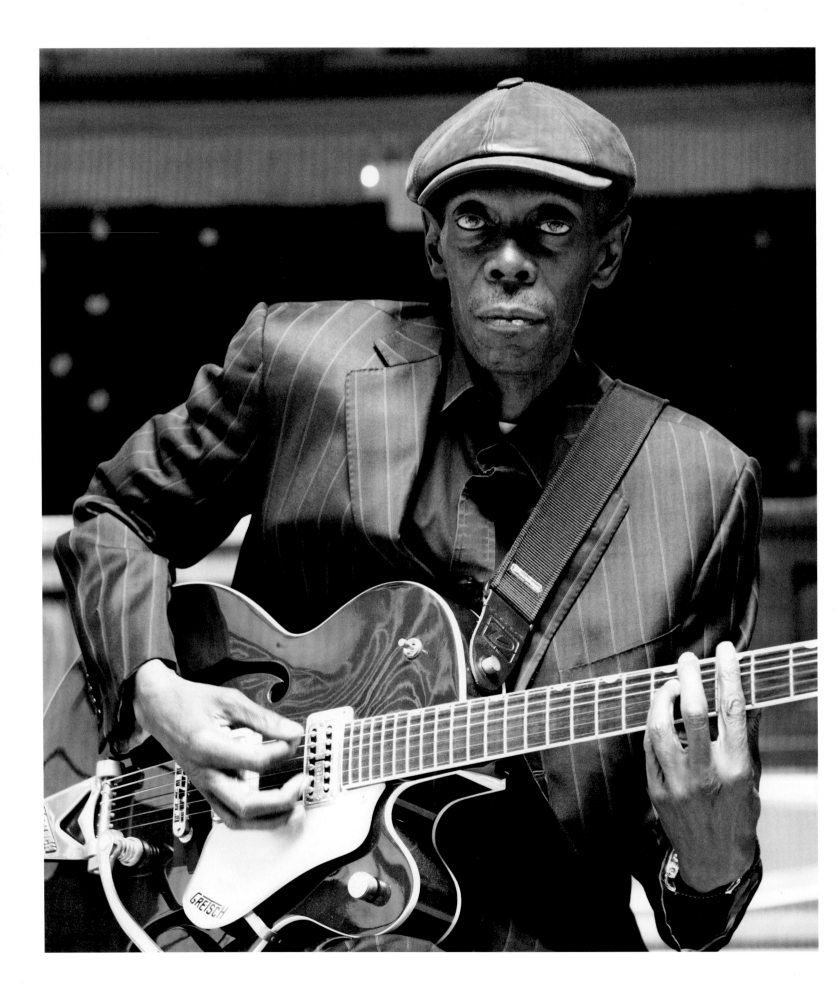

MAXI JAZZ

SINGER / SONGWRITER / RAPPER

Born 1957, Maxi Jazz is an English singer, songwriter and rapper, most famously performing as a frontman for Faithless. Maxi's lyrics as part of this band are wide-ranging, covering small-scope personal frustrations and wider social issues. As of 2015, Maxi performs as lead singer and guitarist with his new band, Maxi Jazz & The E-Type Boys.

Is vinyl important, and if so, why?

Vinyl records are the product of analogue recording, a microphone attached to a tape recorder that records every sound in the room, including the subsonic and ultrasonic ones that you normally can't hear. Digital recording *removes* those sounds. Growing up, it was important to improve your Hi-Fi any chance you got, 'cos your records sounded so much better! You hear more. Waste of time upgrading your Hi-Fi if you're playing CDs, 'cos all that good stuff is gone.

First vinyl memory?

My parents' parties in the '60s; I was allowed to stay up and DJ. I was ten years old!

What was your first vinyl purchase and what did it mean to you?

'Layla' by Derek and the Dominos. The idea you could hear incredible music on the radio and then actually *own* it blew my young mind!

Most cherished piece of vinyl you own and why?

My new record, *Simple.. Not Easy*. Four years of effort buried in those 52 minutes of music. Very proud of my E-Type Boys!

Piece of vinyl you're still chasing?

There are so many! Having spent most of my life broke, there are so many tunes I simply couldn't afford to get!

Why has vinyl returned?

Because it's quality. You don't need 'specialist' ears... It's obvious.

Will vinyl continue to be in vogue, or is the recent interest just a trend which will pass?

Like miniskirts, they're back for good.

Serato or vinyl when playing out and why?

Serato all day. I can take 4,000 tunes to a dance with it. Without, I'd need a truck and crew!

How many records do you have currently?

No idea. Plenty...

Crucial release for any audiophile to have on vinyl, because it just sounds so much better?

Anything at all by Laura Mvula, Little Feat, Led Zeppelin or The E-Type Boys.

Any other last words of Maxi wisdom?

There's a jewel of genius that exists in every single person on the planet. Including you. Impossible to access unless you believe you have it...

Believe in yourself. You're amazing.

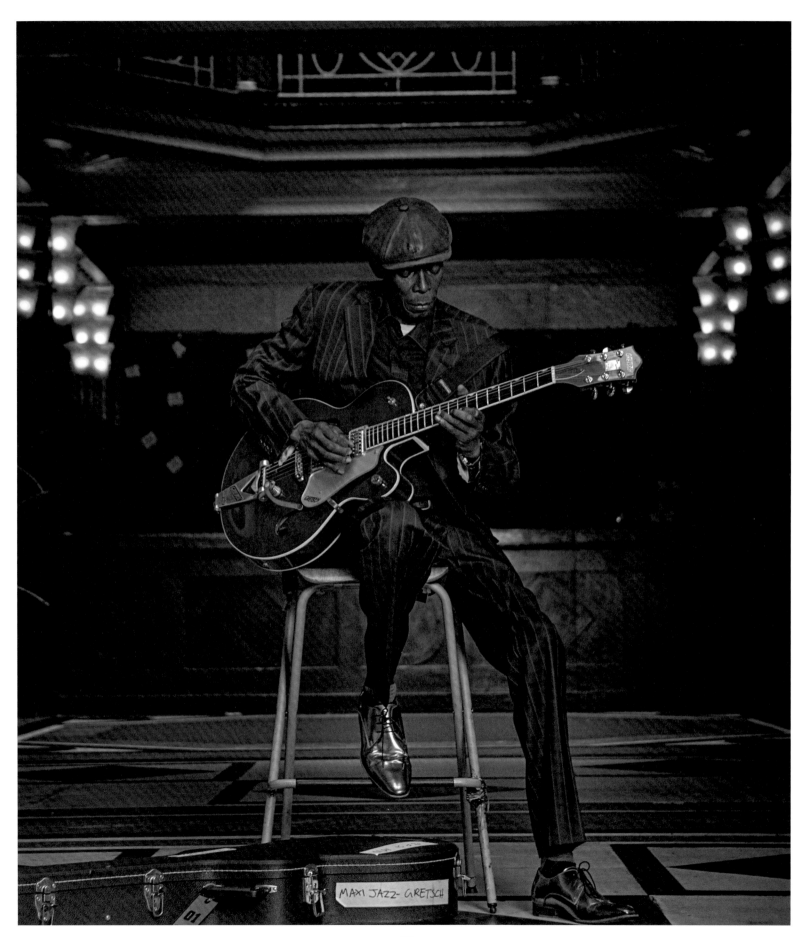

MAXI JAZZ-GRETSCH

MIKE NESS

GUITARIST / VOCALIST / SONGWRITER

Mike Ness is the chief songwriter, as well as guitarist and vocalist, for the long-running punk rock band Social Distortion, formed in 1978. The band is best known for iconic hits such as 'Story of My Life', 'Ball and Chain' and 'It Coulda Been Me'. Ness himself has released two solo albums exploring his roots in country music, *Cheating at Solitaire* and *Under the Influences*.

Is vinyl important?

It's so generational. It is making a comeback, but I feel like a lot is getting lost in translation. For instance, the way vinyl is mastered now. It's not the same as it used to be. You used to cut it on a big huge lathe, transferred from tape. I remember how in the late 1980s they started mastering vinyl from the CD. That's not the way it's supposed to be done – something gets lost.

Another aspect is the number of shit box record players on the market. There are some little record players that sound like a Hi-Fi from Sears back in the day – like from 1967 or something. But on the whole, decent systems have become near obsolete. Admittedly, not every kid has $500 to throw towards an old '70s-style system — one with a Pioneer or a Marantz turntable. But the equipment is important. Vinyl is the means by which music was meant to be listened to: on big speakers, speakers which vibrate through the ceiling, the floor, the walls and the body.

Vinyl itself is *extremely* important. Here's the thing: I don't have an iPod. I have music on my computer because someone gave it to me like that, but I don't like to listen to music that way. The whole vinyl experience for my generation and the generation prior was that you went to the store, you spent at least an hour in there – maybe two – flipping through records. You had to make a decision – what record you were going to buy, or if you were going to buy a couple. It was a big day! You understood, back then, that you couldn't just push a button and have everything at your fingertips. First of all, you had to get your allowance. Then you rode your bike to the record store. You spent time in there. That was what made it an experience. When you went home and opened the record up, it felt like a reward. You put it on, and you listened to that record while you studied the album cover. I got into music very, very

early on; I had uncles giving me records by the time I was six or seven years old. It was a form of escape for me. It really held a lot of power, and it occupied my time. I needed that. The whole process – it is sad that younger people are missing out on that. It's so different. Everything is at a finger's touch now. That's convenient, yes. But when it comes to music – there is just something about vinyl, something about wood speakers, and the way that they are configured, and the amplifier... It's the combination of everything that makes vinyl an essential part of how I listen to music.

Your first release was a 7-inch – *Mainliner/Playpen*. Why this format and not a tape?

That was the beginning of the transition: 8-track tapes were fading out in the late '70s, early '80s. The punk thing was all on 45s. It was inexpensive; the punks were young men who didn't have any money and didn't belong to any major labels, so it was all very DIY. A lot of these bands may not have had enough material to put out a whole record or album.

Will vinyl continue to be in vogue or is the recent interest just a trend?

The younger kids are starting to want to experience it. I think it's great. I love to see a kid in a record store, just appreciating the work that went into creating each piece. It wasn't just the artist that made the record; it was the guy who cut the record, the artwork, the packaging, all of it.

How does vinyl play into the ethos/ values of punk?

It gives you a sense of accomplishment. You're holding in your hand something that you guys collectively did. It's in record stores, it's being sold, it's being reviewed in fanzines. You didn't have to be a five-year music grad

> **" The younger kids are starting to want to experience it. I think it's great. "**

to do it. I guess in that aspect, it was a great kick start to punk as a whole. It was a way to get from point A to point B. That first vinyl record put us in the game.

First vinyl memory?

That one is going to be hard, because I'm going back to *early* childhood. My uncles would give me their records when they were done with them. I remember going to visit my grandmother – she lived in a nice little house, with a raised foundation and hardwood floors. She had one of those huge, six-foot Magnavox Hi-Fis. I put on the 'Day Tripper' 45rpm by The Beatles, and it was larger than life. That was the biggest guitar sound I had ever heard at seven years old. Just hearing that, through that big stereo, the raised foundation house – it was beyond epic. The best thing about it was that my uncle and all of his friends were out in front of the house in their low-riders. For the duration of that record, I felt like I was part of that.

What was your first vinyl purchase and what did it mean to you?

It was probably David Bowie, but I'm not sure. I remember saving my money to buy my first record player. It was a monumental time in my life.

Where were you working to get the money to buy the record player? Do you remember?

I was canvassing house to house, selling air conditioning.

No way! You were not! What I would pay to see that!

Oh my God, it was a scene. This place hired flunkies. We would clamber into the back of this van, get high, then go to people's doorsteps at dinner time, out of our minds, saying 'Hi, we are not trying to sell you anything, but we were wondering...' [laughs]

[Laughing too] How old were you when you were doing that?

I think I was in ninth grade – so 14 or 15.

You were a freshman in high school?

Yeah.

And you actually sold some air-conditioning units this way?

I sold a couple. Enough to fund a record player.

Favourite album cover and why? What's the first thing that pops into your mind?

The first thing that pops into my mind – I don't know if it's subliminal because of his recent passing – is David Bowie's *Pin Ups*. I would just stare at that cover for hours – and the photos in the inside. I think Mick Rock shot the whole package. David Bowie, in a three-piece suit, custom made, holding a saxophone... It's very evocative.

What is the process for creating Social D's album covers?

Most of the time, if the album has a title track we play off that. It has to be something that grabs a person and pulls them in, as much as if they're listening to that track for the first time. Whether it's an album title or an album cover, it has to be just as engaging as the lyrics and the music and the songs. It has to be interesting, it has to be representative, it has to be poppy and catchy. All those things come into play while we record.

This is a weird thing – I just got done producing an album for an artist. I am just getting ready to write mine now. It's the first time in my career where when I leave the studio, I do not have anything in my hand. I mean I will, because I will get it burned to a CD for myself. But if I didn't do that, I wouldn't have anything physical. It's all in the 'cloud'. It's just so weird. Now even CDs are becoming obsolete. I am sure half a million or a million people own our last record – but they did not necessarily buy it. So what do you do? Do you just put together some artwork of a tiny picture to put online, for the people who are going to buy it? It's hard for me. I know we will release some on vinyl, but that's only a small percentage of what we would normally produce. We would normally press a bunch of CDs now, then for our record-buying fans, we would manufacture some vinyl especially for them.

Social Distortion has had some iconic albums and record covers, specifically *Somewhere Between Heaven and Hell* and *White Light White Heat White Trash*. How did those images come into being? Do you still like them 20+ years on?

Yes, I do. It's funny about the *White Light one*, it has nothing to do with title or anything – it's just an image. The '70s was the best era for vinyl art. People understood the album cover's importance. That has just been embedded in me as part of the deal when you make a record. Having grown up with The Rolling Stones' *Their Satanic Majesties Request*, I used to stare at *Cosmo's Factory* by Creedence Clearwater Revival, those photos of them in a studio. It was very garage-y; they did not seem like they were that far away from me. They even used the same kind of electric guitar chord that I use. I would study every detail of a record when I heard it. There are records that I could play for you, and know every single nuance, I was so absorbed in them while growing up.

Crucial release for any audiophile to have in a collection because it just sounds so much better on vinyl?

The first thing that comes to mind is AC/DC. Anything by AC/DC.

Any other last words of Ness wisdom?

Wisdom... hmmm. I realise the importance and convenience of iPods and stuff like that. My wife can turn on her phone in the kitchen and listen to music; she doesn't need to go up to the room and turn on a stereo and hope she can hear it downstairs. I get it. But I do urge people to have a little set-up in your house. It can be very inexpensive! You get some vintage gear, and you buy a first pressing of a Stones record. Then you just put it on and absorb.

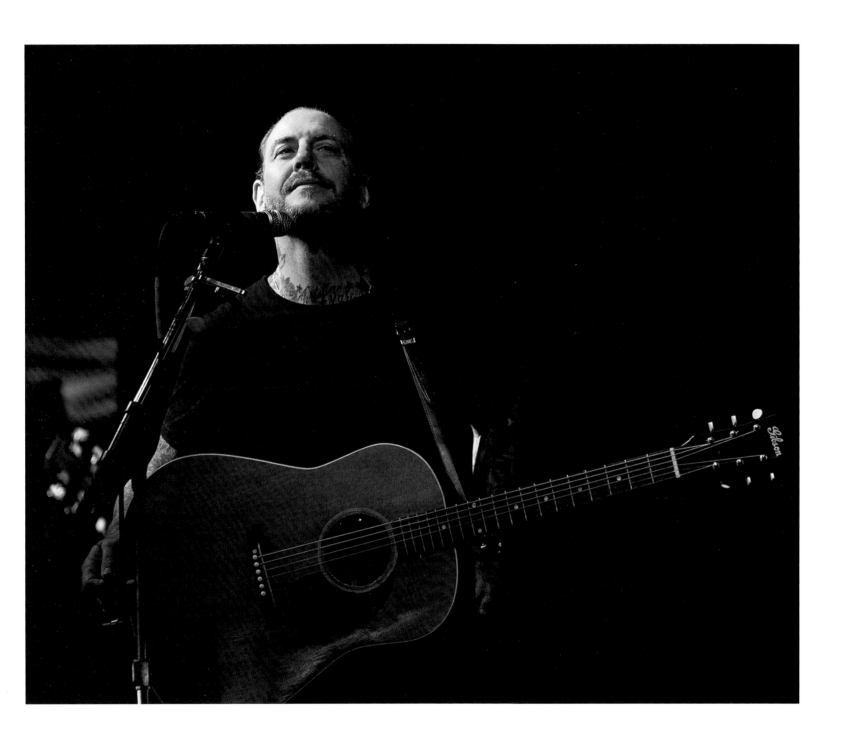

THE ART OF THE PRE-DIGITAL ALBUM COVER

STEVE PARKE

"The album cover has to capitalise on its large scale, so as to jump out at the customer from the shelf."

Steve Parke, the designer behind Prince's iconic album *Graffiti Bridge*, explains the business behind album art

In the days before photoshop, album art had to be photographic – or, if you wanted something more conceptual, either hand-painted or collaged. Images couldn't simply be sent back and forth over the Internet. Everything had to go via courier, and thus the editing process took a considerable amount of time.

Ingenuity and artistic experimentation often had to be sacrificed for the sake of meeting these deadlines. Ideally, each part of the process would be scheduled and pre-planned well in advance. The lengthy wait time meant that great ideas were often whittled down to disappointing results.

Large labels dominated the industry, with a different worker for every aspect of the design – spell-checking, colour correction, concept art, etc. They had the money and resources to bring great album art to life. However, the ethos of the day was that if you couldn't do something yourself then it wasn't worth doing. There were many smaller labels with a limited employee pool. This meant that everyone pitched in, often learning on the job.

Artists were rarely employed by the musicians themselves, especially when those musicians were signed by the larger labels. For designers who were unaffiliated with a label, finding work could be difficult. If the label already had someone in-house, they might not want to pay a freelancer. Production and distribution costs also limited the scope of what could and couldn't be created. This was particularly true for independent record labels, who didn't have the option of taking production overseas. For them, pushing the boundaries of package design was difficult; it was far more cost-efficient to stay within the conventions of the medium.

As a result, the final product might not necessarily be the designer's first choice, or even the musician's. Album packaging had to be a compromise between multiple factors – from the cover's saleability and its appeal to the album's target audience, to the ease with which it could be transported, stocked and stored.

What makes a good album cover?

'Eye-catching' is the most obvious answer. But what does that mean? For many, the appeal of vinyl lies in the tangibility of the format and the sense of becoming 'closer' to a band, which comes from the album paratext: the liner notes, and the various other parts that express something about the artist's personality. The album cover has to capitalise on its large scale, so as to jump out at the customer from the shelf. But in doing so, it also has to provide the customer with their first glimpse of the band's style – what they're trying to put across, the mood that's brought about by their music. The packaging is integral as a tool that helps you move product. But it also provides the first impression of the artist that people will be exposed to.

PETER SAVILLE

ARTIST AND DESIGNER / FACTORY RECORDS

The art director of the legendary independent UK label Factory Records, Saville rose to fame through the record sleeves he designed for Joy Division (and later New Order) at the beginning of their professional career. He is associated with radical designs that omit 'necessary' information, such as names or titles, while embracing open space.

Tell me about your first vinyl experience and how that affected your personal design aesthetic.

At the very beginning, with Factory Records, my thoughts were about what I would like pop culture to be. As a 20-year-old in the UK in 1975, I thought: 'What is lacking in *my* world? In *my* culture?' In a very unprecedented and unique way, within the possibilities of post-punk, I had the opportunity to make some suggestions about pop culture through the platform of Factory. Factory could be understood as an autonomous collective, which is sort of an oxymoron – but that is very much what it was, by virtue of not being founded on the principles of profit. It was a stage for facilitating, brought wonderfully into existence by Tony Wilson. A stage upon which any of the players could express themselves as they wished.

Growing up, the music collection came into the home via my two older brothers. In 1974, there was something that was not on their radar, so I had to buy it myself. It was Kraftwerk's single 'Autobahn'. It was a hit in the UK; I think it got playlisted as a novelty! I did not hear it as a novelty. 'Autobahn' tapped into my studies about modernism, as well as being about music and just *coolness*. I bought the single, then learnt about the 22-minute version on the album; I had to have it. The cover of 'Autobahn' in the UK was the blue and white monochrome image of the German autobahn sign. This cover was my introduction to semiotics, though I did not know the word at the time. What I absorbed from that cover would shape my sensibility going forward. It was not an epiphany when I bought the record. It was just one of those things that on reflection, I see was fundamental. Sometimes it's family, sometimes it's a moment at school; you never know when it's happening, but there are some moments in life where your future takes shape.

When young people are interested in music, they read the interviews and want to find out about the group. I learned about Ralf and Florian of Kraftwerk, who had studied classical music at the conservatory in Düsseldorf. I sensed that the Kraftwerk project was very carefully considered and an intelligent, conceptual proposition. I was lucky; I picked up a Deutsche Grammophon album at a friend's house, and it happened to be Mozart's Clarinet Concerto in A, which is a very good entry-level piece. I thought, 'Oh, I actually like this' – but I know I would not have picked it up had it not been for Ralf and Florian.

What I felt from the 22 minutes of 'Autobahn' was a European experience. We did not travel abroad in my family. I may have been on a school holiday once to Switzerland, but I didn't know much about continental Europe. I was fascinated and intrigued by it though; even as a teenager, Europe was sexy. Places like Saint-Tropez – that sounded sexy! And Berlin – ominous. So I had a fantasy of Europe. What I heard when listening to 'Autobahn' could be encapsulated as a journey across Europe. Then I looked at the cover; there was this simple, monochrome symbol. That sign was able to represent 500 years of European cultural history to me. The potency, the language within imagery – it still astounds me to this day. I see that symbol, and I see the history of Europe, from the Dark Ages to the cold war. Because time is a road, a pathway, a super highway – an 'Autobahn'. And that journey, because of the conflation of classical chords and contemporary synthesizers, was a conflation of time. It was the 12th century to the 20th century. I would listen to 'Autobahn' and contemplate the European canon, from cathedrals to power stations. That's what I got from my first vinyl purchase.

Five years later, I was looking at a sign on a workshop door at art college that said 'Use Hearing Protection'. In that sign, the entire genre of what we call 'industrial music' was epitomized. That sign

> " Through the advance, the company owns the artist. The minute the artist takes that money, the company calls the shots. "

was coming off that door and home with me! It defined the beginning of Factory. It is my version of 'Autobahn'. 'Use Hearing Protection' in the context of a musical situation refers directly to the industry of sound; the industry of music, the music industry, the 'industrial' factor that is inherent to 'making music'. Machine music. So 'Autobahn' is really important to me, as my first lesson in semiotics.

How much input do you have when you're putting together a cover? Or is it always a collaborative process?

This varies enormously. From complete control to consultant advice. The situation at Factory was unprecedented. That was really my first experience. I did the first Factory poster while in my final term at college in 1978 – the black and yellow Fac1. Modest affluence and the tolerance of my parents afforded me a very comfortable existence when I was at art school. I dragged that out for nine further months, until my father lost his temper with me. But in those months, between doing the first Factory poster and finally getting a job, Factory was founded. We formed the label, mostly through a sort of serendipitous opportunity. One day Tony, Alan Erasmus and I were sitting in Alan's flat – 86 Palatine Road in Manchester. Completely out of the blue, Tony suggested that we release a record. He said, 'Look, some of the bands that have played Factory nights [the name 'Factory' was originally used for a club, run by the label], don't have a record deal yet. Why don't we make a record from the club? And that will help some of these bands

to get a deal.' So it was a strategy from Tony, in a post-punk independent way. From my point of view, it was entirely self-interest to do a record cover. I had done three posters for the Factory nights, and they had gone up around Manchester. I knew if we did a record, it would be national. So out of pure self-interest, I said, 'I think that's a great idea.' And then Alan said, 'How are you going to pay for it?' Tony said, 'I have £5,000 that my mother left me; we've got to do it for that.' I just thought, *can* you release a record for £5,000? But it was the spirit of the time. In 1978 the phenomenon of independence was being realised. People around the country found out that you could actually release a record yourself – you didn't need to sign your life away to EMI or CBS. Tony knew that. For £5,000 we made *A Factory Sample.*

This was where the autonomous collective began. The £5,000 went to realising the product. No one was paid. Everyone was there because they wanted to do something, and nobody had any formal experience. No one knew what they were doing, so therefore no one presumed to tell anyone else how to do their job. It was a bit like friends having a party; you don't criticise the shortcomings! With groups in those days, you could become the manager if you had a van. Factory was a collective to make something happen, and no one was in charge. There was no contract, no advances.

Through the advance, the company owns the artist. The minute the artist takes that money, the company has control. If you go and borrow

£100,000 from the bank, you are not autonomous anymore. The bank owns you. That is how it is – but that never happened at Factory. That culture of debt and control never happened. Everyone did their bit the way they wanted to do it.

When it comes to *Unknown Pleasures* [Joy Division's debut album], the group gave me the pulsar diagram from the *Cambridge Encyclopedia of Astronomy*. They had found this image and thought it was interesting – and they were right. It's fabulously enigmatic. It's brilliant. They gave me that, they gave me some credits; they said they wanted it white on the outside and black on the inside. Stephen Morris said, 'Textured paper is quite nice.' After that I just got on and did it! I did what I could do. It was the first 'real' work of graphic design I had ever done, so I didn't really know what I was doing. It was great they wanted it black and white as I couldn't do colour – I had no idea how to do anything in colour. It was the days of paste-up and mechanical artwork; everything was a learning curve. And I was at the very bottom of it. I couldn't figure out the sizing of things. I decided that I wanted to have the wave diagram; I wanted that on the label. But then I thought: 'If it's bigger on the outside and smaller on the inside, would that look weird? Maybe it should be the same size all the way through.' So the size it had to be to fit on the label ended up being the size on the outside.

It ended up being quite small on the actual cover then.

Yes. It sits in a sea of black – space.

But when it translates to the CD, it is a completely different proportion.

Yes. That's one of the problems with scale. I also was not sure where to put the words. When taking

the brief at the beginning, I said to the band, 'Does anyone want it to say "Joy Division" on the front?' 'Mmm, no, we don't mind; not really. No, no, it's not cool.' OK, we all agree – *Not Cool*. 'Does anyone want to have the title on the front?' 'Well, you know, that's probably not cool either.' So I was at liberty to use the given elements as I felt appropriate. Had the cover been for a major record company they would not have accepted the artwork. At that time, and right through to the end of the '80s and particularly in the US, unless the name of the artist and the name of the album were on the top third of the front cover, record stores wouldn't take it. So we were out on the fringe. Everybody involved had total autonomy. No one actually approved the cover. I just took it to show it to Rob Gretton, the manager of Joy Division, then New Order, and he said, 'Oh, that looks alright.' That was it. Beginning to end. I was afforded full freedom.

The day that I had to sit down and listen to the test pressing of *Unknown Pleasures*, I was in real trepidation. I genuinely did not think I could sit through 40 minutes of Joy Division. I was with Rob. It was the day I delivered the artwork for the cover. Rob said, 'Do you want to hear the album?' And I was thinking, 'Oh fucking hell.' But I couldn't refuse, so I said, 'Yeah, sure.' And from the first second to the last, it was transcendent. I knew it, by the time the second track started. I looked at the cover on the table in front of me, and I thought, 'Oh My God. I have just done the cover for probably one of the greatest albums of our times.' It was obvious, it didn't falter.

How different was creating the cover for Joy Division from working with Wham! or Roxy Music?

It's totally different. When I did *Unknown Pleasures*, the band knew what imagery they wanted to use

because they had been thinking about it for months – but when we got to *Closer*, Joy Division's second record, it was a different story. They were recording at Britannia Row in London. I lived nearby, so we met up. The band had nothing, so they defaulted to me for the *Closer* image. I didn't know. I hadn't even heard the recording; I didn't know what it was called. But I was pressured to put something in front of them. I showed them these Bernard Pierre Wolff photographs, not expecting them to like them – twelve months earlier, they had given me a scientific diagram! Rob really put me on the spot. He asked, 'What are you into?'

As Joy Division became New Order, my situation at Factory evolved into creative autonomy. Take something like 'Blue Monday.' The group and the company didn't even see it; it went straight from me to the printer. The group didn't see it until it was in the shop! That summarises the nature of my relationship with New Order through to the end of Factory in 1993. I did the covers; they made the records. They didn't like the covers? We didn't talk about it. I tried to get their consensus – but nothing ever came of it, and at the end of the day I just had to get on and do it. I tried, out of respect, to get their guidance, to get their take on what I was developing. I'd say to them: 'I like this and this and this, what do you like?' But it became evident really quickly that they all disagreed in principle. Post-Ian Curtis, there was no hierarchical structure within New Order until the mid '90s, when they reformed. They were previously a democracy. But after Curtis' death they quickly became a democracy of disagreement. They never agreed. What's left when you don't make a decision? No decision. And that's what happened with the album covers. No one's say was greater than anyone else's, so once they disagreed, it was an impasse. I would turn to Rob; he would say, 'Just fucking do it.'

In all other groups, there's a hierarchical structure. Even though there might not have been in the beginning, give a band a choice that needs to be made and a hierarchy of authority will very quickly crystallize. You soon know who it is: for a Roxy Music cover, it's Bryan Ferry. Suede has Brett Anderson. Pulp cover? Talk to Jarvis Cocker. And so on and so forth.

There's no problem associated with a record cover other than the principal artist liking it. What's on the cover doesn't matter. Unlike any other form of packaging or communication, nobody has *not* bought a record they wanted because they didn't like the cover! They may sometimes be influenced to buy a record that they are indecisive about because of the artwork, but if there is a song, a track – something that speaks to them – the cover art won't put them off. So, therefore, it doesn't really matter. But one thing does matter: the principal artist. Because if Bryan, Brett, or Madonna aren't happy, the release is delayed. Things like that are always left to the last minute, and ultimately, the record companies give in and say: 'You know, we don't fucking care. Just get it approved.' And the person it has to be approved by is the principal ego. That's how it works.

Sometimes, the principal ego will leave it too late. I discussed a cover with Kanye West over the phone one day. I was actually standing outside a supermarket as I suggested what he could do. He had passed the deadline – and potentially burnt the release. I knew that Kim, his partner, was having a baby, and that they were getting married. He'd phoned me to ask, 'Have you seen the latest visuals?' And I said, 'Kanye – isn't this coming out soon?' He said, 'Yeah, next month.' And I said, 'Kanye, you won't have a cover.' And he said, 'How do you mean?' I said, 'If this record is coming out in four weeks time, you do not have a cover.' I asked, 'Is the release date important?

> **"** I created a lot of space around whatever it was I did. Most exciting, dynamic graphic work pushes the edges of things. It bounces *out* of the poster it is in. **"**

Can it be delayed?' 'No, no way.' I said, 'Then you don't have a cover.' He said, 'How do you mean?' I said, 'You don't have time to finish one of these images, print it and proof it. You don't have a cover. You are not going to have a cover.' He said, 'What can I do?' And I said, 'Look in my book. You will see what looks like a cover, that wasn't a cover – it was a concept visualisation for New Order. It was for a version of "Crystal", New Order's 2001 single, that never happened. It's a clear box with a stripe on it. And there's a clear CD in it. Just do that. Just put it in an empty box. I think something like that will be your only option at this time.' And sure enough, that's how the album came out. That is exactly what he did! That's the most 'arm's length' guidance I have ever given for a cover... from the car, outside a supermarket.

What's it like to see the *Unknown Pleasures* cover everywhere?

It's phenomenal. I have some unexpected friends and acquaintances because of it! One is Professor Brian Cox, the British astrophysicist and TV presenter. He and I became friends because of a shared Manchester history. Brian, and his American wife Gia, who is quite obsessed with *Unknown Pleasures*, were able to enlighten me as to the true story of Jocelyn Bell Burnell. It's a heart-rending and breathtaking story about this young researcher, the physicist who discovered the first pulsar – the image used for the *Unknown Pleasures* cover. It begins with Jocelyn at Cambridge

in the late '60s, a female postgraduate research assistant in a team of men.

These men, her seniors, received a Nobel Prize based on her endeavours. At the time, they told Jocelyn she was seeing things. They even gave the prefix LGM to her discovery – Little Green Men! But of course, they were super happy to receive the Nobel Prize. She's the one who observed it first. Then two astrophysics professors from Cornell University plotted her data to create an enhanced version of the image as part of their PhD studies at Arecibo Observatory in Costa Rica, and that's where the image comes from.

From pasta plates to full-body tattoos, the distance that image has travelled is extraordinary. It's totally embedded in the universe of popular culture; it is now a perennial. For every slightly edgy kid, as they work back through the eras, there is Joy Division – along with The Velvet Underground and The Doors. It's so sci-fi, that image. And so ambiguous. You can project anything you want onto it. It's a heartbeat. It's a sound-wave. It's a terrain. It's brilliant. Bernard Sumner saw it. Jocelyn Bell Burnell discovered it. The guys from Cornell shaped it. I framed it. And Ian Curtis' death [Joy Division's lead singer] made it immortal.

With regards to *Unknown Pleasures*, I am just a contributor to a piece of late 20th century iconography. I just played a part.

I placed it in space, in that sea of black. One of the things I can see in my early work, which I was not

aware that I was doing, was that I created a lot of space around whatever it was I did. Most exciting, dynamic graphic design pushes the edges of things. It bounces *out* of the poster it is in. The record covers push away at the seams of their edges. They are exciting and dynamic. They create a cacophony of colour and form. If you stick a Peter Saville cover in amongst them, everything stops. The stillness of a gallery space is in that reductive, reticent style of mine. You see the *Unknown Pleasures* symbol *because* there is space around it to see it. When I see bootleg versions of it, where someone's made it as big as they can, it looks terrible. The endless T-shirts out there are awful. Nobody would have cared about it if it had not initially been shown to them beautifully. And, in a way by chance, that is what I ended up doing. So that was my contribution.

Most challenging record cover and why?

One that instantly comes to mind is Peter Gabriel's *So*. I didn't really want to do it; I wasn't that interested in Peter Gabriel. Brett Wickens [Saville Associates Partner] liked Peter. Entirely independently, Brett got into working on a cover for him. He would ask, 'Do you want to talk about it?' And I would say, 'No, not really. But you know, it's good, it's all good.' He went through trial and tribulation with it. I did not know then – but I subsequently found out – that Peter himself did not really want to be on the cover. When I looked eventually at his previous covers, he was hiding, behind a tree or similar. There was an initial almost-completed cover, which ultimately Peter did not like. Brett told me we had almost run out of time, and I said, 'I am not surprised.' Brett said, 'We're not even sure about the title anymore. I think we should go see him.' When we did, this really nice man came out to greet us. He was lovely. Very affable. I liked him straight away. This is the stupid prejudice of

life. We sat down and we had a chat. He said, 'Do you have any ideas?', and I said, 'Well, maybe.' Gail Colson was managing him. She had engaged us independently of the record label, so the budget was not restrictive. The problem with record covers is that they take about ten times longer than you get paid for. So there is no long-term career path in doing record covers. They don't pay much, and year-on-year, they pay less. But Gail had made an exception for this record. I did not know why. I was going to find out.

Gail took me to one side and she said, 'He has made an important record. You have got to bring him out of himself.' I only vaguely sensed what she was getting at. I did not fully appreciate the situation. So we had this lovely hour with Peter. We just talked and then left. As we were leaving, he gave a cassette to Brett and he said,' I think I have finished it.' Brett said thank you. We got in the car, and we started driving away. We are heading for the motorway, and we put this cassette on.

First track: 'Sledgehammer'. I stopped the car! I stopped the car on the slipway; I pulled over. I looked at Brett, and said, 'That is a hit. That is a *massive* hit.' And Brett was like, 'Yeah it is.' I mean 'Sledgehammer' – it's impossible to not like 'Sledgehammer'. But by the time it got to 'Don't Give Up', I was in tears. Within 45 minutes of having left Peter Gabriel's, I knew – just like with *Unknown Pleasures* – that I was listening to a great, seminal album. And that was when the cover started. I suddenly knew exactly what Gail Colson meant: I had to bring him out.

A record like that needs a face. I am not a fan of faces on records. But for certain songs that reach hearts and minds all around the world, an audience who doesn't know the artist needs someone to

identify with. They need a face to go with the music. It has to attract, it has to be relevant and it has to be contemporary. For *So,* we went about it with photographer Trevor Key, in exactly the way we had gone about New Order's *Low-Life,* using a very special type of Polaroid roll film. The person being photographed is in control of the session; they are able to see the pictures as they happen – which was unusual then, as it was pre-digital. The same process had had remarkable results with New Order, who also did not want to be photographed. The pictures on *Low-Life* were fantastic. Exactly the same thing happened with Peter. We got the shot in the third roll. It was there. He saw how he could look and delivered it. He said, 'I don't want my name and title on the front.' I said fine. That image of Peter Gabriel was the logo for *So.* It was the logo for Peter Gabriel for the next 20 years. It's the way the world still likes to think of Peter Gabriel. When the record label said, 'No, we will not accept it without his name on the front.' Peter went to them and said it was his way or no way. And they said, 'You won't sell any records.' Ten million albums later, he was proved right.

Final thoughts?

The amount that is owed to Ian Curtis. The equity invested in Factory Records, the capital was Ian's life. Ian Curtis was going to change my life, although I didn't know it. I often argue that modern Manchester stands on his sacrifice. I have to acknowledge that the success of my career – not the work itself, but the *success* of the work – I owe that to Ian. There are many people who owe a lot to Ian. The passionate, tragic gesture he made, changed the lives of many. It's extraordinary. We cannot know when we first meet someone. Before I even got to know Ian, he was gone. If I describe to someone what a pulsar is, I tell them it's a dead star that continues to emit energy until the end of time; the analogy is profound.

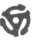

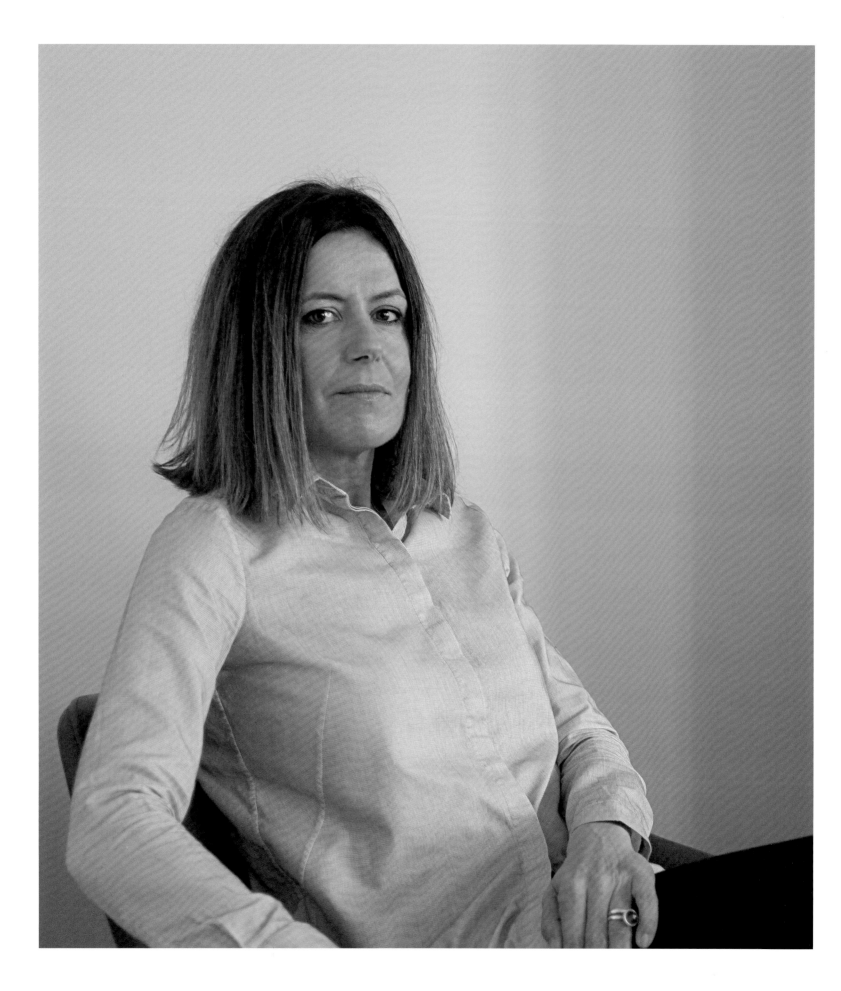

ALISON FIELDING

DESIGNER, BEGGARS BANQUET

Alison Fielding works for Beggars Banquet, an independent record label inspired by the punk rock scene and its DIY style. She has worked with artists like David Bowie, Bauhaus, The Charlatans, The Horrors, and Natacha Atlas.

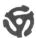

Is vinyl important? If so, why?

Vinyl is a huge part of my life; I'm lucky to have worked with the 12-inch x 12-inch format for so long. Sleeve design is a great avenue for experimentation, and the results can really be open to interpretation. There is a perennial interest amongst fans and designers. Vinyl is often the place where we see the most truly innovative designs. It's interesting, naughty, and challenging at times – and of course, hugely rewarding. From a design perspective, I don't always have free rein to do whatever I want. But we like to find something new for every album, ideas and visual applications that feel different.

First vinyl memory?

My mum and dad playing Frank Sinatra's *Come Fly with Me*.

What was your first vinyl purchase and what did it mean to you?

I didn't buy my first vinyl – I found them! I was shopping with my mum in Birmingham and found a plastic bag on the train home. There were two records in the bag: the 7-inch of X-Ray Spex's single 'Oh Bondage, Up Yours'; and Plastic Bertrand's 'Ça plane pour moi'. Whoever left them had very good taste. I played them over and over. I had no idea what bondage was, but I used to sing it at the top of my lungs around the house! The very first record I bought with actual pocket money was not quite so cool: 'Mull of Kintyre' by Paul McCartney & Wings. I really remember the Capitol Records 7-inch label and the brown dust sleeve.

How did vinyl records influence your interest in design?

My parents had some arty friends whose children were a bit older than me; they were the best! We went around to their house, and the kids had commandeered the dining room. They had an A-board in there with a fluorescent pink *Never Mind the Bollocks* poster on it. They were the first punks I'd ever seen. They played the Pistols and The Clash; I'd never heard anything like it. I remember eating lunch in the dining room, surrounded by bright punk posters and staring at the A-board; I suppose something must have sunk in.

At about 13, I was listening to the John Peel show on headphones and I heard 'I Will Follow' by U2 for the first time. I was blown away. I thought it was incredible. I remember the process: hearing the track, shouting about how amazing it was to my family, being told to 'shut it' as they couldn't hear Kate Adie reporting from war-torn Iran, ordering it from the local TV shop that doubled up as a record store, and waiting, until finally, there it was in my hands. I had no idea what it would look like. When I got it, I just thought it was so beautiful. I stared at it for hours. I played it and played it, endlessly caressed that silver metallic border, read each detail. The thick plastic dust cover, the reverse board, the sleeve notes, those hairstyles, the beautiful Larry Mullen Jr... There's something almost *Mona Lisa*-like about the photograph on the sleeve. There was *Boy*, his innocent little face gazing back at me. That face. What did that face mean? Was it one of the band as a child? Was it really about the transition from childhood to adolescence? Did I even care? Did it capture innocence, or something darker? They used the same boy two albums later for *War*, by which point he had a split lip. Turned out he was the brother of a friend of the band. I believe he has now photographed the band himself. I'm not sure if there was much of a backstory, or even a concept behind the sleeve, but to my teenage self it was everything. I don't care much for the graphics nowadays. However, that album is very evocative

> **" Vinyl is a huge part of my life; I'm lucky to have worked with the 12-inch x 12-inch format for so long. Sleeve design is a great avenue for experimentation. "**

of a time in my life that shaped my love of music. I can now look at it more objectively and see that the type on the back is clumsy – atrocious, in fact. But from that moment on, every penny I had was spent on vinyl, every sleeve copied (badly), every logotype traced. Like an addict, it was too late for me. When I was about 13 or 14, I had this big blue Adidas bag for school. I wrote 'U2' on it in really big lettering in ballpoint pen, messily and badly. That was my first attempt at graphics. The slippery slope had begun...

How did you become a vinyl cover designer?

I went to the Goldsmiths University in London. My first proper job was as a paint and trace artist for the company that did *The Snowman* animation. I then went to work for a design co-op in Dalston, where I learnt my craft on a very small Mac. One night, I was on the tube and saw an advert in the *Evening Standard* to be a junior designer for a record company in South London. I thought it sounded quite cool, and rang them up; it was Beggars Banquet. Bauhaus was one of my favourite bands and they were on the label. The interview took place in the pub opposite. After a few beers and showing them some pretty shoddy work, I was offered the job. On my first day, I was told to go and help at a photo shoot where Anton Corbijn was photographing Peter Murphy. Not a bad first day! I've been here ever since.

Favourite project you have helped design and why?

Like covers, I have favourite projects most months (until they grind me down), depending on what I'm working on. I am currently doing an interesting project called *Planetarium* with Sufjan Stevens and Bryce Dessner, where lots of different artists have been commissioned to create a piece of art for the planets. We've gone to the space rock genre for the design and type – really funky stuff. I also recently worked with a new artist called Pixx. That's been a great collaboration, with an incredibly talented creative model-maker, costume, hair and makeup artist, who develops the artist's visual appearance while we have fun with video, GIFs, and photography. It's been an amazing project to work on.

There are numerous memorable projects that I've been a part of. Working with The Prodigy at the beginning of their career and then watching their rise to stardom was incredible; their input was always varied, energetic and bold. Bands that spring to mind who were great to work with include The Charlatans, Mercury Rev and Dream City Film Club. Working with Natacha Atlas on set at the pyramids in Egypt was fun! In terms of an aesthetic, I was really thrilled with The Horrors *Higher* boxset I did a few years ago. I could use anything I wanted: paper, finishes, multiple colours. You name it, I used it! It was great to have that creative freedom and print budget. It's a privilege to work with some of the bigger artists. As part of the Gas Associates

umbrella, we were pleased with the way the David Bowie *Five Years* boxset turned out.

What is important in a good record sleeve?

Like any design: a good strong idea.

Having collaborated with artists who create music that is talked about decades beyond its release, I believe that the associated design work needs to be just as timeless. The key thing is that the artist feels the sleeve and campaign represents their music and vision, that it serves to enhance their music. I try not to follow trends; I've learnt from my mistakes!

I feel that sometimes a cover is seen as good or iconic because the audience becomes so familiar with it, largely because it's a huge selling or successful artist. It doesn't always mean that it is a great cover; in fact, it might be a dreadful cover typographically or the imagery used could be terrible. It's quite incredible how many artists I work with use very old covers as a source of inspiration. Quite often, a sleeve is a homage to one of the classics – Bruce Springsteen seems to be cited a lot.

There are many people whose work I admire, particularly independents who push the boat out when it comes to packaging. For me, anything too busy annoys me visually. I admire when the type and the image work effortlessly and equally. All beautiful art-directed sleeves should tell a story.

One of my team in New York has just done a beautiful sleeve for Perfume Genius with hand-painted red type; it's so fantastic and I'm very jealous of it

After the music, I still like to see the album cover as the centrepiece of the creative campaign. The focal visual point is the sleeve, and everything else is an extension of that, be it the website, a pre-roll, a YouTube channel or advertising/marketing. With a huge melting pot of different platforms to either access the music or its visual elements on, it's important that everything is coherent.

Most cherished piece of vinyl you own and why?

We have a copy of the first pressing of the first Beatles album *Please Please Me* and some original Elvis 7-inches; if things get tough, they'll have to go!

Piece of vinyl you are still chasing and why.

My partner actually once held a copy of the *White Album*, no. 7 of the first pressing, which once belonged to George Harrison. I wouldn't mind that coming my way.

Why has vinyl returned?

CD was a format that virtually rendered vinyl extinct, but a jewel case was never pretty. It is interesting that until the recent resurgence of vinyl, the CD format was always the first format we thought about when starting the design process, both for us and the bands. Then something happened: the digital era brutally took away the idea of collecting records. The physical format was dead. I thought I'd be out of a job, destined to design thumbnails for iTunes for the rest of my life!

Then the shift happened, and now vinyl is always the first format we design. Bands don't really care about the CD now, although there has been a move away from the plastic jewel case, towards more environmentally friendly materials.

Will vinyl continue to be in vogue or is the recent interest just a passing trend?

Record companies see its growth, an uptick not seen for years. Vinyl sales have recently overtaken downloads as people switch to streaming services. I don't know if it will be a passing phase, a bit of the zeitgeist. I hope not. I really hope it continues to flourish. Who would have thought that we would be where we are now with vinyl, even five years ago? On a more cynical level, it could be seen, particularly with the younger market, as a fashion.

How many records do you have currently?

Not as many as I used to. When vinyl was on the decline, I sold over a 1,000 records. I think it was to pay for a bathroom! I enjoy the bathroom, but it's something I now regret. I'm gradually building it up again. I thankfully get a lot of pieces for free, so I'm buying more of an eclectic range: jazz, classical, grime. I get just as excited by new stuff as I always have been.

Crucial release for any audiophile to have in a collection because it just sounds so much better on vinyl?

I'm not such a purist as to only listen to vinyl; the other platforms, let's face it, are more convenient. But these two are both old and evocative of the time. I got into them when I was a teenager:

Bob Dylan: *Blonde on Blonde*. I loved that album so much. 'Sad Eyed Lady of the Lowlands' – one take, epic, beautiful. You can't listen to it on anything else but vinyl.

Fleetwood Mac: *Rumours*. The heyday of vinyl pressing. It cost a fortune to record, it involved loads of drugs, and a ton of inner-relationship conflict. I've never listened to it on any other format.

COLLEEN MURPHY

DJ / EVENT FOUNDER, CLASSIC ALBUM SUNDAYS

Colleen Murphy is the founder of Classic Album Sundays, a listening event which invites the audience to hear music, in her words, 'contextually, communally, uninterrupted, and in the best sonic detail'. Prior to this, she was known as 'Cosmo', an American radio and club DJ.

Why is vinyl important?

It's a physical representation of you as a person. I like having a record of what I have listened to or what I have read. Those are two really important things to me: music and reading.

For me, there's a romance about it: sitting there, holding the album cover while you listen to the album. I took my daughter to the David Bowie exhibition at the Victoria and Albert Museum in London when she was nine. We came home, and she put on my old copy of *Hunky Dory*. She sat there with the cover in her hands, like I used to. It was an incredible moment.

What made you want to start Classic Album Sundays?

I felt that music had become a free or cheap commodity. People are not paying for music. Instead of people recognising how powerful and important it is, it has become the backdrop – it's the backdrop to my night out, it's the aural accompaniment while I work. There is no real focus on it. When I was I growing up, I would listen to records in my room. When my parents were out, I had the living room turntable at my disposal. I would just sit around and listen to records, and dance and sing. That was the activity. That was it. I wasn't doing anything else. Then I would have friends over, and that is what we would do. We would listen to a record. It was something you could share or do alone. You could completely focus on it. You would give it 100 per cent of your attention.

With Classic Album Sundays, I wanted to make music the focus. I wanted to provide a space where people would not do anything else – working on their computer or their phone. They would just be

listening. Just like books and films, albums have influenced culture, politics and societies in other ways. Speech patterns. Humour. It goes beyond influencing other bands. Fashion, film, art, comedy. Music can influence all of these disciplines, just like great books can. We could argue that The Beatles have been as influential as Shakespeare. I felt that the album needed to be treated like the great novels: you can't just pick and choose chapters – you have to study the whole thing as an entire piece of work. I also felt that audio formats had gone down in quality. The CD was touted as this audiophile thing. I never started buying CDs. I got a lot of them because I was working in the music business. But I kept buying vinyl. CD has a 16 bit, 44.1kHz sampling rate, so it's not even as high resolution as the new digital downloads, which are 24 bits with a 96kHz sample rate.

You can really hear the difference if you train your ear. That is not to say that every piece of vinyl sounds amazing, since so much of it is made poorly. But when you get a great record that is recorded properly, mastered properly and pressed properly – and then you play it on a proper system – it's like nothing else. I felt I wanted to challenge the whole CD thing, and the various audio formats of ripping stuff off. I wanted to prove to people with evidence that this is a different experience when you listen to it *this* way.

I also wanted to share my love of Hi-Fi. I know most people can't run out and buy a £50,000 sound system. Some of the systems I have used have been worth half a million pounds. But you *do* hear things you didn't hear before. Friends would come over and listen to records, and would say, 'Wow, that sounds so different.' That in itself is something to share. It was really those types of reasons. I never thought it would go out into the world and become what it is. I was just a crusader.

> **"** I felt that the album needed to be treated like the great novels: you can't just pick and choose chapters – you have to study the whole thing as an entire piece of work. **"**

What was the first Classic Album Sunday like?

There were five of us; I knew everyone! I lost money with having to hire a babysitter! I got really lucky, though, as one of those people was Kate Mossman. She was writing for a magazine called *The Word*. After attending, she wrote a piece called, 'Are record clubs the new book clubs?' She grasped the concept immediately. The first album we did was *Abbey Road*. And despite the initial low turn out, I kept doing it. I did not have a Facebook page, I did not have a website, I did not have a Twitter account. It just shows that this wasn't a grand commercial plan. I don't know how I promoted it; I have no idea. It intrigued people on many different levels.

There were only ten people, fifteen people by the third one – but then the BBC came. They just phoned me up, this guy from the online services. He had read the article by Kate Mossman, and wanted to do a piece about us for their online hub. 'What's your next one?' '*Ziggy Stardust*.' 'Oh, that sounds perfect, I'll come along!' Then he calls me back. 'David Sillitoe would like to come along.' Now, Sillitoe is the arts editor for BBC television. I was like, '*Wow*. OK. Amazing.' He is very knowledgeable about music. I play something that I call the 'musical lead up' in the beginning – inspirations but also contemporary stuff – to give people an idea of the social and musical fabric of the time when the album we're spotlighting

was released, to put them into the moment. I was playing some obscure stuff – like Soft Machine – and David Sillitoe said, 'Is this that Soft Machine song...?' He actually knew it! That week we were on *BBC Breakfast*. After that it kept going on repeat; we went to the BBC Worldwide Services; my phone did not stop ringing. That was when it became, 'Oh, this is what I'm doing now.'

I felt like Classic Album Sundays fused together all of my musical knowledge. I have worked in four record shops, I have written, I have done loads of radio, I have interviewed hundreds of bands. I also do events and run DJ nights, and this – Classic Album Sundays – it put them all together. But at heart I just remain an audiophile and a vinyl collector. I had no expectations at all. I was surprised at the response. I licensed Classic Album Sundays worldwide, getting friends to start it up in their own city. The vinyl revolution was starting to happen on many different levels, and Classic Album Sundays helped make that happen. Our albums are art. I am not saying every album is great beginning to end. Let's face it – most are not. I am talking about *Classic Albums*. The ones you can listen to the whole way through, over and over.

Did vinyl records influence you wanting to become a DJ?

I started collecting records really young. I had a radio show from the age of 14 on the ten-watt radio station at my high school. My first proper after-school

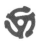

job was at the record shop when I was 16. So it was always vinyl. I remember in 1984, I started working at Strawberries Records and Tapes in Framingham, Massachusetts. I had to clear out the bins for these new things called CDs. They were really overpriced: $14.99 if you were lucky. They came in big long boxes, with a lot of plastic. They were being touted as the new high-fidelity, audiophile format. Now we know that's not true. At the time though, people believed it.

I started making mix tapes at home at the age of 12. I had my GE Trimline in my room; it had been handed down to me. It was my first turntable. It had the speakers that pulled out, the platter that pulled out. I had a load of aunts and uncles who were teenagers and in their early 20s with big record collections. I was borrowing all their stuff, then making mix tapes. If you think about it, that's DJ'ing. That was at 12. It wasn't my job until later. I went to college radio right after high school, in 1986; I was the program director of WNYU. I remember doing some DJ gigs before I got into dance music. I remember playing at CBGB Record Canteen in the '80s, I played on the roof of Mars. I was playing punk; we did not have the word 'alternative' yet; it was still indie rock, new wave, the Wax Trax! stuff. So before I became a proper DJ as a living, I was already doing this. It has been an evolving story.

First vinyl memory?

I had Donny and Marie records. I also had a Donny and Marie turntable before my GE Trimline. My first record that I really loved was given to me by my aunt for my eighth birthday in 1976. It was *Elton John's Greatest Hits*. One really fun vinyl memory was going to the Lechmere Mall – this really bad mall in Framingham, Massachusetts – and buying the Sex Pistols' *Never Mind the Bollocks* with my mum. My first favourite album, which I borrowed from my uncle when I was 12 years old, was The Moody Blues' *Days of Future*

Passed. That was the first album I was really obsessed with. There were a lot of vinyl moments. They were all signposts along my teenagehood. My coming of age was wrapped up in music, rather than boys!

Do you ever feel the gender difference, being a female in the predominantly male world of DJ'ing and vinyl?

It has changed a lot; it's definitely getting better. I remember when I was getting into dance music in the early 1990s. I was white, female and straight. What else could be wrong! I had a radio show. I was mixing; I was answering the phones; I was speaking into the mic. Someone would call up and think that I was just the announcer, and they would say, 'Tell the DJ he's doing a great job.' And I would say, 'Actually, it's me.' And they would be all 'Oh my God, I am so sorry!' They would be cool about it; I mean, there weren't a lot of female DJs playing that kind of music at that time. I just got on with it. I knew that sometimes I surprised people. But a lot of the time I didn't think about it. This was before the Internet, so you wouldn't necessarily know what someone looked like. I would go into record shops where I didn't know the people behind the counter and no one would serve me. I would literally be standing there; I was this young, white woman. They just assumed I wasn't there to buy records. Another time, I was opening up for Josh Wink and Laurent Garnier. I was walking across town, hauling these big record bags. I got to the gig early; there was already a queue, a velvet rope. I said to the bouncer 'Hi, I'm Cosmo, I'm opening up. Can you please let me through?' And he said: 'Cosmo is not a girl.' I read him the riot act!

Crucial release for an audiophile to have because it sounds so much better on vinyl?

Analog Production have some of the best stuff. If I had to pick one record label, it would be

> **" There were a lot of vinyl moments. They were all signposts along my teenagehood. My coming of age was wrapped up in music, rather than boys! "**

them. They do a lot of reissues. They have The Doors, The Beach Boys, Duke Ellington – all sorts. There's a Duke Ellington album called *Masterpieces* – if I was on a desert island and I could only have one album, that would be it. It's all unedited arrangements and concert arrangements; 'Sophisticated Lady' is on there. I'm not even a massive jazz buff. But when you hear this album on vinyl, it's just astounding. It's the foundation of everything. You hear more and more every time you listen to it.

Last words of Cosmo wisdom?

When record companies say 'It's on 180-gram vinyl, therefore it is audiophile', that isn't necessarily true. What matters is the source from which it was mastered and how it was pressed. That's what matters. How well was the original recording done? That's number one. You can't polish a turd.

Such an American expression! If you have a great recording, then it's about how it is mastered. If you are mastering from a CD rip, it's not going to sound great. Was it mastered by a great mastering engineer? And mastered from the original source, i.e. tape or a really super, super high digital transfer? If so, then your chances are a lot better for getting a quality product.

Also your turntable: you have to set up your turntable properly. It needs to have the right amount of tracking force, so there is the right amount of weight on your stylus. Every stylus will say how much weight it is supposed to have. That's what the counterweight is for: making sure it's level, not lopsided; making sure the anti-skating is working properly, so that the arm is not being pulled too far in or too far out; making sure that the stylus is fitting exactly where it's supposed to fit in the groove. That's how you hear vinyl properly.

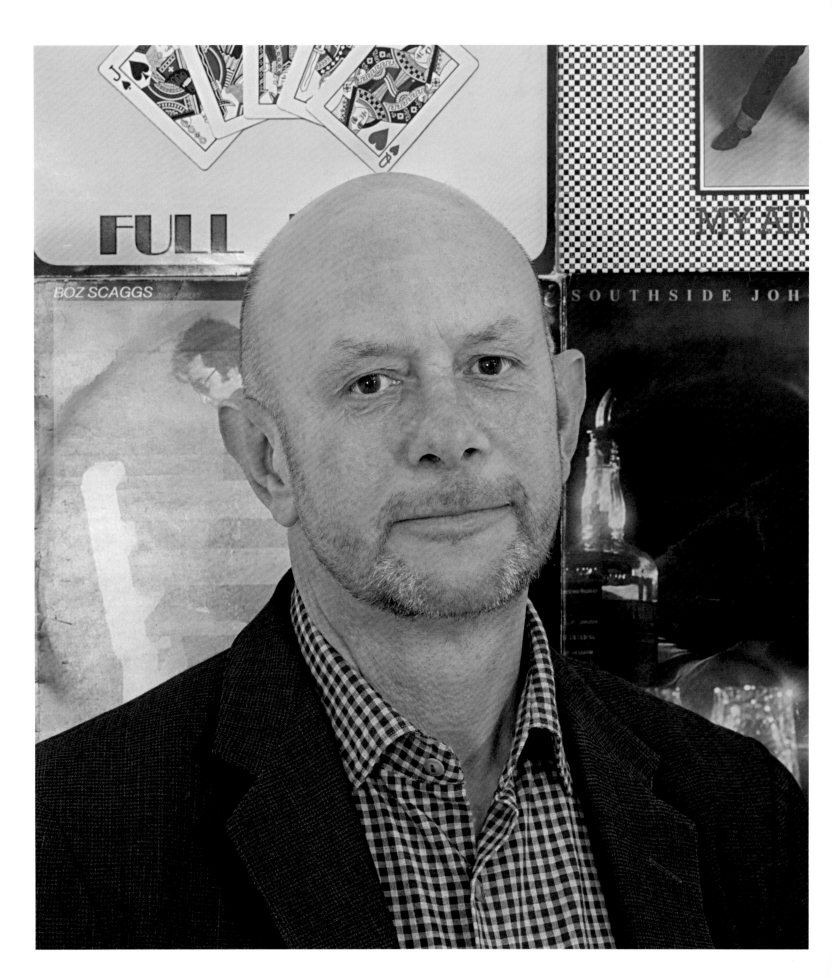

NICK HORNBY

AUTHOR

Nick Hornby is a writer who has published essays, screenplays, lyrics and novels. Of these, his best known is *High Fidelity*, which centres around the life and trials of London record shop owner Rob Fleming. The book follows Rob and his employees, Dick and Barry, as they discuss their desert-island 'top five' music lists and the importance of mix tapes. *High Fidelity* has sold over a million copies. In 2000, it became a feature film, and went on to be made into a Broadway musical in 2006.

Why is vinyl important?

I don't think it's important, really. I like it, and still buy it, for reasons that I'll get into. But I only ever wanted the music. The format was immaterial to me. These are wonderful times to be a music fan: every piece of music ever made, more or less, is available to you in a device the size of a cigarette packet for no, or very little, money. This is particularly helpful if you know a lot about music already. The only limit is your ignorance – so only knowing the top 40 is a disadvantage.

How did vinyl records influence your writing process?

I wasted my time at university, and one of the ways I wasted it was by looking for vinyl in the second-hand shops around the town. As a consequence of my time wasting, I was unfit for the kind of high-flying career that some of my friends embarked on after college. I became a writer instead. But what I wanted from my books was the kind of punch and accessibility that the best popular music has.

What does a record provide that other formats do not?

The reason I started buying vinyl again was that I didn't think I was making enough of a commitment to music. I'm an enthusiastic user of Spotify, and I'm not enough of an audiophile to tell the difference between the music provided by a streaming service and a pair of good earphones, versus a vinyl record. When audiophiles talk about the obvious superiority of the latter, they forget that most people are not and have never been audiophiles, and that an iPhone and a pair of earbuds can provide better sound than the kind of crappy stereo systems we used to use. But these things enabled me to pay less attention to the music itself. I skip tracks all the time, I listen to things for twenty seconds before deciding whether

I like them, I don't pay enough for the music I do appreciate. So I decided that whenever I fell in love with an artist or an album, I would do them the courtesy of spending some decent money on their work, sitting in a room and listening to it properly, over the course of twenty minutes or so. It's stopped my endless skid over the surface of things.

Why has vinyl returned?

Well, of course it hasn't really returned. Sales are still tiny. But it isn't, as we thought, going to vanish completely, at least for a while. There's snob appeal, for sure; vinyl looks great, the covers are cool, the format is fashionably retro, and so on. But I suspect that many young people are taking the position that old-school music nerds adopted: what you own says something about you. You can't own the music on Spotify. Everyone has the same – namely, everything – despite attempts to personalise the new platforms. Vinyl offers a way of distinguishing yourself from those who care less than you do.

What was your first vinyl purchase and what did it mean to you?

The first album I can remember buying with my own money was the first Paul McCartney solo album, which neatly sums up my place in relation to music history: I was too young for the '60s. Records meant a lot to me for the next seven or eight years, because they represented a commitment. I had one record, and then, a month or so later, I had two, and then, a few months after that, I had 15 or 20. When I bought something I didn't like, it was disappointing but also weirdly humiliating, as if I'd been made a fool of. I knew those records very, very well. Nobody will ever again know a collection of songs so intimately. I'm not sure that's a good thing, actually. I shouldn't have listened to a mediocre Paul McCartney album thousands of times when I'd never heard *Blonde on Blonde* or *Kind of Blue*.

How many records do you have currently?

A few hundred. I sold the vast majority when I switched to CDs. I was one of those people! But like I say, it's the music that's important to me.

Top five records of all time on vinyl and why.

Today: Cannonball Adderley's *Somethin' Else,* Bruce Springsteen's *Born to Run*, Bob Dylan's *Highway 61 Revisited*, Al Green's *Greatest Hits*, Jackson Browne's *Late For The Sky*. Tomorrow: a different five. And on and on, forever. Always for the same reasons: a record must have ten or twelve truly great songs that are brilliantly sequenced, and no filler.

How is your vinyl collection arranged and why? Do you rearrange yours during times of 'emotional stress' like Rob in *High Fidelity?*

I have always organised my music according to what is now the Apple system: first names first. I did it this way because Andys Records in Cambridge, where I bought a ton of music, did it this way. So J. Geils is always under J. I have never messed around with it.

Why did you include the scene where the jilted wife sells her cheating husband's prized collection to Rob?

Because it's such comic agony for music collectors! It was funny, hearing the reactions of music fans to that scene – they dream of finding records like that, but they were more sympathetic to the cheating husband than was appropriate...

How does the physical object of a vinyl record play into this equation?

People want to own what they love, and to demonstrate that they love it. This mostly has to be done out of the house. It's interesting that the appetite for live music seems to be growing, just as people are willing to spend less on recorded music. The sense of wanting to be in the same place at the same time, for an unrepeatable event involving loved musicians, is very strong.

When *High Fidelity* came out twenty years ago, Rob seemed a bit sad and stagnant in his belief in the record store and vinyl. Would he be having the last laugh today? Are record clerks and vinyl enthusiasts the true taste makers?

I don't think we're back to that, not yet. The taste makers will remain online, and the people I know who run record stores are not making a secure living. It's tough out there. My kids love music, but unless something changes, I'm not sure they will ever pay for it. Those of us who can remember paying for it must surely constitute the bulk of the record-buying customers now. When we're gone, it will be even harder to keep vinyl alive.

Any other last words of Hornby wisdom?

One more thing about vinyl: it's only used for music. CDs were horrible, not least because our homes and offices were littered with discs containing photos, instructions, work, all of them loose and scratched. The 12-inch or 7-inch record is only ever used for songs. That's why we have such a powerful connection to it. It hasn't been damaged by any other associations.

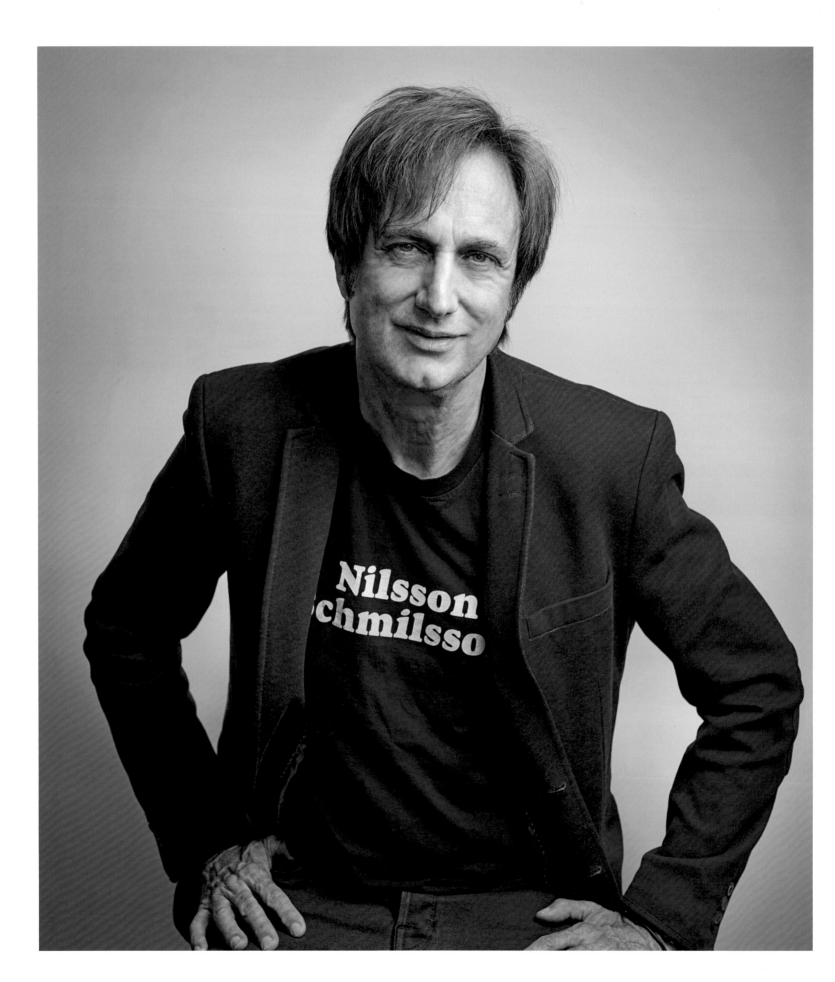

MICHAEL KURTZ

CO-FOUNDER, RECORD STORE DAY

Michael Kurtz is an award-winning ally of the independent record label, having served as president of the largest record store coalition in North America, the DORS (the Department of Record Stores), as well as being the co-founder of Record Store Day. Record Store Day is an event which celebrates the unique culture that has grown around independently owned record stores worldwide. It is considered the biggest music event in terms of global participation in history.

> **"** I often hear artists say that they don't feel like their album is complete until it's pressed on vinyl and they are holding it in their hands. **"**

What is Record Store Day?

It's an international celebration of independent record stores by record stores, artists, record labels and their distributors. We represent a unique culture, a place where people meet and connect. For the artists, it provides a chance to do something really creative and special. This can be either a live event in record stores, like the Foo Fighters and Metallica and hundreds of artists have done, or it can be a vinyl record that is completely unique. For the labels, it gives them a chance to work with their artists in a record store environment and with creative packaging and special events. For the stores themselves, it's a chance to offer really cool releases, throw parties and offer performances for their customers, serve food and drinks to music fans, and connect with their community in a big way. In many locations, this goes all the way up to political leaders who do things like DJ at a store, or tour their neighbourhood record stores to celebrate, or offer official proclamations. Record Store Day is a day that brings everyone together in a very positive way.

Why not 'Music Store Day'? Why specifically put 'record' in the title?

When we first worked on the event, we considered different names. After talking with artists, it was clear that 'record store' implies something specific, something kind of romantic and something entirely owned by independently owned businesses. As much as we were defining ourselves, we were also defending ourselves from becoming co-opted by major corporations. But, mainly, we were just trying to resonate with the culture of the record store and idea of the record store that has been cataloged in everything from books to movies.

How has Record Store Day changed music consumers' purchasing habits?

When we first launched it with Metallica nine years ago, we discussed the idea of creating special records and performances. We started talking about doing vinyl records but, at the time, almost no record labels were manufacturing vinyl to sell in record stores. And in the stores, pretty much all they sold was used vinyl. No one could see the possibility. As it turns out, Metallica was working with Warner Brothers. Records at the time and they understood what we were trying to do. They helped us to get about ten vinyl records made for the first Record Store Day. Try as we might, because vinyl as a business was dead, we couldn't really get any other labels on board; no one thought we would be successful at relaunching the vinyl industry. And to be frank, I wasn't sure either. At that time, there wasn't a business model to follow; we had to create it from scratch. But then it became easy after the massive success of our first event. We benightedly relaunched the vinyl business and relaunched the love of buying physical things for consumers. The other big thing to happen was the international coordination that took place and the creation of one street date for the Record Store Day releases on a global scale. At the time, all of the

major and independent music companies segmented the various countries and there was no coordination between them. We changed all of that. We brought the world together and today Record Store Day is celebrated on every continent except Antarctica.

Future plans for Record Store Day?

This year [2017] is Record Store Day's 10th anniversary! Our plans to celebrate include launching a Vinyl Club through which we will release special records once a month throughout the year, with part of the money going to support individual record stores who have opted to join us. Music fans will be able to go to our website to pick a record store in their area that they would like to support. They will then be able to get one record every month at that store, a piece that is totally unique and made for them. If they don't like any particular Vinyl Club title, the stores who carry them will do what they always do and allow the music fan to pick out something else in the store. So, in fact, the sale for the vinyl record doesn't occur until the customer makes their choice. Our goal is to tout the excellent customer service that music fans can get at a record store, and to get music fans thinking about how they can support their local record store year round. With rising rents, these local, independently owned record stores will need everything they can get in the coming years.

What is record store culture? How does vinyl play a part in it?

The culture of record stores is complicated. Record stores are often where musicians come to work while they get their careers off the ground. It's a place where people get human interaction and advice on everything from the best songs and albums, to what is happening at the local club. A good record store is a combination of a library, a gallery, and a temple.

A place for kindred spirits to find a future partner. As far as vinyl goes, record stores are generally curated places with deep selection and fair prices. Many big corporations are into carrying vinyl now, and that's fine; but they can't give music fans what a great independent record store can: the human touch.

Has the relationship between artist and record stores changed with the resurgence of vinyl?

I often hear artists say that they don't feel like their album is complete until it's pressed on vinyl and they are holding it in their hands. Record Store Day made it viable for record labels to do this once again, so we do have a unique relationship with artists. We helped them to attain their dream.

How do you decide who is the 'Ambassador' for Record Store Day?

Every year the process is somewhat different and, in a way, the Ambassadors pick us instead of the other way around. The Eagles of Death Metal's frontman Jesse Hughes first came up with the concept of a spokesperson sporting a bit of braggadocio and calling themselves 'The Ambassador of Record Store Day'. The vagueness of this part ended up being exactly what we needed, as every year a different artist steps into the role and creates something unique, with a different approach. In recent years, Ambassadors like Jack White, Iggy Pop, Chuck D, Dave Grohl and Metallica have really ratcheted things up by doing a lot of press interviews for the stores, as well as special records and surprise live events in record stores themselves.

What role have independent retailers had in the resurgence in vinyl?

When we launched Record Store Day, most vinyl

> **"When you play the record, you conjure a spirit. I think we long to connect with something bigger than us. Vinyl does that in some mysterious way."**

was being sold by audiophile companies direct to the consumer. These were high-end pressings done for people with expensive stereos. By accidentally creating a huge demand for vinyl, Record Store Day gave both indie and major label record companies the confidence to step out and start pressing records again. This has spiralled to the point now where a large percentage of new albums are pressed on vinyl. Record stores did that. Almost no one was interested in pressing vinyl until 2008 when we launched Record Store Day.

What does a record provide that other formats do not?

On one hand, it's a very personal experience where the listener pours over the artwork, reading liner notes and looking at the artwork and absorbing the overall vibe that the artist created. On the other hand, it's a communal experience where people get together to listen to records. I think the latter experience explains why the majority of people who are buying vinyl are so young.

Why has vinyl returned?

I don't really know. As much as I was involved with its relaunching, I can't say why it happened. There was always a culture, and love, of vinyl before Record Store Day. But my understanding is that in 2015 more vinyl was sold than any year since they started gathering sales data in the '90s. In the first year or two, most of the people that came out to

celebrate Record Store Day were in their 40s and 50s. Now it's mostly people under 25, so there is definitely a generational element to the movement. Other than that, buying and collecting vinyl is just fun. It's really that simple.

What does the return of vinyl in popularity say about the place and space of music in our lives?

In a way, listening to vinyl is pretty similar to seeing a ghost. What you are experiencing is the recording that an artist made in the past. You bring it to life when you play it on your turntable. This is especially true when you find something like an old worn copy of Tom Waits' *Nighthawks at the Diner,* or Miles Davis' *Kind of Blue,* or Radiohead's *OK Computer.* When you play the record, you conjure a spirit. I think we long to connect with something bigger than us. Vinyl does that in some mysterious way.

What is your first vinyl memory?

I actually have a kaleidoscope of early memories, but my first 7-inch singles were The Beatles' 'Strawberry Fields Forever' backed with 'Penny Lane', which I got at a little record store called McGraph's that specialised in carrying Beatles records; and a copy of The Monkees' 'I'm a Believer' backed with 'I'm Not Your Stepping Stone' that a friend gave me. I can remember coming home from school in the fourth grade and playing them by myself on my parents' console and just being blown

away by what I was hearing. I loved those records so much that I started saving my lunch money to buy more. I got skinny that year from not eating so that I could buy more records – and have remained thin ever since!

What was your first vinyl purchase and what did it mean to you?

The first full-length album I ever bought was The Doors' *Strange Days*. Ironically, this early purchase was made even more strange later in life when I found myself doing a tour of book stores with The Doors' drummer John Densmore in France for Record Store Day 2014. I remember waking up one morning in Paris hearing The Doors song 'Indian Summer' in my head and then later ending up in the same arrondissement with John where Jim passed away, all by accident. Life is mysterious.

How many records do you have currently?

I haven't counted, but my Beatles collection contains over a hundred 7-inch singles and various albums by the band, or the individual members and their side projects. I think I probably have somewhere in the region of 3,000 records total. I try to get all of the Record Store Day records that I either work on or like.

Why would you tell a band to release their next project on vinyl?

In the US, all record stores buy vinyl one-way from the labels' distributors throughout the year. This means that the stores buy them, and cannot return them if they don't sell. So a record store owner has to have a sense that there is interest in the album to be able to stock it. Thankfully, there are literally tens of thousands of albums that meet this criteria. What

a band, or any artist has to decide is 'Will people want my music on vinyl and do enough people know about it?' If the band, or artist, think they do then yes, it makes sense to press it on vinyl.

Crucial release for any audiophile to have because it sounds so much better on vinyl?

That actually changes for me all the time. Right now I'd have to say it's albums like David Crosby's *If I Could Only Remember My Name*, Stevie Wonder's *Songs in the Key of Life*, The Clash's *London Calling*, The Beatles' *Abbey Road*, Wilco's *Sky Blue Sky*, and Aldo Ciccolini's *Erik Satie Gymnopédies*. The last one is especially great on a rainy day when there's thunder and lightning outside your window.

Any other last words of wisdom?

It takes a special kind of DNA to be the person who wants to own a record store. They don't tend to get rich, or even want to make a bunch of money; but they bring so much to our neighbourhoods and home towns. Support them. Computers and smart phones are necessary to modern life, but listen to me when I say that you need to get away from them as much as you can. Go to a record store, pick up a few wonderful albums, take them home; love them; spin them while you make dinner, or chat with friends, or play with your kids. Life is short. Celebrate it with art and music. You will feel better.

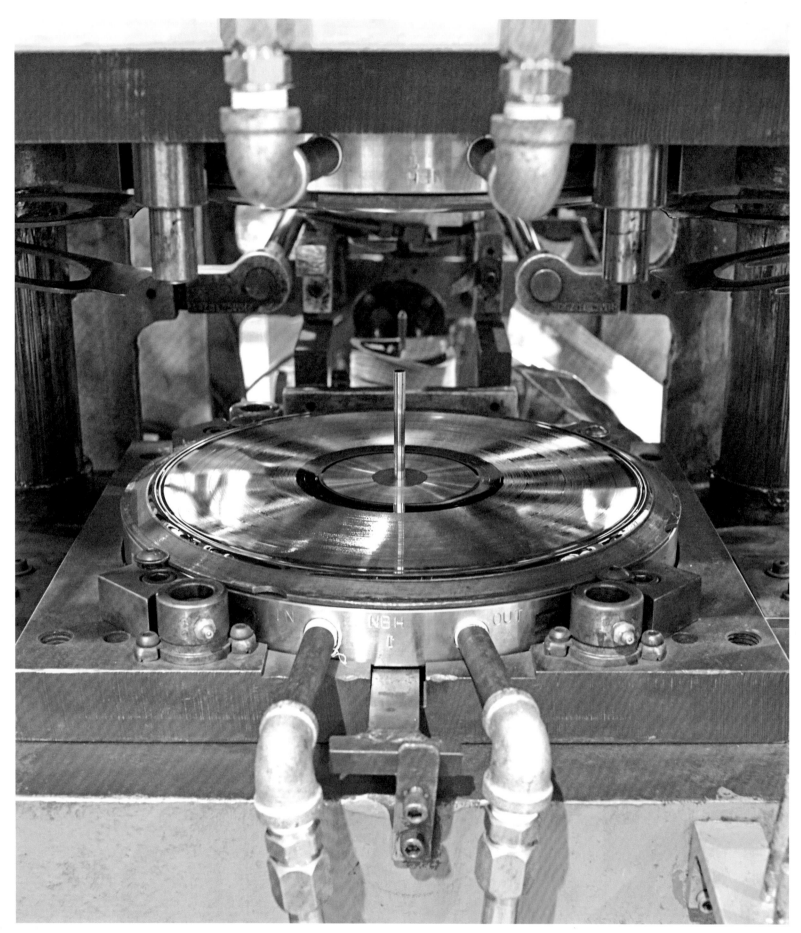

MAKING VINYL

MARK RAINEY AND MICHAEL DIXON

Mark Rainey, CEO of Cascade Record Pressing, explains the process:

A lathe is a record player in reverse. With a record player, the stylus reads the information in the grooves, then broadcasts this signal to the speakers.

Lathes engrave the music onto physical material, in most cases a 'lacquer'.

This is an aluminium disc that has a very thin layer of lacquer material on it. To cut a record, you need two lacquers – one for the A-side and one for the B-side. The signal is transmitted directly to the lathe. The ruby cutting head slices a physical record of the information in a long spiral that goes concentrically to the lacquer's centre. You now have a 'master copy' of this recorded piece of music, which is the first piece in the process of mass replication.

Next, the A- and B-side lacquers are sent to an electroforming facility. Through a process called

silvering, a metal 'negative' impression of the lacquers called a 'father' is created. Fathers allow the plating engineers to produce the next part in the process, which is called a 'mother,' a metal copy of the original lacquer. Like lacquers and records, you can play a mother on a record player. Mothers are the part that make the 'stamper'. The stamper is a thin nickel plate that contains a negative impression of the program information. The stamper is essentially a less durable, disposable version of the father, that you are able to reproduce via the mother.

A father can produce three mothers. Each mother can produce up to ten stampers. Each stamper, by today's standards, should give you 1,000 records. So one father begets 30,000 records.

Back when vinyl was the mass music medium, it was all about quantity. Pressing plants would run 10,000 records off of one stamper. This is why you see record collectors looking for earlier pressings, known as 'Hot Stampers'- copies that came from the

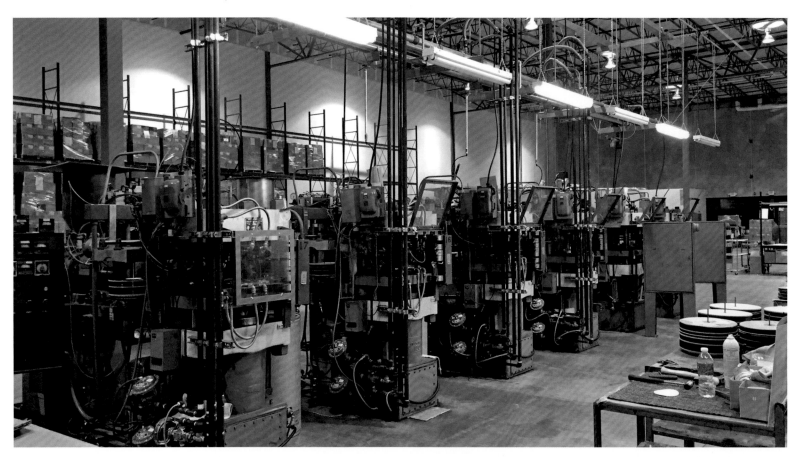

144

beginning of the press run because, theoretically, these are going to sound better. But in the context of the modern focus on quality, the line that has been agreed on is 1,000 cycles per stamper.

After completion of the electroforming, stampers move on to the pressing plant where a test pressing will be made. The test pressing provides the client with a final chance to make sure everything sounds right; they have one last opportunity to edit or change anything before going to manufacturing.

Once the test pressing has been approved, the job is ready to run. Record presses are a complicated orchestration of very simple, fundamental services: water, compressed air, steam, hydraulic pressure and electricity. Stampers are affixed to the mold inserts, which are inside the pressing table of the pressing machine. Typically the B-side will be on the upper mold, the A-side on the lower mold; it is essentially a big waffle iron! Labels are loaded into the label cages, and the hopper is filled with PVC compound in whatever colour the job calls for. Let the pressing begin!

Michael Dixon of the Soild Gold label pushes the boundaries of the record format

Records don't have to be cut on vinyl! As part of a movement to encourage people to return to physical music mediums, artists like Michael Dixon are experimenting with the record format itself. Dixon cuts plexiglass, garage sale materials and even used picnic plates, ensuring that every release is unique.

His goal is to make records an art form in and of themselves. This makes people invest in them not just for the music (which can usually be found for free online) but also for their appearance, and the hours of hard work that go into their creation. With each record being individually crafted, it's a laborious process – one Dixon compares to silk-screening prints by hand. Combining upcycling, real-time record cutting and an embracing of all things odd, Dixon's work is truly one-of-a-kind.

DAVID MILLER

PLANT MANAGER

Throughout high school, Dave Miller was employed by his family, building record-pressing equipment while also working in the plating room. Eventually he became the plant manager. Over the last 50 years, he has witnessed at least three boom and bust cycles in the record business, and has been involved in building, designing or dismantling approximately ten plants.

Could you please walk me through the history of your family and record pressing?

I built the machines at Independent Record Pressing and Cascade Record Pressing with my father, while I was still in high school. These machines, built in the '70s, were meant for the record-pressing plant in Cranberry, New Jersey.

Was it the family business?

Yes. Right after World War II, my uncle, father and grandfather took their GI money and started a pressing plant, right outside of Philadelphia. I don't know how it came about. I think my uncle and his brother–in–law used to record weddings. From there, they decided to actually make records and press for other people, or make their own music instead of having it pressed elsewhere. They dug up presses and some old equipment and built a place in Philadelphia, in an old movie theatre. Everybody worked there – the whole family. My grandmother, my grandfather, my aunt – they all worked the presses. One of their big hits was Bill Haley. At the time, he was Bill Haley and the Saddlemen. My uncle renamed them Bill Haley & His Comets. On one of his songs, 'Rock The Joint', the chorus in the background is 'yeah, yeah, yeah, rock this place and tear it up' – that's my whole family in the recording studio! They were starting to yell and jump up and down because the music sounded so good. That's the story that has been passed down.

On and off, as vinyl came in and out of fashion, I would do something else, but I would still tinker with machinery. Every time a wave of vinyl interest returned, I would go back to a record plant. I keep telling people, it's like a hot ex-girlfriend: you remember the good times, but not the frickin' roller coaster that it takes to make a record – the

customers, the stampers, the compounds, the labels... You are relying on product that everybody else makes, and you have to assemble it and bring it all together. Sometimes, it's a bitch.

Why have you continued doing it?

Glutton for punishment, I guess! My first job was building presses. When I was in eighth grade, I would come home from school, go over to my father's plant and tinker around in there. Don't get me wrong – I still hung with my friends! But occasionally, I would swing by the plant, and play around with the presses or drive the forklift around, or weld stuff. Through high school, I ran a third shift in my senior year in one of the plants that my family had built. We probably pressed most of the records you know about: The Stones, Crosby, Stills & Nash, The Moody Blues, Joni Mitchell, Joanie Collins... The list goes on and on. They did overflow for the major labels – Atlantic, Reprise, etc. In the heyday, in the '70s, when rock 'n' roll took off, we pressed records seven days a week, 24 hours a day. I got so fricking sick of *Saturday Night Fever* and *Grease*, I still can't stand to look at those albums! We had ten presses for months going on those two albums alone.

On records like those that were so huge, how many records would you press off one stamper?

That would depend on the stamper itself, as well as the music, the cut, and the compound being used. Anywhere from 1,000 to 2,000. If I would take an order in for 10,000 records, I would order five sets of stampers right off the bat. As attrition happened, maybe order one or two more, or an A-side or a B-side. You always liked to shoot for 1,000-1,500 per stamper. But I have had one stamper go for 2,000-3,000; it just depends on the

compound, how hard it is on the record, the cut, and the quality of the plating and the nickel at the time that they make it.

What's your favourite record cover and why?

I don't really have one. I never collected records or kept records. I don't have any personally. Zip. When I got a brand new record off the press in the '70s – The Rolling Stones stuff like *Sticky Fingers*, or anything by Traffic – I would take them home without the covers. That was how they counted records; if it had a cover they were not our property, they were the customer's. It was taboo to take record covers, especially records that hadn't yet been released. So I would listen to these coverless records, then I would give them to my friends. I kept it low – I didn't spread it around! No bootlegs, I swear.

What was your first vinyl memory?

My mother had a huge Hi-Fi set that my father had built out of mahogany. It was like 12-feet across. She used to listen to Johnny Mathis. That was her favourite. Frank Sinatra; that's what I remember growing up. It was playing in the house all the time. The first record that I ever bought was Janis Joplin and the Holding Company. I purchased it on my own, rather than taking it from work, when I was in sixth or seventh grade.

Did you ever think that vinyl would come back the way that it has?

Yes. Actually, I did. I've seen it come and go a couple of times now. Back in 2007, it was starting to wane, but then it came back again. People were starting to realise that CDs hadn't delivered on the hype: they deteriorate, they don't last forever like

everyone thought they would. I remember telling the owner of a CD-pressing plant we were working with one day that business had been kind of slow, and we should lay off a bunch of people temporarily and tighten our belts. These guys were getting old. They basically said that I was out of my mind and that they would never do that shit. I said 'OK, I guess you'll just have to sell the place'.

Oh my gosh. Between this prophecy and the end of the CD-pressing plant, how much time passed?

Not long enough. I still rub it in every time I talk to them! It was probably two years? It was pretty quick.

You have seen the demand for vinyl ebb and flow. Why do you think vinyl is surging in popularity?

Because it's something new for the purchasing generation. They have seen an iPod, downloads, CDs, streaming; vinyl is something new. An album cover, artwork, liner notes... It's a tangible product.

Do you think this is just a fad that will pass?

I don't know. It's hard to say. I think it will slow down somewhat. There are people investing some serious money these days and they are building plants – which is a surprise. I didn't think that would ever happen. I just thought that the existing plants would either expand or ramp up. I'm really surprised at the number of new plants that are trying to come online. I definitely think it will flatten out.

Any last words of wisdom?

If you want to build a record-pressing plant, give me a call!

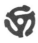

ADAM GONSALVES

MASTERING ENGINEER

Adam is the senior mastering engineer at Telegraph Audio Mastering. He is known for
his expert handling of both digital mastering and lacquer cutting for vinyl. From 2010 to 2013,
Adam produced a podcast on this subject: *Square Cad Mastering*, and is an
Apple Certified iTunes mastering engineer.

What vinyl-related services do you offer at Telegraph Audio Mastering?

Telegraph is a full-service mastering studio. We provide full and complete vinyl mastering, which means preparing the audio for a good transfer from the recording to the vinyl product, as well as cutting the master lacquers. These are sent off to electroforming, and then the pressing plant.

Speaking of lacquers – could you explain the differences between a 'flat cut', 'master lacquers' and 'reference acetates'?

A flat cut isn't an object, it's a process. Let's say you are a band. You haven't hired me to master your record, but you would like to put out some vinyl. Instead of having me master the record, I can do what is called a 'flat cut'. I will take the songs as you have them, then just cut them as they play. I don't make any changes, even if the music could be sweetened or adjusted. I'm hands-off. I'm just making a transfer of the music you provide me onto vinyl. The quality of the music you get for flat cuts can vary, as well as how well prepared it is for the format. Some people don't want you to master their record, or they've had it mastered by somebody else. They just want to take the master that someone else prepared and make lacquers from it. A flat cut is a way of preparing, as opposed to full vinyl mastering.

Master lacquers are the objects that start the vinyl manufacturing process. They are aluminium discs that are coated in lacquer, then put onto the lathes. Two lacquers are cut for a two-sided record – one for side A and one for side B. The A-side is loaded into the top of the press and the B-side into the bottom. The two sides squeeze what they call at the plant 'the biscuit'. This is a little warm piece of vinyl that becomes a record. So after I cut those two lacquers, I box them up and send them to what is scientifically known as electroforming; 'electroplating' is the colloquial name. What happens at an electroplating facility is this: there are big tanks full of a solution made from water and dissolved silver, and there are large, heavy balls of nickel in the tank. Lacquers, one at a time, are dipped in these tanks, and a beefy current is applied. All of the dissolved metal that is floating around in the water sticks to the lacquer. The longer you hold the lacquer in the tank, the thicker the build-up. After a few hours in the tank, the lacquer is taken out. A metal imprint is peeled off of the lacquer; that is the beginning of the stamper process. The metal imprint is called 'the mother'. You clean the mother off, you get it prepared, and pull stampers off the mother. The reason this process is useful is because a stamper is good for making about one thousand records. If you make a mother first, you can pull multiple stampers off it. That means in the future, if you want to re-press or if you want to make more than 1,000 records, I don't have to keep cutting lacquers. I can cut one set of lacquers, they can make one strong mother from it, then pull multiple sets of stampers from that mother. The stampers are mailed to the pressing plant. The pressing plant takes the stampers, loads them into the press, and uses them to press records.

When you send something off to the pressing plant, it takes a long time to get anything back; it's a full manufacturing process. If you are a band, and you would like to hear how your album sounds, but you don't want to wait eight weeks for a test pressing – or if you have concerns, and you're thinking 'Hey, we have this really long side and I'm not sure if it's going to be distorted at the end' – I can cut you what is called a reference acetate. That's a one-off record that I cut right off the lathe in real time. It's

> **"Vinyl mastering requires a much higher degree of skill and knowledge [than digital]. On vinyl, we are cutting grooves onto a disc."**

not a vinyl – it's not made of vinyl polycarbonate. As a result it's much softer, and it does not hold up to as many plays. But you can play it a few times, so you can listen and make sure it sounds how you like. A reference acetate is like a proof: it's not required for the process, but many artists like to receive one.

Could you explain, for the uninitiated, the relationship between mastering and vinyl a bit more?

When you are mastering for digital, there are very few constraints. Vinyl mastering requires a much higher degree of skill and knowledge. On vinyl, we are cutting grooves onto a disc. We literally have 12-inches of space to fit all this music, for each side. If you are trying to cram a lot of music on there – for example, one common challenge is that one side is much longer than the other – the geometry of those grooves has to be very precise or there won't be space for everything. Also, there are things that are possible in digital – for example, extremely loud, high frequency synthesis information, or blow-in that's completely out of phase; I am thinking of things that happen in techno or maybe synth-based indie pop – that really stretch what's possible for vinyl playback without distortion. Record press inventors had no way to anticipate today's music when they made this equipment. They weren't thinking about hard, European techno. They were thinking about rock 'n' roll and pop. The equipment is made to cut things within a certain frequency range, stuff without too much high-end.

When you get something like that coming through the door, it's not like mastering something, then burning a CD. You have to find a way to make the music sound the way that it does on the original recording, so the artist will be happy; but cut it in a way that people are going to be able to play it back without distortion. That can sometimes be a very tricky needle to thread. Having somebody who is knowledgeable about what's possible for vinyl, what has to be done in terms of groove geometry, and what is the nominal depth for a cut of different lengths makes it easier. But there's so much to learn. How does a side that's 18-minutes long differ from a 25-minute side? How far can you push in one direction before you have to compromise in another? These things are so important; you can't just guess at them. You need to test, to try, to practise a couple times, so you're not fumbling in the dark when confronted with one of these scenarios.

The thing to keep in mind is that vinyl is the only physical playback format left. Think about the way that you buy music. Most people buy online. With vinyl, you are getting an object that's played by other physical objects: a needle and a stylus. When you look at a disc, at each side of a record – somebody had to fit this music onto a physical thing. That's fundamentally different than mastering it for consumption on a computer, then having it played back on a computer. There are concerns for physical playback that simply do not exist for the electronic format.

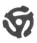

Have you always offered vinyl mastering or is this a new service to go along with recent demand?

I haven't always offered it; I have offered it for the past six or seven years. I was in the same boat as a lot of people before I got a lathe and learned how to cut. I would tell people I could prepare files for vinyl, but then you would have to hand it off to someone else for the mastering. I spent a long time looking for a lathe – that's the device you use to cut lacquer. Then I found a lathe that was in total disrepair, which is how most people find them – if they find them at all! I met somebody who was a mastering engineer from the '60s. He helped me fix it up, and taught me how to cut. I then began the long, arduous process of trying to cut over and over again, making mistakes, fucking up. I knew the fundamentals, but learning comes from practice. It's like any other highly specialised skill.

How important is vinyl to your company?

It's probably just under half of my business. There are so few people who can do this. Once you're established as someone who can, you're sought out for it. It's not that surprising in a field where there are few service providers. There's going to be an over-representation of requests for that service, because there aren't many people who do it. I still do more digital, which is pretty typical. But I do a lot of vinyl.

"Unlike digital, your playback equipment for vinyl is crucial."

So tell us from an engineering perspective: *does vinyl really sound better?*

That's a complicated one. I hear this question often – and honestly, it depends on context. When I'm going for a jog, vinyl isn't an option. But let me start first with the technical part of the answer. If you look at the signal-to-noise comparison, digital to vinyl, there's no competition: digital is better. Vinyl is a comparatively noisy format. Most people, when they're playing vinyl, are using modest turntables; they aren't using turntables that cost thousands of dollars, or with specialised tone arms. So if you're comparing based on how quiet the playback is, digital is better. It's objectively better. That's one of the reasons CDs were invented: to get away from the background noise of vinyl. Another reason that CDs were invented was to trick people into buying their record collections on a new format. So technically, digital has a lot of legs up on vinyl. One of the things that's nice about vinyl though, is that the format was designed to be very close to the way that humans hear. For example, we tend to hear the mid-range of music very, very well, and less well at the extremes. That's what vinyl reproduces. It emphasises the pleasing things about music that people like.

But does it sound better, or is it just more pleasurable to listen to? That's a more complicated question, and not one I can answer. If you don't value sitting down with friends and all listening to a record together, or sitting down with a drink at the end of the day or with your coffee in the morning, listening to a few songs at a time and consuming musical thoughts; if those things are not important to you, you aren't going to like vinyl. It will just be a pain in the ass because it's so inconvenient.

Unlike digital, your playback equipment for vinyl is crucial. You're dragging a needle along a groove that has been squashed into plastic. If you are trying to make a judgement about whether you like vinyl or whether vinyl is worth it to you, it's probably worth investing in a nice turntable. The nicer your playback set-up is, the more I think you're going to enjoy it. I think that sometimes there is an 'in group / out group' thinking in terms of vinyl, which I understand. Vinyl has a rich culture around it, and that can't be diminished. There are a lot of subcultures that exist primarily because they helped prop vinyl up during the downturns. When you think about punk hardcore, indie rock, dance music, underground hip-hop – those things kept the format alive during the CD days. A lot of people who are part of those musical subcultures have a really fierce adherence to vinyl, and I love that. But if there's a young person who is thinking about getting into vinyl, it's just one of many options. There's no reason to be binary about it. If you think about it, vinyl is ancient technology. The technology to play back phonographic records is almost 70 years old at this point. Why has this format endured? With all of the innovations that have come, with all of the formats that have been birthed and died since vinyl was created, why has it endured? I don't think it's because of its amazing technological prowess – although in its own right, the vinyl record is a technological marvel. I think it's because of the humanity of the product, and the way that it forces you to engage with music. That's what has people coming back to it.

SIMON RAYMONDE

MUSICIAN / PRODUCER / LABEL FOUNDER, BELLA UNION

Simon Raymonde made a name for himself with the 1980s and '90s band Cocteau Twins.
He founded the independent record label Bella Union, which has signed bands such as
Dirty Three and The Czars, Midlake, Beach House and Fleet Foxes.

First vinyl memory?

Stealing money from my brother to buy records. He used to have a coin jar, a pint mug with 50-pence pieces in it where he would keep all of his change. When he was away at university, I used to pop up there and top up my pocket money. I would go down to Small Wonder Records in Walthamstow and buy punk singles. I am 54 now. I was 14, 15 when punk happened, so I could not have been luckier in terms of when I was born. Pretty much every weekend, I would go and buy the next batch of punk singles. I am looking at them right now; I still have every single one of them.

What was your first vinyl purchase and what did it mean to you?

I think the first record I spent my own money on was the Sex Pistols. My brother had bought me a £50 Woolworths bass guitar for my birthday that year. I remember learning how to play all the bass lines of the Pistols and the Elvis Costello record *My Aim is True* as a 15-year-old. That's my memory of physically owning music for the first time.

The Cocteau Twins had some legendary covers. How did you pick the art for your covers? Do you still like them 20 years on? How has this translated into the cover art at Bella Union?

At the time, we moaned a lot about those record covers. *Treasure* was the first album I was on, back in 1984. It gave us an image. At that point, we were completely uninterested in visuals, to be honest. We were just basically punk kids who didn't have too many ideas on the visual side. We knew what we wanted to do in the studio, but we didn't know what we wanted our band to look

like. On stage, we did fuck all. We didn't have lights, we didn't have any productions. On our sleeves, we were pushed into using the 4AD art team. Obviously, their stuff is really beautiful and iconic. But at the time, we fought against it a little bit. We thought they were making us out to be this bunch of fey Victorian wizards. I suppose in hindsight, it was a cool thing, because we didn't have much in the way of image. The sleeves gave us one, and they gave it vicariously. They didn't look very punk rock – having lace and all that on the covers. But looking back, they were really cool. Once we had a little more confidence, we did the sleeves ourselves. With *Heaven Or Las Vegas*, we went with a photographer and a designer called Paul West. There are a few sleeves I think are great – like the *Echoes in a Shallow Bay* and the *Tiny Dynamite* sleeves; they were two 12-inches we put out. If you look at what 4AD's designers did, they pretty much broke the mold for sleeve design.

When you're a punk rock fan at age 15, you're interested in the physical side of it: the music, going out and meeting people, letting it take over your body. The sleeves weren't something that bothered me that greatly. The 4AD experience did teach me stuff though, and nowadays the way I run Bella Union is that I let the bands do the artwork themselves, if they want to. If they have absolutely *no* ideas, like we had no ideas, I am happy to have them use our in-house designer. He is really great. But he isn't somebody who pushes his own art towards them and says, 'I think you should use this.' He is much more collaborative. He will think about what they want – even if they may not be able to articulate it very well. You find quite a lot of musicians are not particularly articulate about their art, especially when they are younger – that's why they make music. They communicate in another way, so sometimes those conversations

> " In my opinion, if we didn't have the vinyl format, I wouldn't be doing this. There's no interest in just putting out a digital file to me. "

about record cover art are difficult. As a designer you have to be instinctive, because sometimes what the artist says is rather incoherent. So I am very opened minded about it. If the artist is giving me something that I think sucks, I will say so. Ultimately, it's their sleeve, and I don't give a fuck. I will offer an opinion, quite often they will go 'Oh shit, it's awful, let's change it.' But for some people, what I think sucks they think is awesome, and I have to respect that.

How does a vinyl release differ from a digital one in terms of marketing and the cycle of an album?

In my opinion, if we didn't have the vinyl format, I wouldn't be doing this. There's no interest in just putting out a digital file to me. The whole thing is just boring. I have never met a band who, when I sent them their digital album cover, said 'Wow! I am so excited!' But if you give an artist the vinyl pressing, the joy they feel... There's no comparison. I get no excitement from listening to music on Spotify, whereas when I buy a piece of vinyl I open it up, I smell it, I put it on the turntable. I'm 100 per cent invested in vinyl. It goes back so many years; I can't really do without it. Obviously, if you are younger, your exposure to it is going to be much less than mine, so your commitment is going to be less. But as far as I'm concerned, if I didn't have vinyl to make, I wouldn't be running a record label. It just wouldn't interest me enough.

Is there a special relationship between vinyl and indie bands? Indie labels?

Yes, very much so. I think that when you're a teenager coming to music for the first time, you're not going to get excited if I say, 'I am going to put your record out digitally.' If I say 'I'm going to make 300 copies of a 7-inch and we will make it on red vinyl.' I see these kids' eyes light up. It's as basic as that.

I totally understand them. I feel very similarly about it, even though I've been doing this for a long time – the label is almost 20 years old now. I don't know if it's an indie thing; maybe if you are a major label band, the idea of your record coming out on vinyl isn't very interesting. They're more concerned with playing a huge arena, and getting the experience of the live vibe back from there. That's probably how that works. I don't know for sure if it's an indie label / major label thing, but virtually everyone I come across in my world is motivated to put vinyl out. There are a lot of drawbacks to it at the moment. Pressing plants and the time it takes them to make a record; these things push people away because you have to say to a band, 'Look, if you want a vinyl version out, we are not going to be able to release it for at least six months.' That can be really hard for artists to accept. So there is good and bad in it. For the most part, the experience is very positive.

Independent labels and artists make vinyl. If we're not doing that, what are we doing? If we are just

there, putting files up on Spotify... I mean, any idiot can do that. The whole point of making vinyl is to see it on tour, put it in shops, do promotions with Rough Trade, be involved with independent retail – it's about the whole process. It is not just about making it; it's about selling it and spreading the word. That relationship continues from the artist to the label. The label then sends it to the record stores. At that point, you have those cool kids who work in retail stores; they recommend the product and pass it on – without them, you have nothing! You are nothing! They bring the excitement about the vinyl – about the music – to the customer. Without them, the whole thing falls apart.

Why did you open your record shop?

It was actually a bit of a whim, if I'm being honest! Me and my wife spent our first few dates in record shops in Canada. We kept saying 'Ooh, it would be fucking great to have our own record shop.' Years later, my wife was out getting her nails done in Brighton. She walked back down this tiny little alleyway. There was this 'For Rent' sign in the window, and she sent me a picture of it on WhatsApp. I said, 'That's really cute. Let's go have a look.' We went in. I asked how much the rent was. It was so cheap, it was practically free. We had records to fill the shop – as by that point, I'd owned the label for 20 years. We figured we'd make it a Bella Union only shop, so nothing was for sale but our own product. We gave it a go, and took the lease on in October 2016. We talked about it all the time: how we wanted the shop to look, how we wanted the experience to be.

It's a tiny shop, and we love how it feels. The reception we have had from the customers is amazing. It's very new – we've only been open a couple months – but I already feel like the town is really happy with us. Especially since the area is a

bit scummy. You come out of the shop, and there's some guy smoking crack in this dingy alleyway with lots of graffiti on it. At night, people from the pub down the road go there to take a piss. It's not somewhere you'd want to walk on your own at 3 a.m. in the morning. Having said that, we're trying to engage with the council. They're really awesome down here; they really want to help brighten it up, light it better, encourage more people to come down here. Our lane isn't like the North Lanes, which are quite posh and really lovely to walk around. We're trying to be the first to improve this particular area of Brighton.

I worked in shops until I joined the Cocteau Twins – so until I was about 20. I managed some shops in London; I always loved the experience of passing on my taste and my tips. In a funny way, I'm still doing that now with the record label. I love that immediate interaction with people. I love saying 'Hey, you should buy this John Grant record... And by the way if you like this, you may really love this.' That whole thing of building long-term relationships with people, encouraging them to come back time and again, is amazing. When a customer goes, 'Oh remember that single you told me to get? I absolutely love that', it's a brilliant thing to hear, because you know you've passed this on to someone who has experienced as much joy out of it as you did. That whole experience is very rewarding.

What's your favourite record cover?

I love *The Terror* by the Flaming Lips. It's metallic and gold and shiny. You can't stop looking at it. I think they got inspired by the Steppenwolf album from the '70s which had this sort of metallic, foil sheen to it. I don't know how they did it back then, but it must have been pretty expensive. It's got this apocalyptic, end-of-the-world, nuclear-

explosions-just-happened kind of feel about it. It goes with the music as well. The music of that album is pretty terrifying. It's electronic, very dark, and with an early Cabaret Voltaire feel about it. Very different, for the Flaming Lips! That sleeve is one of my favourites of recent times. They have this brilliant designer called George Salsbury, who works very closely with Wayne Coyne of the Flaming Lips. Obviously, Wayne is massively into the artwork, with the cartoons and graphics. He's a super-interesting fellow, and he has a lot of ideas. It's wonderful that they have an in-house guy there who they can collaborate with so well. Because I think all of the Flaming Lips sleeves are fascinating.

I'll tell you another one: the Father John Misty sleeve. It's a Bella Union album, *I Love You, Honeybear*. The artwork is sort of like a cartoon illustration; it's fascinating and it's dark, and you can spend literally hours looking at it, opening the sleeves, seeing all of the different characters in different guises. I love sleeves that you can actually sit down and look at for a while, rather than putting them down without engaging with them in any way. That's fine, but the ones that really make an impression on you, like the Flaming Lips one or the Father John Misty, those are ones you really gravitate towards when you are pulling out a record, because you want to see the art. The Father John Misty one is really special. The de luxe version of it has a MIDI player inside it as well, so when you touch the sleeve, it plays a MIDI file of one of the songs. It also has a pop-up, so that when you open the gatefold, this absolutely incredible pop-up unfolds with characters from the front cover. There's also an instruction booklet inside on marketing. Father John Misty is a hilarious, super-intelligent musician and artist, who is also thinking very laterally about life in general, and the music business and himself as an artist. He plays with the whole thing of being a rock star. Sometimes you read a piece or you see something, and you're like, 'Is he for real? Or is he taking the piss out of everyone else?' He's actually like that in real life. Sometimes he says things, and I think, 'Was he being serious or was he being a wind-up merchant?' I love that playfulness. And I think it comes across in his sleeves. Artists can use their artwork as a window into their psyche.

Crucial release for any audiophile to have, because it sounds so much better on vinyl?

The Mercury Rev album, *The Light in You*. That's the case in point. I will fight someone to death if they argue against it! When I got the test pressing back off that album, I couldn't believe it. I was texting all my friends saying, 'Have you listened to the test pressing of Mercury Rev? It sounds 50 per cent better than it did when I got it from the studio. How is that even possible? How can the vinyl sound *that* much better than it did in the studio?' I sent it to the band, and they were just astounded.

The thing is, it's not louder; sometimes you can be fooled by mastering where they have basically just

compressed the vinyl to up the volume. When you hear something that is louder than you've heard it before, it's easy to go: 'Wow this is amazing!' But it's not really any more amazing – it's just louder. In this case, it was nothing to do with the volume. I was actually hearing new things, things I didn't hear in the WAV files that were sent from the studio.

I also feel that about the Nick Drake album *Pink Moon*. In the '90s when I was touring with the Cocteau Twins, I used to have that on my iPod and on CD. I knew that record back to front. I listened to it on my headphones when I was travelling all around the US and around the world. I had only had the CD, but then they reissued the vinyl. I got a really nice system at home for the first time in a long while: lovely Hi-Fi, old Swans turntable, lovely old amplifier, and these KEF wooden speakers I bought off eBay. I got the whole thing for like £300. I set this beautiful system up, put this Nick Drake record on, and I was looking at the sleeve thinking 'What have they done? This is a different record. I have never heard *those* instruments before.' I was literally blown away. I stood in the living room without any words, thinking, 'What is this?' It was exactly the same record, it was not remastered. It was the original, just a reissue of the original pressing. I think with vinyl, the stereo picture is just clearer, so you just hear things in a different place.

I dread the day I wake up and don't get excited about listening to music, whether it's something old or something brand new. That's my greatest fear. I still have as much enthusiasm for it as I ever had – probably more. I get so distressed about the world, and what's going on outside of my headphones. I

pretty much just want to hide in those headphones for the rest of my life. Music is the only place where I can make sense of things.

Any other last words of Simon wisdom?

The importance of vinyl can't really be overstated. Today I saw something that really annoyed me. It was in *NME*, I think. It said something like, 'Vinyl buyers are all lonely, introverted middle-aged men.' I was like, I am one of those things. But that is a hideous generalisation. I don't believe that to be true. I can only go by my own experiences – but the people that come into my shop are anything from 16-year-old kids who want to have a piece of vinyl by their favourite band, to 65-year-old men and women. We're not just selling to one bunch of people. I think we need to get rid of this idea that vinyl is just for nerds and old farts. It absolutely isn't. You don't just buy a couple bits of computer gear and have yourself a pressing plant. There's no end to the technology and manufacturing stuff that goes into pressing: oil and plastics and hydraulics. You don't learn how to do that in five minutes. There's only a small bunch of people left in the world from those original pressing plants who can teach new, young kids how to press vinyl properly. So there's going to be a process of teaching, and of learning, over the next two or three years before we see more pressing plants spring up. Until then, the prices are going to be high, and the pressing time will be high. If you're a 15, 16, 17-year-old kid, and you go into the record shop and see your favourite band's vinyl is on sale for £22, that's a bit eesh! You don't know if you can afford it. You would love to – but this CD is only £9.99. I think that until the prices come down, vinyl is always going to be a niche thing. But that's OK.

People will always gravitate towards something that sounds that beautiful and looks that good. When my kids were 15 years old, and were loading

> **" People will always gravitate towards something that sounds that beautiful and looks that good. "**

a million songs onto their iPods from Limewire [file transferring site], I literally believed we were fucked. If *my* kids were doing it, you could be sure that every 15-year-old in the world was doing it. If they believed music should be 100 per cent free, how were you ever going to convince them that there was a value to it, and that artists should be paid? Unbelievably – and here is proof that miracles do happen – as they got a bit older, as they got tired and bored of free shit, the ethics came into it, and they started to develop more of a conscience. They, like us, get older, and become more interested in owning things. Because there's nothing interesting about having everything at the touch of a button on your mobile or your computer. There's no soul to it.

You suddenly move into a bedsit, what are you going to do in the evening? You're going to watch a bit of television on your computer, maybe. But if you're into music, and you have seen vinyl on sale at your favourite bands' shows, you're going to be like, 'I would really love one of those.' But you can't really afford a record player. But you know what? You're going to go and buy it anyway. That's exactly what happened to my kids. Not because of who I am, not because I am into music and into vinyl, not at all – I never pushed them towards it. When they were downloading shit for free, I literally gave up! Then when my son was 21, he said, 'Yeah, I bought the Squarepusher vinyl.' I said, 'What?' He said, 'Yeah, I can't afford a turntable right now but I got the vinyl.' He was like all of us: you get a bit older, you get a bit of money in your pocket, you get some cash,

we want to have something on the shelf. It doesn't matter if they're interacting with it in the way that it was made for us to interact with. Here is the weird anomaly of today's record business. People that come in the shops, in the record shops, are buying vinyl that they do not listen to. They are buying the vinyl, and putting it on the shelf. They either don't open it or slit the shrink packaging and take the CD out, which will be played in cars that still have CD players. These are the weird things happening that I never predicted. I know if it was £10 or £12 for an album, we would be selling shedloads of them. That's a very positive way to think about the future. There really is a demand for this beautiful thing that people have enjoyed for so many years. It's not dead, it's not gone, and it's not just a playground for people in their 50s. It's for everybody.

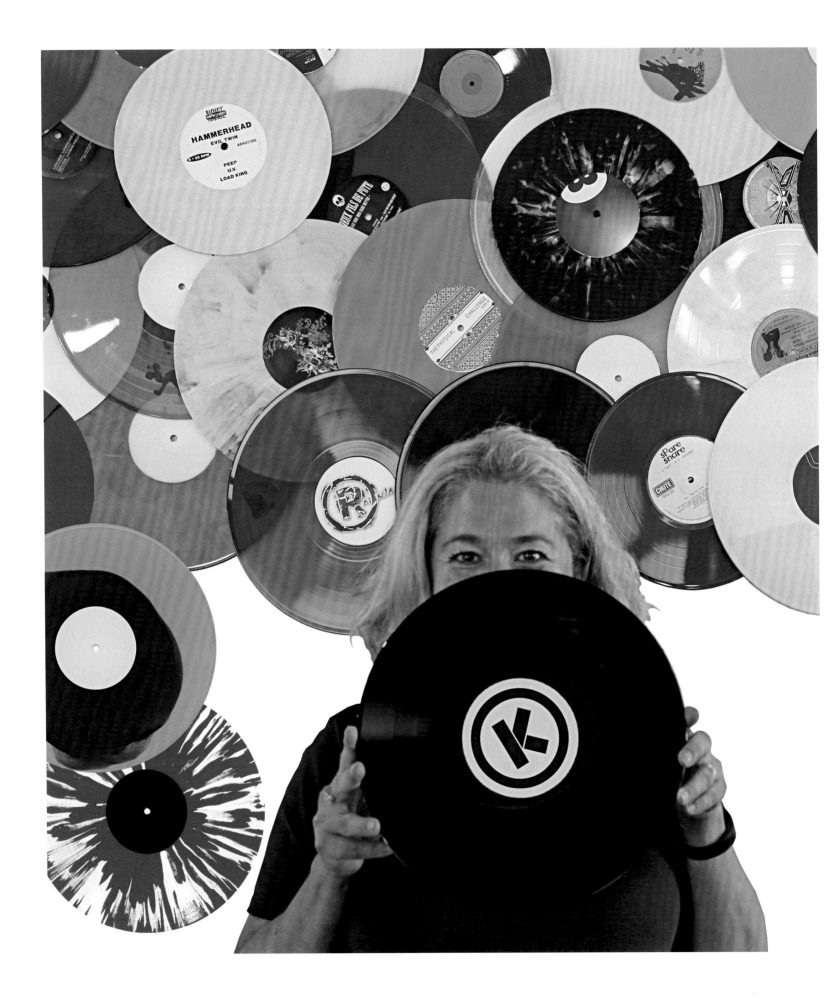

KAREN EMANUEL

FOUNDER, KEY PRODUCTION

Karen's career began at Rough Trade Distribution (RTD) where she started as a receptionist and finished as Head of Production. During the demise of RTD in 1990, Karen started Key Production, an agency that project manages the manufacture and supply of product to the music industry, from vinyl records and cassettes to CDs, associated print and packaging, and merchandise.

> **"** Maybe because we almost lost vinyl for a while, people have come back to it more adoringly. It's about the beauty: the beauty of the sound, the beauty of the artwork – the beauty of the record. **"**

Why is vinyl important?

It is an amazing format, both to look at and to listen to. I think where it wins over downloading is that it tells a story. When you want to listen to an artist, you want to listen to them in the way they want you to listen to them. On an album, there's a progression through the tunes and through the sides. When you are downloading things, you're just picking random bits, hearing them out of context.

For me, the artwork is really important too. Nothing beats picking up a piece of 12-inch vinyl and feeling it, touching it, reading the liner notes. It's iconic.

When you see DJs using it, you see an art form. When the DJ is going off a computer, I just feel, 'I could do that! What's the point, its cheating!' I love to see the magic that DJs can create by mixing and scratching vinyl.

Going back into your history, from your time at Rough Trade – what role did vinyl play in creating an artist brand?

My life was all about vinyl because that's what sold. We were doing hundreds of thousands of units; the amount of pressings we would do were beyond thought. People seem to care a lot more about the quality of vinyl now than they did then. Then, it was all about getting it in the charts, and getting

it very quickly. We used to press vinyl – and this would be unheard of now – in a 24 to 48-hour turn-around. When something was charting, you just needed that product out there. There were so many pressing plants, so much availability. It's a completely different story these days.

Big organisations like Sainsburys and Tesco have started to carry vinyl. How will this impact the renaissance of the format?

I was brought up in a world where retailers were selling records. Boots was one of the biggest high street stores that stocked them. Woolworths used to be another place where you'd go and buy your records – nowadays they only exist online. It was all about high street retailers in the past. In a way it's a good thing that the big chains are carrying vinyl again, as it's making more people aware of the medium. The bad thing is that high street stores demand big discounts if you want to stock your product with them. They want big names: they won't be stocking many independent releases. They won't have people working there who know about the music. The beauty of going into an independent record store is that you talk to the people who work at that store, and they are all really knowledgeable. They get excited about new music, and they make *you* excited, and help you to learn new things. You aren't going to get that in the big stores.

Why did Key Production continue to offer vinyl as a format when it was out of vogue?

There have always been small niches who want vinyl. For a time, it was all about dance music and DJs. We did loads and loads and loads of 12-inches for that crowd. The other thing is that the independent sector has always released vinyl. When I first started, it was all about the vinyl; then CDs came and took it over; but we have always had a steady output of vinyl because of the kind of client base we keep. While vinyl sales may have gone down overall, they remained steady for us. Then it became more and more popular in the independent sector, so more and more independent record labels were doing it. There was a lot more 'special' vinyl put out. Then the majors clocked on, and realised, 'Oh, hang on a minute, we haven't been putting anything out on vinyl! Everybody wants vinyl – shit, we had better go and do it now.' That's what has caused the current explosion, and the difficulty of getting vinyl out quickly. Suddenly all of the major labels are putting all of their new releases and re-releasing all of their back catalogue on vinyl. That's a hell of a lot of product, and it has caused a lot of bottlenecks.

What specific demands in the vinyl market are you seeing?

It varies. It is mainly album-based product. For Record Store Day, we do a lot of coloured, splattered, 180-gram vinyl. We do everything for everybody. For a period of time, you will get everybody wanting to do a 10-inch. Or everybody wants to do etched vinyl. Then it goes out of fashion again. I would say that a lot of people like the heavier vinyl. We have also seen a constant trend for beautiful packaging, especially boxsets. When people are fans, they want to have and to hold. They want to own something from the band,

and they are willing to pay money for it. Rather than a standard album in a sleeve, we are doing products that have really beautiful coffee-table books with them, signed paintings or artwork, all these different accessories. We're seeing a big trend towards that. While you produce less of them, the margins for the labels, and for the artists, are a lot higher. And the fan gets something absolutely stunning in a limited edition.

What's your favourite project that you have worked on?

One of my favourite things to come out in the last couple of years was Nick Cave's *Push the Sky Away*. I know the amount of work that went into it, how it evolved and how it looked at the end. The process of making a vinyl record is like nothing else on this earth.

Favourite record cover?

That's impossible to answer; there are just too many. *Orchestral Manoeuvres in the Dark* springs to mind – the one with all the die cuts, the '80s self-titled album. You pull it out and it's one colour behind and one colour in front. That's the first time I noticed something clever being done with the packaging.

How does the relationship between vinyl and fans differ now, compared to when you first became involved in the music business?

I think it's changed. When I was growing up, there was only vinyl. It was all about the release. It was about going down to the shops, getting the record and playing it with your friends. Now it's a lot more about the product. Maybe because we almost lost vinyl for a while, people have come back to it more

> **"** It's hard to know what the kids are going to do – whether they think it's a trend or whether they genuinely like the sound, the art, everything. **"**

adoringly. It's about the beauty: the beauty of the sound, the beauty of the artwork – the beauty of the record. I think it has become more of a creative and artistic whole.

What does vinyl's return say about the place and space of music in our lives?

That maybe people are listening to music in a different way. We are taking more time about it. Downloading and physical product go hand in hand. People consume a lot via downloading and streaming – they work out what they like. Then they go out and buy the vinyl, and really get to know the artist. Before, you bought the single. The physical single. I have seen it change so much recently with the younger generation. A few years ago, kids didn't know what a record was. Now, my friend's kids are asking for record players for their birthdays. It has changed very much in that sector – they think it's cool.

Will vinyl continue to be in vogue, or is it just a trend?

For me, it never went away. So I cannot actually see it going away. I think vinyl has been brought back into everyone's psyche. The older generation

that has always bought vinyl are never going to stop buying vinyl. It's hard to know what the kids are going to do – whether they think it's a trend or whether they genuinely like the sound, the art, everything. If it's that, then yes, it's going to stay. I can't see it going away in the near future. I can see there being less hoo-ha about it as a medium, because it will just become a standardised product – everything comes out on vinyl. Record Store Day has done quite a bit to promote special releases, but there's also a slight backlash against how the event sidelines the smallest labels. I don't think vinyl is going away; I think it may just calm down a little.

What was your first vinyl purchase and what did it mean to you?

The Specials single 'Ghost Town'. They're probably the band I have seen the most, and are also the first band I ever went to see. I sing along to every tune. They were amazing, and they mean a hell of a lot to me.

Final words?

The plural of vinyl is vinyl. Not 'vinyls'!

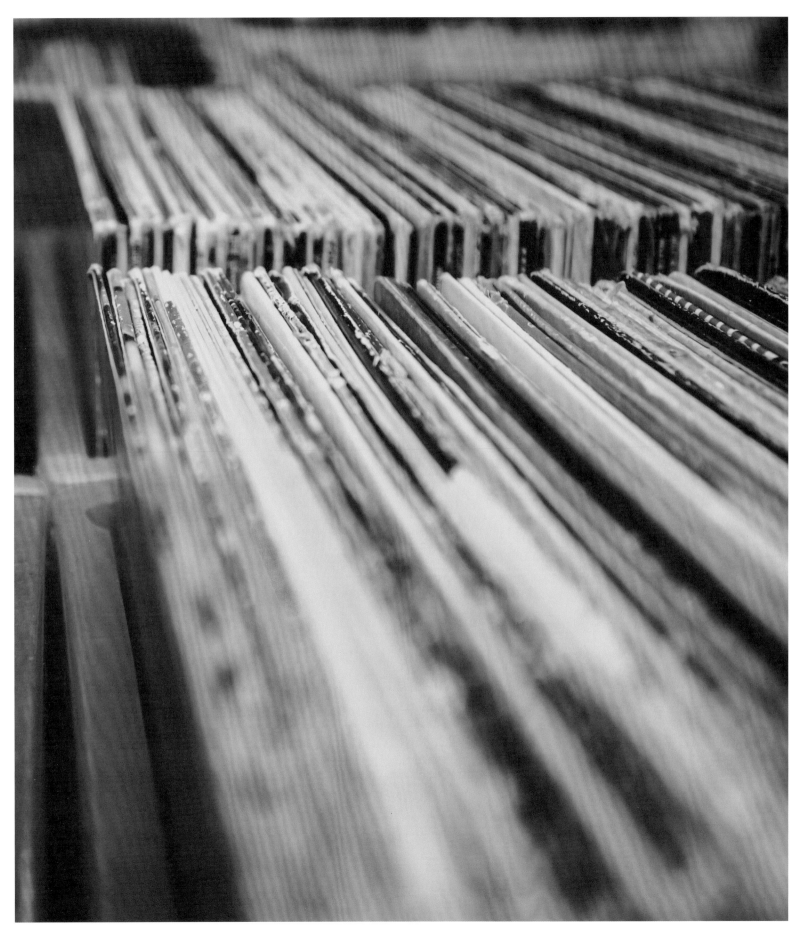

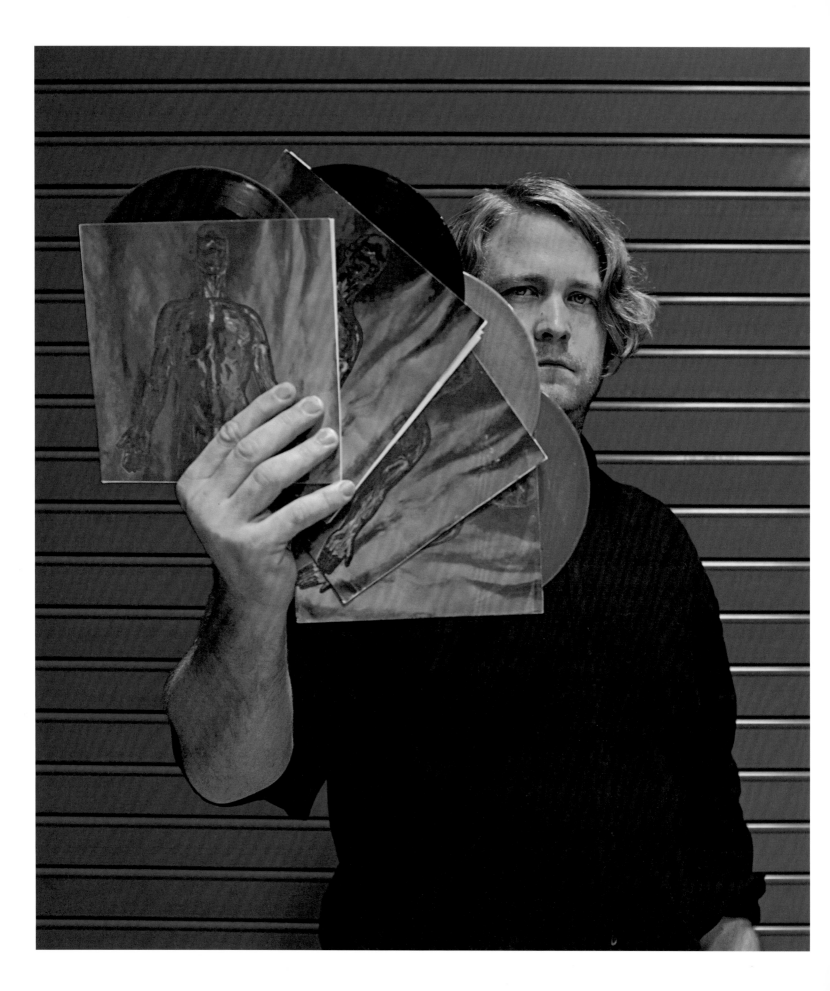

BEN BLACKWELL

**MUSICIAN / RECORD COLLECTOR /
DIRECTOR OF OPERATIONS, THIRD MAN RECORDS**

Ben Blackwell was the first employee at Jack White's record label, Third Man, and currently works as The White Stripes' archivist. In addition, he is an avid record collector, and a drummer. He plays with The Dirtbombs, a Detroit-based rock band known for opening for bands like Blondie, Radio Birdman, and the Yeah Yeah Yeahs.

When were you introduced to vinyl-making as a business?

My first real exposure to the label industry was in 1998, working for Italy Records, a small independent record label in Detroit. The White Stripes were putting out their first record with them – their first release of any kind! At that time, vinyl was the simplest way for a new band to mass-produce music. It wasn't seen as the next big thing, or as a sign of vinyl's 'comeback'; it was just easier than putting out a CD because it was cheaper. For 15-year-old me though, it was cool. I thought: 'That's underground. That's the real shit.' All of my favorite bands – The Stooges, Nirvana, the Germs – all of their first recordings were released on vinyl. It seemed a no-brainer: you couldn't be a music fan without a record player.

At the time, there was so much music on vinyl that never made it to CD. If I wanted to hear Mudhoney do a version of 'Baby Help Me Forget', that would only be on the B-side of a 45rpm, not on any CD. I, as a Mudhoney fan, needed that vinyl to understand the band, their history and their legacy: what they had done, what they had produced. However, that was a time where you could walk into any Salvation Army thrift store and pick up a $10 fully functional record player. Nowadays, things have changed.

What's your first vinyl memory?

It was seeing an ad on TV for a *Monkees Greatest Hits* record. I bugged my mom to get it for me. Not long after, that record showed up at our house. I didn't feel like I possessed it though; that feeling would come later. I liked the songs 'I'm A Believer' and 'Steppin' Stone'.

First vinyl purchase?

The first vinyl purchase I partook in was Weird Al Yankovic's 'Fat' on 45. I remember being with my mom

at a record store, Harmony House in suburban Detroit, seeing that record on the wall, and saying, 'Mom! Mom! We should get this!' I'm sure she just thought it was funny or cute that I wanted a record. That was the first transaction I participated in. Even though it wasn't my money, I felt like that record was mine.

The first record that I legitimately bought with my own money was a 7-inch copy of Nirvana's 'Sliver' on Sub Pop. That was probably 1995 – so I was 12 or 13. I had read the Nirvana *Come As You Are* book, and I had read about that single. That version of 'Sliver' has a drunk answering-machine message that Krist Novoselic left for one of the owners of Sub Pop. They put it at the end of the record as a kind of joke. But it never made it onto CD. I saw the 'Sliver' single on the wall at a store and thought, 'Oh, I have to get that!' And it went downhill from there.

What are your favourite album covers and why?

Any one-of-a-kind covers, hand-painted ones especially. Kelley Stoltz did an album called *Antique Glow* that he self-released. All of the covers were hand-painted, on reappropriated thrift-store jackets, completely different from one to the next. Another buddy of mine talked about trying to assemble images of these covers – there were probably two or three hundred out there – to create a poster showing all the different ones. Things like that make the product personal. An artist can't hand-do every album cover, of course, but I like the personality and that uniqueness aspect. So for Kelley Stoltz's *Antique Glow*, I have four copies. I bought one at Amoeba Music in San Francisco on a whim before I even knew Kelley. A mutual friend of ours suggested that I buy it. Then I contacted Kelley, put out a record by him, and asked him for more copies. I said, 'Look, let me give these to people.' So I gave one to Jack White, I sent one to John Peel, and I shared it with Ian Svenonius from

Weird War and Make-Up; he was really into it. I tried to spread the word, but I kept handful of them as well.

Why do you create live pressings of shows?

People like it. When a live show is cut directly to vinyl, I definitely see a stronger reaction from the crowd than if we are just recording to tape, which we also have the ability to do. There's an 'in the moment' presence in the room. Everyone is aware. They know that this isn't perfection, and anything can happen; it's that sort of vibe. I think it's good.

What was the thinking behind 'The Vault', your members' record club?

When we started The Vault, I wanted to make a White Stripes Live subscription club. We had this embarrassing amount of White Stripes recordings, hundreds of them. I wanted to do one live White Stripes album a month. Just generic, rubber-stamped jackets. We were thinking we'd only get a small number of subscribers, as this was before vinyl made its comeback; we were just doing our own small thing. Pretty early on in the discussions though, we realised that it would be a lot of work. And that it could get old and boring pretty quick. The next idea was to switch it to quarterly, four times a year. The recordings didn't have to be White Stripes. They could be anything. The first one we did was a mono version of The White Stripes album *Icky Thump*. It was a single, two unreleased songs – they were both cover songs by The Dead Weather – and an exclusive, Vault-designed T-shirt. Every package would be in that format: an LP, a 7-inch and some bonus item. We've stuck mostly to that. We change it up for boxsets – sometimes we might not include a 7-inch then. But on the whole, that's what we've been doing for the past 29 packages. It's pretty crazy.

We had begun making limited-edition coloured vinyl records that we were selling exclusively at our storefront here in Nashville. The immediate online complaining class started: 'Well, I live in Sweden. I would love to come to Nashville and buy your coloured vinyl, but I can't. *Do* something about it.' Our thought was that we could start this subscription series for our unlimited limited records – 'unlimited limited' means that they are available to everyone, anywhere in the world, but the record will only be available to purchase for 30 days. It doesn't matter if you can show up in person or not. Once those 30 days are up, we count up the number of subscribers we have, we press up the number of records based on those subscribers, and then they get them in six to eight weeks from there. I don't think we ever anticipated that we were creating a community. We fell into that. But we work hard to create an environment on the online Vault that members can take pride in.

Why did you want to have a record played in space?

Jack White said something in an interview along the lines of 'It means everything and it means nothing.' The whole point of what we do is to push the limits for record labels and artists. If we just sat here and put out records, we would be just fine – we could do that all day long, and people would buy them, and we would know what to expect. But eventually, it becomes boring. Doing something like this keeps us excited; it keeps us motivated. This isn't just sending a record to the pressing plant! There's so much else involved. How do you get something into space? What can be expected in that process? We don't just want to release the records, you see. We want to make limited editions, we want to create records that are sealed inside of other records, we want to design liquid-filled records, records in helium balloons – all that crazy stuff. Every one of those releases gets us more press coverage. It makes people that much more aware of what you can do with vinyl.

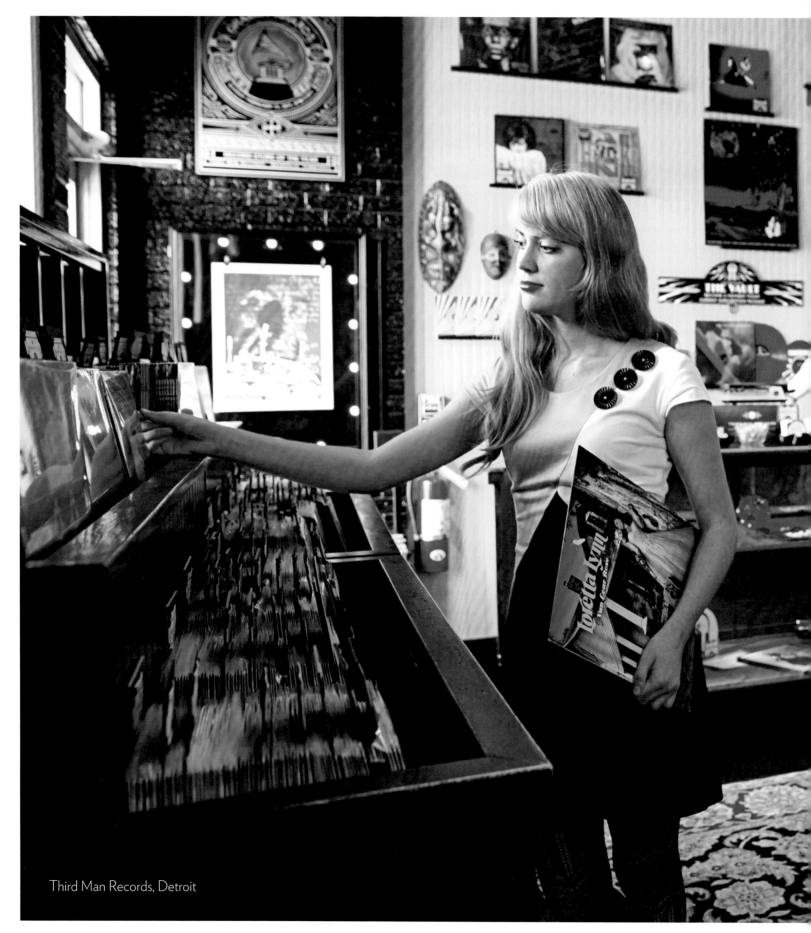

Third Man Records, Detroit

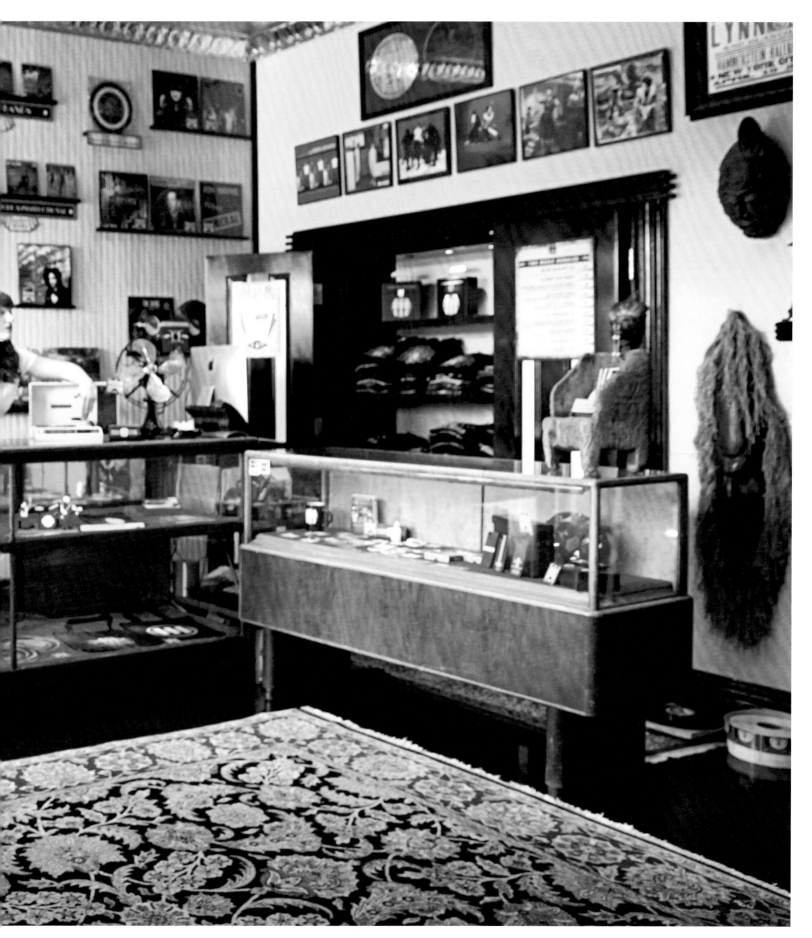

Has Third Man's vinyl focus impacted the overall place of vinyl in the marketplace?

Third Man as a name came into play in 2001, but as a functioning label, we weren't around until 2009. In 2001, it was an entity created basically as a White Stripes insurance policy for when they were signing record deals with larger labels. But every White Stripes album was pressed on vinyl. There were always 7-inch singles. We were doing coloured vinyl and limited editions back then, in 1998. We were in the right place at the right time doing the right things, and so we became one of the major forces in the vinyl resurgence. The face of our company is a charismatic, internationally-known platinum-selling artist. You cannot say that about Warner Brothers or Sony or Universal, even though they press infinitely more pieces of vinyl than we do or ever could.

All older people say about those labels is, 'Why are they re-pressing Fleetwood Mac *Rumours*? That's a dollar bin record.' There's a prime disconnect between crusty old dudes who have been going to record stores for the last 40 years, and new aficionados; the older generation is entirely disconnected from the youth market. They don't know what the current demand for titles is, from millennials and younger. The perfect story I have is from a buddy of mine who runs a record store in Detroit, called UHF Records. He was talking to me and said, 'Hey, I need a line on all the old staples.' I said, 'What do you mean?' He said, 'I used to have a stack of original pressings, maybe 20-25 copies of Bruce Springsteen *Born to Run* on a shelf in my back room. Those are all gone. I can't replenish fast enough.' It's the same thing with *Rumours*, or with The Beatles or Led Zeppelin, or Black Sabbath titles. These are things that were essentially available to us throughout the '90s. But now, if you're a 15-year-old from suburban Detroit and you want to hear Fleetwood Mac *Rumours* on vinyl, it's prohibitively more difficult. You can't find it just anywhere. And if you're a 15-year-old, you probably don't care if it is a re-pressing or an original. You just want it on vinyl.

This is a conversation I had recently with some friends. They were complaining about the Rolling Stones' *Exile on Main St.* They said, 'The reissue of that record is $45!' And then somebody else said, 'But if you go to a store, they're going to charge you $70 for the original!' All of us are guys in our 30s and 40s, and are like, 'Gosh, I got that for $5, and I could have gotten 20 more copies at that price if I had bought them all!' It's a shifting of the marketplace. Before, you could just get the used copies because that record originally sold millions and millions. That's not the case right now. So there's demand to be selling these reissues. That obviously creates backlog and glut in the manufacturing process, and the older generation starts to complain: 'Why are you pressing *Rumours*?'

I totally get it. I won't begrudge any label for pressing a title that sells. It's pressing titles that stick around, or don't move, that is really hard to justify; that's what frustrates me.

Tell us more about your Nashville Voice-O-Graph.

We knew these machines existed, but had never seen any. Jack says he always expected that he would show up on tour in Romania, and some old cafe would still have one running. But that wasn't the case. When we were assembling a lot of the coin-operated machines that we have in our store, one of the gentlemen that we were working with said, 'Oh, you should get a Voice-O-Graph.' Our reaction was, 'Oh, well yeah, we would love a

> **"** Vinyl specifically, for a long time, wasn't what you did to make money or to be cool. You did it because you loved it, you cared about it and it was art. **"**

Voice-O-Graph machine, but you can't just walk into Kmart and buy one.' And this guy, Bill Bollman, said, 'Give me a week and I will get back to you. Let me see what I can find.' He's a guy who does a lot of collecting and refurbishment on coin-operated machines. Just about a week later, he came back and said, 'Alright, I have found three that are available and for sale. Here are the descriptions and here is what they have going for them.' All of them were very reasonably priced. We thought about it for a second. This had been on Jack's radar and consciousness for a decade. And he said, 'You know what? Let's buy them all. We may never see them again.' So we bought three of them!

First one, as soon as it was uncrated we plugged it in. First attempt, it cut a record. It wasn't a great sounding record, but sounds were transmitted to grooves and it could be played back. That's the booth that we have in our Nashville shop right now. Throughout that process, there was a lot of re-engineering and reverse engineering, to make it sound as good as possible. We also had to figure out what medium to use for these discs – acetate, pressed records, plastic, etc. Throughout the lengthy refurbishment process, Jack said, 'We are never going to make our money back on this. But this is beautiful and it needs to exist, so we will make it functional.'

Then, the first day we had it open to the public, Neil Young walked in and did a song in there. I was all, '*Wow*, that is some immediate validation.' Two

or three months later, Neil got ahold of Jack and said, 'Hey, I want to do my whole next album in that booth.' So clearly we were doing something right there! The booth became the 'studio' for that album, and the 'studio' fee ended up covering the costs in regards to that. So even though we weren't thinking about the profit, we still wound up making some! Once the record came out, people saw the footage of Neil recording in there, and it was aired to millions on *The Tonight Show*. It became a thing: 'Oh, I want to record in the booth where Neil Young did his album!' So we got interest and intrigue from people all over the country, all over the world, about this little phone box-sized booth.

Any last bits of wisdom?

A lot of the people I deal with now are people I met 15 years ago. Vinyl specifically, for a long time, wasn't what you did to make money or to be cool. You did it because you loved it, you cared about it and it was art. A lot of the people I consider friends, who are 'fighting the good fight' at other independent labels like Sub Pop or In The Red Records – these are people I have known since I was a teenager. They are not going away. If you aren't into it, or you aren't good at it, vinyl isn't something you would slog at for 10, 15 years. So the people that were doing it 15 years ago are still passionate about it, despite production delays and people claiming that it's a fad or a trend. Fads or trends are Beanie Babies or Pet Rocks. This is a medium.

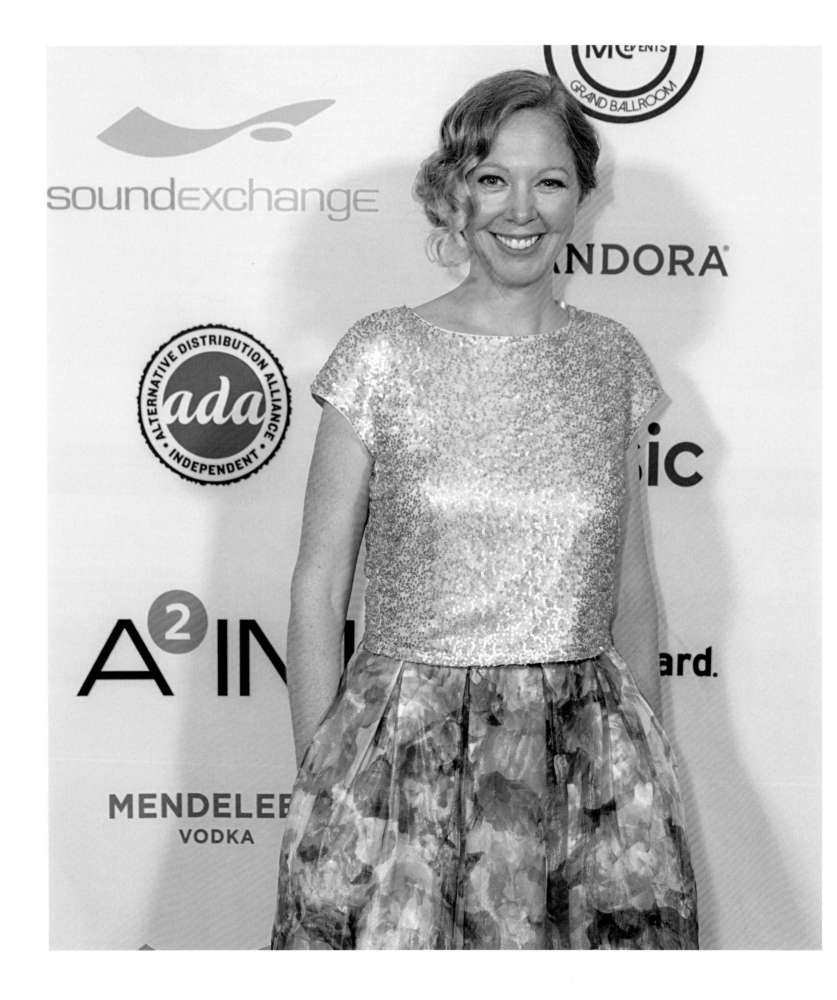

PORTIA SABIN

MUSICIAN / LABEL OWNER, KILL ROCK STARS

Portia Sabin hosts a music business-orientated podcast, *The Future of What*. She has performed with The Hissyfits, and in the 2000s she founded Shotclock Management and took over the legendary punk record label, Kill Rock Stars. Sabin sits on the Board of Governors for the Pacific Northwest Chapter of The Recording Academy, and co-chairs for the Portland Rock 'n' Roll Camp for Girls.

First vinyl memories?

There's plenty! My very first vinyl memory is being five years old and listening to *Sgt. Pepper's Lonely Hearts Club Band*. We had the *Evita* cast soundtrack, *A Little Night Music*, a bunch of Broadway cast soundtracks. Honest to God, I believe that my musical taste can be traced to the fact that the only rock record my parents had was *Sgt. Pepper*. My number one favourite artist of all time is Robyn Hitchcock, and to me that is a direct, one-to-one comparison to *Sgt. Pepper*. I see that connection. I have always loved pop. I remember dancing as a child to the *Grease* soundtrack, because *Grease* was a huge movie when I was a kid. When that came out, everyone ran out and bought that on vinyl. We all did the hand jive forever.

What was your first vinyl purchase and what did it mean to you?

I am pretty sure that my first real vinyl purchase was the double album version of *Welcome to the Pleasuredome* by Frankie Goes to Hollywood. I *love* that album. People have no idea. They think Frankie Goes to Hollywood and they just think 'Relax.' Maybe 'War,' if they are really going deep. The cover versions of songs on that album are beautiful. Holly Johnson from Frankie Goes to Hollywood has an incredible voice. He sings a version of 'Do You Know the Way to San Jose?' and an incredible cover of 'Born to Run.' I love, *love* that album. I listened to it like crazy, I just wore it out. That was a good one to get started on. I think I was 12, maybe 13 when I bought that, and I just assumed that they wrote all of those songs. Then I discovered that they were covers; someone else wrote the songs. It just blew my mind. It expanded my horizons.

I also loved the liner notes. That was what made vinyl so fun for me: to read about who played on

what song. It was so surprising, because so many people played on those songs that were not in the band. The band was like four dudes. But then there were ten other people on this record who had credits, but you didn't see them in the videos or anything. Because I was a total music nerd, I started seeing the same names on different albums, and I figured out the studio musician system. I remember in the '80s, especially because of the explosion of videos, it made you have this really strong sense of a band as a very finite unit. Like Tears for Fears is two dudes and that is it. Then you look on the liner notes on the Tears for Fears album, and there are like 20 people listed as having played on that record. You don't see all of these people on TV or even necessarily on tour. It made me really interested as to the world and mechanics of the music business. Kids today do not have that opportunity. If you buy a CD, sure, you can get those tiny little liner notes. Not with digital music; you get nothing. You often don't even get an album cover. It's so depressing.

How many records do you have currently?

Thousands! We built special shelves in the closet in our son's bedroom. Which is sad, because now he has no place to put his clothes! In our house, vinyl is more important than our child's clothing. He is just going to have to put clothes somewhere else!

Crucial release for any audiophile to have because it sounds so much better on vinyl?

One of the funniest things for me is how different electronic bands sound on vinyl. There are some New Order albums on vinyl that I really think people should hear because it doesn't sound the way people think electronic music sounds. It's not cold; it's warm. It feels really different.

Why is vinyl important?

There is something about the way that vinyl has two sides; a vinyl album tells a story. Artists used to be able to use vinyl as part of their art; they used to be able to plan an album, and say, this is going to be the first song, this is going to be the second song, this is going to be the last song – they would have a real feeling for it. You used to plan a whole album. Let's say there are ten songs; the fifth song of the first side is closing out your first side, so you would want to pick that song really carefully. There was an artistic component to vinyl. Then there was the audio quality of vinyl, which was completely different: it's a different medium and a different substance. A lot of people think that vinyl sounds better than other media. I totally agree with that for the most part. There is a nostalgia component though; I am not one of those people who says we have to live in the past, that things were better when I was 12, and that I hate these fucking kids and their bullshit MP3s. You can't survive for long in this industry if you have that mentality. But I would say that there's a lot going for vinyl. It's just a very different medium. And that is important today, more than ever, more than it used to be.

I think back to when I was a kid, and the CD had just come out; people got excited about CD. But you must remember, we had been living on cassette tapes. My generation had been perfectly happy to listen to cassette tapes, because they were cheaper than vinyl. I am sure that audiophiles of the age, who were grown up then, when I was 12, 13 buying cassettes at Tower Records, were really upset, thinking, 'I can't believe you children would choose that terrible cassette over this wonderful vinyl.' But now, we say the same thing. We say, 'MP3s are so cold and soulless, it's just a series of zeros and ones, nobody cares!' But the truth is, every generation interacts with music in a different way; every generation consumes music in a different way.

I think one reason why vinyl is back in vogue, especially with young people, is because it's so different. Kids today, they buy stuff online; you never see it, you never touch it, you never handle anything, you can't smell it. When you buy a vinyl album, it comes in the mail in a big package and you open it up. There's art. If it's a gatefold you can open it and look at it. It's a different experience, and I think that's what gives it some its *oomph* today. There are many different constituencies that vinyl pleases. The audiophiles, the old farts and now the kids – all for different reasons.

How does vinyl play into the ethos of punk and the independent label scene?

I'm laughing at this question, because vinyl is so much more expensive to make now. The 'punkness' of it has been washed out of it by the general expense of production. I think what's really punk right now are cassettes. They've come crashing back into fashion. I don't know where people are digging cassette players out from – I hear you can get them for $1 at Goodwill [US charity store]. People are buying them, and then they are putting music out on cassettes. So I feel that is where the weird nostalgia and punkness of music resides. Cassettes are more punk than vinyl because they are so cheap to make. You can make a small quantity yourself, and sell them at your shows – which is very punk!

Vinyl right now, to me, is feeling more like an establishment. It's hard. It's punk in that you know you are going to be appealing to a certain audience – not everybody, not the mainstream. But at the same time, you have to spend so much money making it. You can't make fewer than 500 vinyl albums, because the set-up charges for making vinyl are the same regardless of how many you actually end up pressing. So you are going to be paying

however much to set it up – $800 or $1,000 – and whether you wind up pressing 500 or 1,000 or 10,000, you never have to pay that initial fee again. So in a way, it behoves you to press more, because you are paying the damn set-up fee. If you only press 500 copies, you are barely going to break even. That's the interesting part about it, and the part that removes it from punk for me. Once upon a time, perhaps, young punks could make vinyl themselves. But nowadays you can't – you couldn't afford it. If you are just a punk band, and you only want to press vinyl, that would be all of your cash gone into that single pressing of however-many copies. This is why kids today are much more likely to say, 'Let's press 100 cassettes.' That's like, $100. People can do it. People can afford it.

How does a vinyl release differ from a digital one in terms of marketing?

We have a little more trouble these days because of the digital nature of music, the 24-hour-news cycle, and the split-second attention span of most people. It's really hard to get people to pay attention to something once it has been released. People talk about releasing albums in this climate; they say it's like dropping a rock into a pond. You drop it and there's this big splash – but then it's gone. You don't see it again. That was it!

Anywhere we make a press announcement, we always include a link to where people can pre-order the album. Vinyl has sold really well in that way. Vinyl pre-orders have turned out to be the thing that people really want because they feel like they are getting something exclusive. We always do a coloured vinyl special. We will press up an album, then we will have 200 white copies available only through pre-order. Those will sell out in a second. People look at vinyl as a specialty item; they don't just want it, they want the *limited* version of it. In

this market, it's really weird. We could do the exact same thing with limited edition coffee mugs. It's not about the specialness of the vinyl itself; people want it because it's marketed as a 'special item'.

Is vinyl still important to KRS then?

It's really, really important! People like to buy it. Our catalogue has some big legacy artists like Elliot Smith – and legacy artists sell so well on vinyl, it's crazy. Elliot Smith vinyl sells like hot cakes, so it's very important to our brand. I think it has to do with the fact that these artists are dead; they're not putting anything else out. People love to hold their vinyl because they really feel like they are getting a special part of the artist. Our next biggest artists are the Decemberists; the biggest album of theirs that we have is *Picaresque*. That album is a double gatefold; it has a 28-page booklet, and it is absolutely beautiful. We just had to re-press it, and we practically went into the poor house doing it, it was so expensive. But it's gorgeous. Vinyl just sells great in general. You have to be careful when you are running a business; you don't want to go crazy and press too much. But the biggest problem we have right now is that we can't press enough! With Elliot Smith, obviously we are going to press a lot because we know we are going to sell it. With other artists, we are a little bit more cautious because we never know how well they're going to sell. And then my production guy gets mad at me, saying 'We have got to make more, Goddammit! Why didn't we make more in the beginning?'

The pressing plants got really overtaxed. I wish I could remember who told me this because it's the greatest story, and absolutely true. In the '90s, one of the major record companies – either Warner or Universal, I can't remember which – had a vinyl pressing plant somewhere, in Germany or the UK. And they fucking *cemented it over* to build a CD

manufacturing plant on top of it. That's how positive they were that vinyl was never going to make a comeback. That's how sure the majors were that vinyl was never, ever coming back. They didn't even bother to sell the presses. They just buried them instead of bothering to get rid of the stuff. It was just crazy. And heartbreaking, as people are now desperate for pressing machines. Vinyl never really went away completely. But as so many vinyl pressing plants closed, when things started revving up again, we were looking at six-month delays for pressings, because there just weren't enough pressing plants.

When Record Store Day started, suddenly it became blazingly obvious, even to majors, that people were buying vinyl. It took them forever to figure that out. It was four years ago that the majors got involved. They are always super late on stuff. Once they realised it, they responded in typical major corporation fashion by doing the wrong thing. It was like, 'I know what we need to do. Let's re-press 50,000 copies of Fleetwood Mac *Rumours,* even though it's available for $1 in every bargain bin in America.' They started going crazy re-pressing all of these old records that were already in circulation. So it just backed up all of the pressing plants like crazy. I'd call a pressing plant and say, 'I have an order for 1,000 Summer Cannibals [new Kill Rock Stars artist] records.' They say, 'That's nice.' Fucking Sony calls them, and they have an order for 50,000 Bruce Springsteen records. The pressing plant will be like: 'Oh, no problem, let's get that going.' I am not anti-majors because the majors are the majors; I am anti-majors because majors are a corporation whose main income actually comes from stuff other than music. Sony is a hardware corporation and a movie studio. Universal has a movie studio. It's ridiculous. They're barely in the business of producing music. Me, as a record label – all I do is sell music. I don't have another income from a theme park, a movie studio or a whole bunch of TV series. It makes me

annoyed when people talk about majors and indies as if we are the same. Because we're really not. We are two completely different kinds of business.

Is there a special relationship between vinyl and indie bands? Indie labels?

I think indies have always grown where vinyl happened, especially since the majors gave it up. In business, you cannot always be 100 per cent ahead of the curve. The vinyl industry is playing catch-up in a huge way, because there just aren't the machines, or the people who know how to run them. There are two new pressing plants in America – Cascade Record Pressing out here in Oregon, and Independent Record Pressing in New Jersey. Their presses are from the same original pressing plant up in Canada. There was a factory in Canada that was going out of business. There were 12 presses – they sent six to Independent and six to Cascade. Then the old dude who is the only guy who knows how to run them and fix them actually came out of retirement and got hired by Independent to take care of their plant and their machines. You can't even build vinyl-pressing machines anymore. There's nobody left who knows how to make them. There is seriously only this one guy, whose name is Dave Miller (see p.146).

The reason that Independent called themselves Independent is because they only want to work with independents. It is the same with Cascade. They particularly want to work with independent bands and independent labels. That is a theme throughout the industry right now. The independents were the ones who supported the vinyl industry in the '90s when the CD was so strong. There were still independent record labels pressing vinyl. Now these new plants that have popped up, they really want to support the independent labels. Not just sell out and press 50,000 copies of a record for some major. That's really nice.

MARTIN MILLS

FOUNDER, OWNER, CHAIRMAN, THE BEGGARS GROUP

Martin Mills is the founder, owner and chairman of Europe's largest independent record label network, Beggars Group. The Beggars Group roster includes Adele, The Raconteurs, Vampire Weekend, and Radiohead.

What's your most important vinyl memory?

When we opened our first second-hand record shop, we put my entire record collection into it. That's how we got started. I think Geoff Travis [founder of Rough Trade] did the same thing.

Why do you think vinyl has returned?

With the growth of digital media, people are consuming music in ways that eliminate its physical manifestation. I think that music identifies people. The records you own are just like the books you own, and even the car you own: a big statement as to who you are.

People like to display vinyl on their shelves in the same way that they display books on their bookcases. They can look at the spines and see what they own. It's a kind of badge or statement. I expect a lot of people buy vinyl and actually never play it. They just stream their music and buy the vinyl to have the artefact that you can see, look at, open and read. They'll actually listen to the music in whatever format is most convenient – which usually means digital. So I suspect that those who are actively buying vinyl may never play it – although their records are loved just as much.

Are we being sold vinyl in a different way?

When vinyl was the only thing there was, most vinyl was made in a very disposable form, especially by the major records companies. Vinyl has got fairly exact packaging cost standards. If you're an artist or a licensed label making music with a major label, then you're told you can only have four colours on the outer sleeves and one colour on the inner sleeve. You can't have folds, you can't have odd shapes and all that kind of stuff. But at the beginning of the vinyl revival, independent labels started making really, really beautiful and unique vinyl packaging without worrying about costs. Their primary drive was to make the packaging interesting in itself, rather just using it to carry the record. During the original vinyl years, there were plenty of packages like that as well. But they were made because vinyl was the principal format for consumption. Now it's no longer the principal form, vinyl can just be something aesthetic; something beautiful and beautifully packaged.

It's part of a bigger debate about the balance of modern life, about the digital world and its speed and its disconnectedness. In terms of retail, people are going to big shopping malls or buying online, rather than visiting little stores and backstreets. I think that whilst that trend is increasing across the world, there's also an opposing trend that insists on personalisation, localisation, specialisation. The vinyl revival owes a lot to that. It's more individual. It counteracts the trend of the times and it appeals to people for those reasons.

How important is vinyl to Beggars' sales right now?

It's very important, because it's how our artists reach their fans. New fans especially; they love the tangible aspect of vinyl.

Really?

Yeah. Again, it depends on the artist, because there are certain kinds of music that sell much better on vinyl. It's very important in terms of hooking fans at an early point in a band's career and having them connect with an artist.

When you're talking with bands about packaging, is vinyl one of the main things that comes up?

Yes, it is. And frankly it never went away, even during the non-vinyl years. The kind of artists we tended to work with were very insistent; they wanted their stuff to come out on vinyl, even though it was uneconomic in those days. Even when it was completely out of fashion, we were still doing it because the bands really wanted us to.

Is vinyl a nostalgia item?

No. That doesn't mean that people don't buy old music on vinyl – they do – but I don't think it's nostalgic. Vinyl is the physical manifestation of music fans' tastes.

Any last words of Mill's wisdom?

I think that vinyl is vital to the continued viability of independent record stores, who have been under threat all around the world. Whereas 20 to 30 years ago independent record stores used to sell all music, nowadays even the biggest independent record stores are specialised. They won't sell Fleetwood Mac or the new Pop Idol, or any of those things; they sell selected, curated music. Vinyl has proved to be an effective way of getting fans to reconnect with record stores. If vinyl had never come back and CDs were still the main format, then the differential between the independent record stores and Best Buy or HMV would be much less than it is right now. Vinyl probably represents about three quarters to two thirds of independent record store sales.

Do you think vinyl is here to stay?

I see no reason why it shouldn't. There are plenty of other technologies that people thought were defunct, which have now returned with a bang.

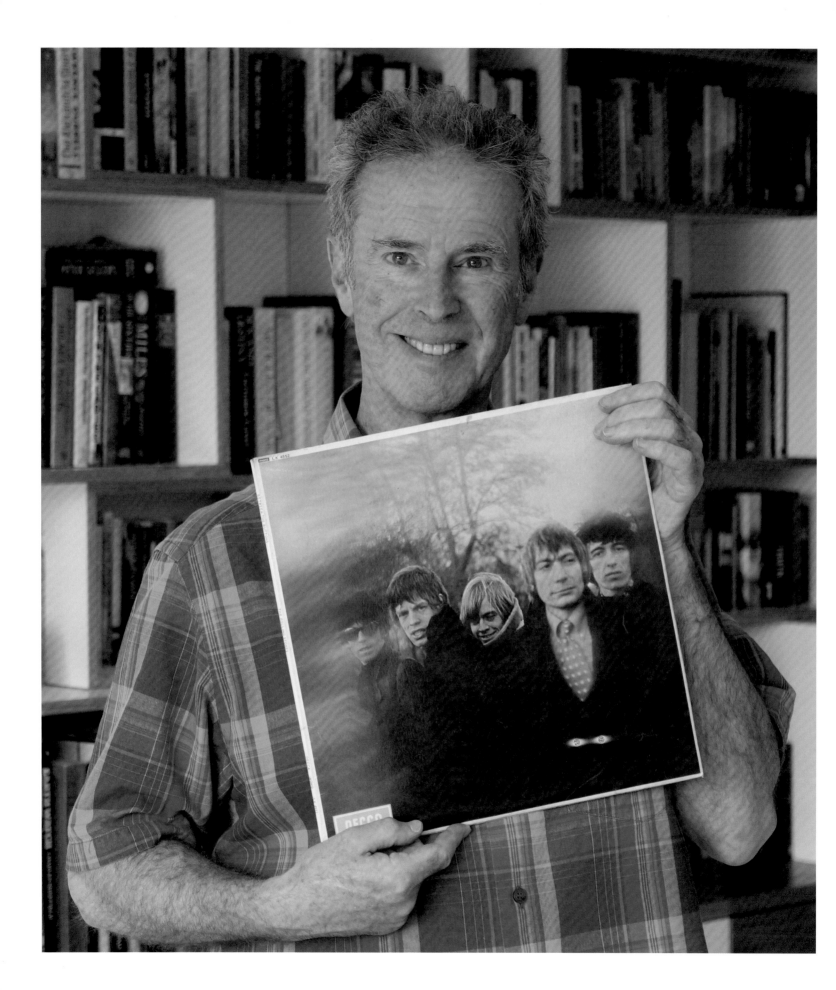

GERED MANKOWITZ

PHOTOGRAPHER

Gered Mankowitz has worked with a number of famous artists, including Jimi Hendrix, Slade, Suzi Quatro, Sweet, Elton John, Kate Bush, Eurythmics, ABC, Duran Duran and Marianne Faithfull. He is best known for his Rolling Stones album covers; Gered's work can be found on 'Out of Our Heads' (US title 'December's Children'), 'Between the Buttons', 'Got Live If You Want It', 'Big Hits' and more.

What was your first vinyl purchase and what did it mean to you?

It was 'Diana' by Paul Anka. I liked it because it had a great melody to it. I didn't know anything about Paul Anka... It just rang bells.

What was your first record cover shoot?

My first record cover shoot was for a duo called Chad & Jeremy. I was 16. They had a hit called 'Yesterday's Gone'. They had an album by the same name. We took them on the roof of Jeremy's flat. We whitewashed a chimney wall, then painted 'Yesterday's Gone' onto it. We had them lean against it with a guitar, and that was the cover. It was shot specifically for that purpose. After that, I got signed up to their record company, Ember Records, to do more stuff.

Covers were not usually conceptual back then. They might have been in some cases; Blue Note Records in America had an extremely prolific and very talented art director named Reid Miles. He created some beautiful album covers. But they were generally images he thought were appropriate for the super cool jazz that the label was famous for. They were not necessarily portraits of the artists. If there was a portrait of an artist, it was often a rather ordinary, not very good quality portrait. The labels would then cut, crop and incorporate a graphic design to turn it into a cool cover. Pop music covers generally had images that had been earmarked for possible sleeves after they had been taken, not before.

When you first started out, what impact did record covers have on the band's overall look?

The album covers were, from the beginning, a crucial part of the listening experience. In most cases, we didn't know what the artist looked like. It wasn't in the media; TV wasn't any help. You didn't know if they were black, white, young, old. Certain genres of music would give you a clue, but you never really knew. So when you saved up your pennies for an album – when you're young, that's quite a big investment – you had to make a really big choice. You were committing. Second, when you got home and opened it, the cover was a part of that process; it is what you would look at first while you were listening. It was part of the whole thing, even if you were just listening to a jazz album and rolling a joint on the cover! It was key. From a photographer's point of view, it was really important because you had such a big space to play with; 12-inch x 12-inch – nothing on a day-to-day basis compared. To aspire to create an album cover was a no-brainer. To want to be a music photographer though, that was rare. There weren't many people choosing music as a career in photography. I wanted to be part of the whole team that made an artist, that projected an image; that's what I wanted from the very beginning.

How important were your covers then, in developing an artist's brand?

I don't know whether the idea of the artist being a 'brand' would have been entertained for a nanosecond in the '60s. What changed everything was when lawyers began to get more closely embroiled in record companies and management. Artists became product. They may have always been product from the record companies' point of view, but you would never have addressed your artist as a product. I think it was in the early '70s when artists began to accept that they were commercial merchandise. They took control of themselves as a product, and therefore became more conscious of themselves as a brand. I think that if anyone had suggested that The Stones were a product, they would have been beaten into a pulp.

> **"** I think that if anyone had suggested that The Stones were a product, they would have been beaten into a pulp. **"**

But they are such a product now...

Yes, but we're well into the 21st century. They're still going *because* they understand the business. They wouldn't exist as an entity if Mick in particular wasn't super-conscious of what it takes to remain on top of the profession.

How did your work with The Rolling Stones on their record covers come about?

The first one was called *Out of Our Heads* – which was *December's Children* in America. That came out of my first session with the band, in 1965. When Andrew Loog Oldham, The Rolling Stones' manager from 1963 to 1967, first gave me the job, it was because he'd seen my pictures of Marianne Faithfull and liked them. He had probably thought that my youth, my enthusiasm, my energy, my naivety and my inexperience would bring a rawness, a natural quality to The Stones which he thought was the antithesis to The Beatles' showbiz. David Bailey (who had done the previous record cover) was a much more experienced, much more talented, and much more sophisticated photographer than I was. Yet he couldn't *not* bring a sort of veneer of glamour to the pictures – whereas I didn't have the skill set to bring that veneer whether I wanted to or not! My stuff was much rawer, and in many ways more honest, as it was much less manipulated. Andrew felt that would be dead on for the Stones.

I was committed to being in the music business. I understood that if you were going to get an album cover, you had to design your work to incorporate the typography, the name of the band, the record label and the record company logo – which were pretty much always going to be on the top third of the cover. Depending on the company, this was going to be the top left or the top right; you had to make sure your photograph allowed for that. I tried to shoot everything with a record cover in mind. That's how *Out of Our Heads* came about, because I gave Andrew material that could be translated easily and effectively with impact onto a record cover. That was the first one. The second one was called *Between the Buttons*. That was in a way the first conceptual cover, because I knew it was going to be a sleeve. It was my concept to shoot them through this home-made filter, which I hoped would impart a sort of druggy, trippy feeling where the band would merge into the environment, and the whole thing would become a shared experience. Hopefully, when the viewer looked at the picture, they would feel transported in the same way the music would transport them.

Did you still have the typography of the cover in mind, even when you were doing a more creative image?

It became instinctive. The bulk of what I shot would lend itself to a record cover, if that management or the record company decided that it was appropriate.

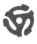

What's important for a good record cover?

That depends on the photographer and the demands of the management. I have always tried to capture the essence of the person I am photographing. I have always maintained that the subject is the hero of my pictures. I never wanted to stamp my brand onto their brand. I never wanted to do that, I never intended to do that. I'm sure my own style developed and evolved, but it wasn't something I consciously wanted to impart.

I think a lot of things contribute to making a good record cover. When you look into Kate Bush's eyes, or The Stones, or Eurythmics, I want you to be looking at them, and I want them to be looking at you. They are saying: 'Love me, buy me, take me, have me.' All of those things.

How would you describe your style then?

Perhaps a simplicity. A lot of my work is very simple – that's how it appears. Very unadorned. Not very tricky. It's all about the eyes. It's about getting across the personality that we want you, the buyer, to connect with.

Among the record covers you shot, which is your favourite?

Between the Buttons would definitely be one of my favourites. I am very proud of the stuff I did with Kate Bush. It is difficult to pick out one or two. But I would have thought Kate Bush, Eurythmics, The Stones, Marianne Faithfull... I loved Marianne in the pub – for *Come My Way*. I didn't like the cover that Decca, her record company, chose but I loved the session. Quite a lot of the work that I think of as being record covers never actually became the record cover. For example, the Eurythmics *Revenge* session. This morning I was

talking to someone, and they said, 'I have always loved this cover you did'. And he showed me my picture of the Eurythmics *Revenge* cover. But I said, 'That wasn't the cover.' 'No, you see,' he said, 'that's the *Revenge* cover.' 'No,' I said, 'The *Revenge* cover was a *painting* of my photograph.' David Stewart for some reason decided that he wanted a painting, not my picture. In my friend's mind, it's my picture that is the cover. Time distorts these things somewhat.

Are record covers still important today?

I think they are getting important again with vinyl coming back. I don't think CD covers were ever as impactful or as important. You couldn't do very much with them; they were almost impossible to read. I think that turning every cover into a little booklet was a nice thing for some artists to communicate a live story, or every word of a lyric. But I don't think they had the same physical impact as a vinyl cover. The answer is that they became less important, and now perhaps they are becoming more important again. Of course, with digital downloads, where people cherry-pick one or two tracks, I know that iTunes will only download the cover as a thumbnail!

How did your covers influence rock 'n' roll?

If an artist selected an image to go on the cover, then that was the pinnacle of my achievement. Nobody reviewed the album cover. Maybe someone might do a side piece about the cover... I always tried to have one or two artists that I'd shot in the top 20. I felt that it was important that my work be represented. I never, ever really had any validation beyond that. I would feel validated if somebody came back to me. That happened a lot. Much more often in the '60s and '70s than it did after; there was more loyalty in the industry back

> **" I have always tried to capture the essence of the person I am photographing. I have always maintained that the subject is the hero of my pictures. "**

then, and a lot less branding. People would ask me to come up with a conceptual approach to shooting somebody, knowing I wasn't restricted to doing the same photograph every time. Quite a lot of my contemporaries tended to do the same thing every time. I always tried to use different formats, different films, different treatments, to try to communicate something about the artist and their music. It wasn't until much later that people started to talk to me about, 'Oh my God, when I first saw that cover in the window of my local record shop, it changed my life.' And I would think, 'Wow, really? How come?'

That didn't really happen until much later – when the work had become historical. People were remembering it 20 years, 30 years later, and trying to recall how they felt.

Will vinyl to continue to be popular?

Vinyl will become a regular part of a release, but only in a limited way. I don't think it will replace any of the new formats. An increasing number of young people are collecting vinyl; therefore, vinyl will have a future again.

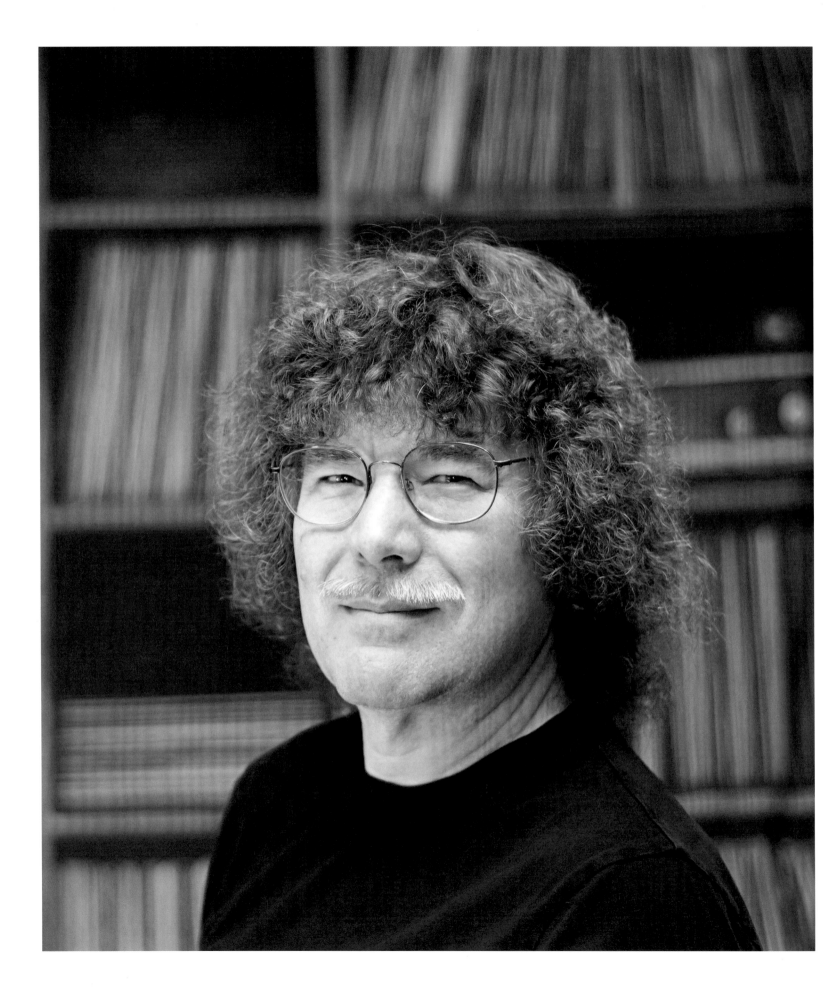

TERRY CURRIER

OWNER OF MUSIC MILLENNIUM, PORTLAND, OREGON
CO-FOUNDER, RECORD STORE DAY
CO-FOUNDER, OREGON MUSIC HALL OF FAME
BOARD OF DIRECTORS, COALITION OF INDEPENDENT MUSIC STORES

Terry Currier is the owner of Music Millennium in Portland, Oregon. He has worked at the store for almost 40 years, through vinyl, cassette, CDs, MP3s – and now back to vinyl again. Terry is on the board of directors of the Coalition of Independent Music Stores (CIMS), the first record store coalition, founded in 1995. CIMS is a collective of about 50 independently owned record stores in 25 states throughout the United States. Currier also is a co-founder of Record Store Day and of the Oregon Music Hall of Fame, a non-profit organisation providing music education in schools and celebrating the rich artistic heritage of the state.

Is vinyl important?

Vinyl – to me – is the greatest invention of all time. It is the ultimate format of music that has ever been made. The record industry made a big mistake in the '80s with the compact disc. They looked at the compact disc as this new format they could use to resell previously purchased music, by pushing the idea of replacing vinyl with the 'new' CD format. The labels knew this would generate a lot of revenue. It was supposed to be an indestructible piece; you were not supposed to be able to damage a CD. A lot of people replaced their vinyl multiple times over the years, due to scratching their records at parties, dropping them, you name it, divorce. Divorce inspires new collections to happen when you have to split up the records.

Vinyl – and a lot of people argue this all the time – has the best sound of any format out there. If you say that vinyl has 12 inches of sound, when you go to the CD format, you might have 10 inches of sound, because it is compressed. The high end and the low end are cut off. When you go to the digital download, you have about 1 inch of sound. You lose all of the feeling, the warmth, everything that you get in that vinyl experience.

What happened with the CD format is that music became more of a commodity instead of a piece of art. In the late '60s and into the mid '70s, vinyl played a big part in the lives of a great amount of the public. There weren't video games, there wasn't cable TV, there were not all these other distractions. It was pretty much down to movies – and music. The thing that would happen with the vinyl experience in the past is that people would go and buy a record. They would go home, either by themselves or with friends. There were a lot of listening groups that got together and listened to music together.

The other thing about vinyl was that the album cover was a very important part of the whole puzzle. People put a lot of thought and effort into that cover. It was a piece of art. A lot of people bought records not necessarily because they heard the music; some people bought those records because of the album cover that stuck out on a shelf someplace and grabbed their attention.

US record stores – especially indie record stores – we thrived in the '70s, '80s and '90s because people wanted to know what the great new music was. They came down and talked to the clerks at the record stores.

For me, I got my first cultural education in the record store.

Record stores were community centres. From back into the '40s, when big band was happening, to when rock 'n' roll really began – kids started hitting the record store. People met their girlfriends there, they met their boyfriends there, they met people who had common tastes in music there, and became friends. And long time friends – for life. You were going down to the record store to buy the first or second Smiths album, and you run into somebody in the store who also likes that first or second Smiths album, when you have probably been at home listening to a couple songs thinking, 'I am probably the only one who cares about this. Nobody at school even cares about this.' And here you run into somebody who has a common taste with you. And you bond. Not only were record stores about the music, it was about the culture and the time. It was something especially that younger generations could connect to. As rock 'n' roll changed, as culture changed, the record store was still at the heart of youth and social movements. As it went into the early '60s, went into Beatlemania,

went into the psychedelic, the drug era – they were still community centres, it was just a change of what was going on in current events.

Political issues became involved. Especially at underground record stores. There were a lot of people working in those stores with really solid political convictions. In the '60s they were against the Vietnam War, the way our country was being run; it later turned into environmental and social issues. As an independent business, as the owner of a record store here [in Portland, Oregon], we have always been conscious of what goes on in our community. We supported a lot of things that became regular music events in this town at the very beginning, by getting different groups of people together to talk, by giving sponsorship to a variety of causes, just getting involved. I say we try to stay out of political issues, but we are always supporting things that are going to affect our city, and the people of our city, because we care about the community.

Do you think people will continue to be interested in vinyl, or is it just a fad?

A lot of people talk about it as a trend; I totally disagree. Vinyl is here to stay. All these new vinyl buyers are developing the same culture that I was a part of when I started buying records. And it's hitting them really hard. It is a really important thing to them. It's staying with them. There are some drawbacks today in comparison to back then. Vinyl,

in many cases, is overpriced and there is a lot of sticker shock; people are put off by the price tag. It used to be that all records were pretty close to the same price. I can remember when Queen decided to go from $5.98 to $6.98 for *Night at the Opera*. There were record stores that were up in arms – 'What, you are going to charge a buck more for this record?'

Would you say that the new interest in vinyl signals a shift away from the disposable culture of recent years?

Yes. When we got to the MTV generation, music started getting programmed at us like commercials. A lot of people bought music in the '80s and the early '90s, especially in the first half of the '90s, due to these visual impressions that were coming at people. Visual impressions of what a song should be: for example, this song is about girls in bikinis and hot cars, this song is about this. That changes the experience of how you remember music. Music from the '80s and '90s, as catalogue sellers, does not sell as well as music from the '60s and '70s. Because when you hear 'Wooden Ships' by Crosby, Stills, Nash & Young, it is hitting a nerve with you, inside of you, in your ears. You are formulating your own thoughts and ideas about what that songs means to you. I am over there, hearing the same song, and I am formulating it too – but it's a different movie that is in my head than is in your head. But if I am watching 'Hot for Teacher' by Van Halen on MTV, everybody has that same exact thought

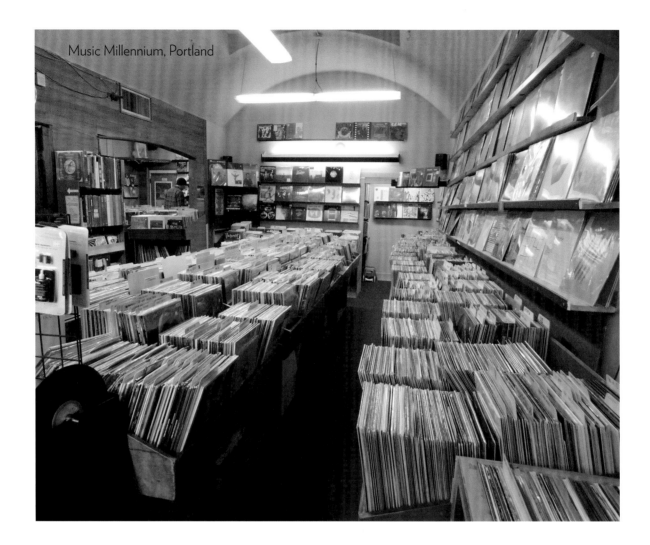
Music Millennium, Portland

about that. Now MTV played these same videos over and over and over and over. They were like commercials. After you see so many commercials, you think, 'Oh, I had better buy that', because it has been compounded into your head that you need it. You did not buy the music because it was hitting you inside and you were going, 'Wow! That's the greatest thing since Swiss cheese.' That was a very awkward time period, as we morphed from vinyl to the CD era.

How much do you think digital services are hurting artists? Do you think that artists should pull their music from digital services?

Digital downloading had an effect on the sale of physical goods. It definitely did. It was just a new format that us stores could not interface with; we could not do any commerce with it very easily. The Coalition of Independent Music Stores started its

own digital store. Yet we eventually shut it down; it just did not work. A lot of our people didn't believe in the format either.

Streaming services are a good way for people to discover music. There are a lot of pros and cons about whether it is good for an artist to have their music on there or not. It's a good place to discover it. I do find a lot of our vinyl buyers stream music and discover it, then they come in and buy the vinyl. So that is a good thing. That is the positive thing about streaming services. As far as artists getting paid from the streaming service? There isn't good commerce in that. Artists are not making money at that. So that has to be an individual, artist-by-artist situation. They have to go 'Does the pay off work for me? Are people out there discovering me worth what is going to happen on the physical side, because I am not really making very much on that?'

How many vinyl albums do you currently own in your personal collection?

Somewhere between 20,000 and 25,000 albums at home. I would have had more, but I had some water problems, I had some records stolen early on. In my entire life, I have only done one purge (on purpose). I think I got rid of 700 to 900 records at that time. I had 3,000 that got destroyed by flooding. But all through time, if someone put vinyl in one hand, and a CD in the other hand, and said, 'Which one do you want?' vinyl won. It is that important to me.

What was your first vinyl purchase and what did that mean to you?

The first two singles I bought were around 1970 – maybe it was 1971 – and both these singles had been out before. One was 'Jean' by Oliver, which was from the movie, *The Prime of Miss Jean Brodie*,

and the other song was 'Pushin' Too Hard' by The Seeds. I heard The Seeds on a TV show. The daughter [in the TV show] had The Seeds come play in the family living room. And the parents were making all kinds of visual expressions, like 'What the hell is this?' But that song really resonated with me.

The first two albums I ever bought were from a White Front store.

What is a White Front store?

White Front was a big giant discount store, kind of like a Walmart. I played in the school band. I was going to go on to college with a music scholarship, but I did not listen to recorded music. I focused all my time on just learning how to play instruments. A friend of mine turned me on to his older brother's records of Frank Zappa. So in a White Front store bargain bin, for $1.99 each, I got *We Are Only In It For the Money* and *Cruisin' with Ruben and the Jets* by Frank Zappa [and the Mothers of Invention]. Those were my first two album purchases.

Did you go through the whole ritual we are talking about? Carefully taking the record out, reading all the liner notes?

No, because though I had bought these records, I still had not gotten into that music experience. That first year I worked in a record store, I was a senior in high school. I made up for lost time. I spent every dime on music. I got out of school at noon so I could work 40 hours a week. I bought 665 albums that first year. I bought current records, I bought old records. I bought country records, classical records, rock records, jazz records – anything that hit a nerve. I had no peer pressure, because I hadn't been in those circles where people were buying records together or listening to music together. If I liked it, I bought it. I would be in my car listening to

> **"**Music is the thing that drives my life. It's connected to about 90 per cent of what I do. I used to be picked out at concerts as the guy with a box of albums under his arms.**"**

Kris Kristofferson on an 8-track, followed by a Savoy Brown record. If I liked it, I liked it.

That is what we are finding in some of the kids today. As they go through their vinyl experience, they may come in and get the thing they are looking for. But they start going through the cheap records. They start looking at album covers. And they go, 'I'm going to try this out, this looks pretty cool, and it's $4 dollars.' And they get home, and it's a blues record. I have seen kids buy classical records. They are willing to take chances with those cheap used records. Because of the album cover experience, it is getting kids to try other genres of music that they may not be familiar with, or may have never ever looked at online or even talked about in a chat room.

How did you go from being a shopper at the store to owning Music Millennium?

In March 1984, the record store I had worked at for ten years, DJ's Sound City, was sold to a company called Tape Town. Tape Town only cared about stereo equipment, and looked at vinyl and cassettes as add-on items. They did not care about the music. In August, I gave them my two months' notice, not knowing what I was going to do next. Two weeks later, I heard that the original owner of Music Millennium, Don MacLeod, was coming back after being gone for five years. I interviewed and got the job of Operations Manager. We were able to pay back the $500,000 of debt in three years. The owner gave me 5 per cent of the business. Two years later, I purchased another 20 per cent. The owner pretty much took a back seat from there, but still came in for a couple years, mostly working in his office on things for his hundred-acre farm. Then he quit coming in altogether. In 1996, he passed away from leukemia and the bookkeeper and I bought his estate out.

Music is the thing that drives my life. It's connected to about 90 per cent of what I do. I used to be picked out at concerts as the guy with a box of albums under his arms. In the heyday of the industry, there were so many opportunities to meet the artists after the show. I'd be ready with my records under my arm in a cardboard box. It was so cemented as part of who I was that one of my employees came to work on Halloween, dressed up as me, with a cardboard record box under his arm.

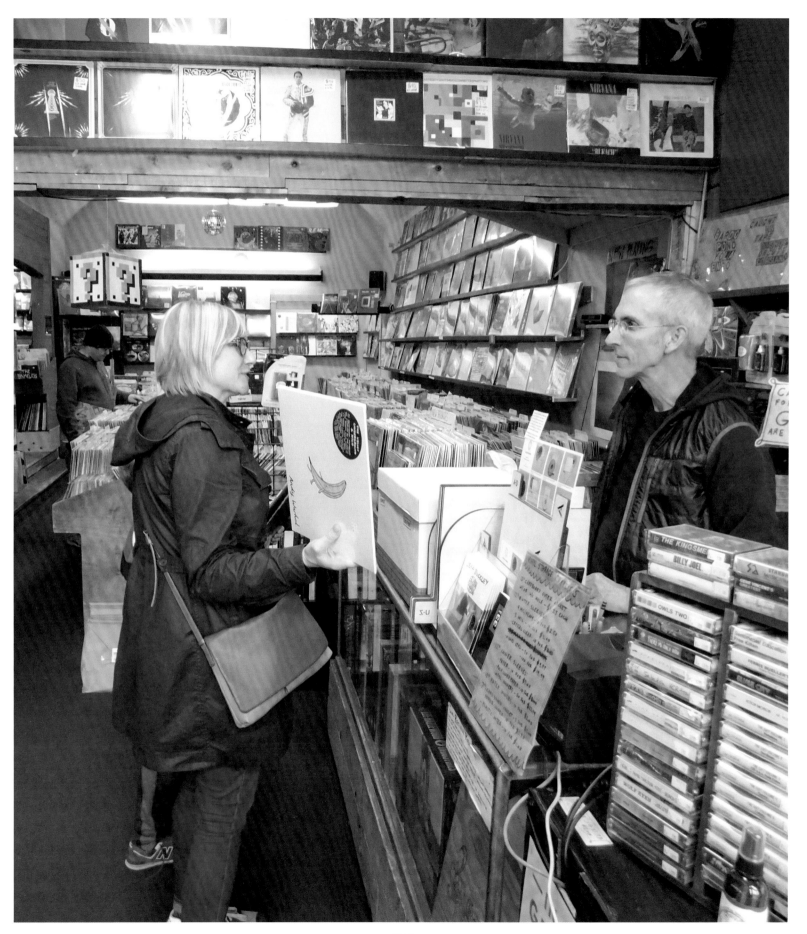

STEPHEN GODFROY

CO-OWNER, DIRECTOR, ROUGH TRADE

Stephen Godfroy is co-owner of Rough Trade, the independent record retailer that originally opened in 1976. Rough Trade currently operates stores in London, Nottingham and New York City, as well as a global online store.

Why is vinyl important?

Vinyl is the definitive audio document. It is a crafted moment of creative self-expression, shared between artist and audience. Commanding ceremony and tactile care, the ritualised respect of the music is preordained. A vinyl record is conditioned to be loved. Consequently, the bond vinyl forges between artist and listener is the most trusted, fetishised, and intimate relationship to ever be induced by a musical format.

The democratisation of the recording process and online distribution have all conspired to erode the status of the music artist, to the extent that record labels have inadvertently become reliant on vinyl to authenticate integrity. More than ever, vinyl is a statement of artistic intent. It stands in sharp relief against the 'free from cost and identity' transfer of digital files by stream or download.

Playing a record has in itself taken on an important post-digital role, disengaging the listener from the pace and hyperconnectivity of modern life. They don't just provide music, but a state of meditative listening focus that is rare in today's world.

Did vinyl influence your interest in working in a record store?

The kaleidoscopic discoveries that can be found in record store vinyl selections fed my teenage craving for stimulation and my search for identity. I have nurtured a devotion to the record store experience over the years, but working at one was never a career aspiration.

Why did you decide to open a store in NYC? Was it a daunting decision?

Most record shop owners would probably name NYC as a 'wish-list' place to open a store, based on the cultural significance of the city. It just so happens that following the success of Rough Trade East in London, we, the Rough Trade co-owners, felt that Williamsburg, Brooklyn had a lot in common with East London. Why not try to replicate our London success in NYC? After five long years, we finally opened Rough Trade NYC in November 2013.

What defines a Rough Trade store, whether in the UK or overseas?

Rough Trade stores are as much meeting places as locations to purchase new music. As hubs that focus on hosting the most exciting, significant artistic music output, our stores attract people of all ages and tastes, unified simply by their curiosity, We cater to anyone who is eager to embrace the unknown.

Being a cultural agora is important, but forever a 'work in progress'. A Rough Trade store is never finished. It is always in a constant state of flux, each store migrating across the local cultural landscape with every 'ebb and flow' of social and political change.

What's important about staff reviews, and the personal curation of a store?

Rough Trade has been editing for 40 years. We're defined as much (or more) by what we don't sell, as by what we do sell. To that end, we've become

a trusted source of excitement and stimulation. It's what makes us who we are, and both artists and audiences respect us all the more for it. For us, commerce always plays second fiddle to celebration, but that in turn is the appeal that drives sales.

What is record store culture? How does vinyl play a part in it?

It is a music culture congregation, where commerce is merely a by-product for what is otherwise a celebration of a freedom in music self-expression. Vinyl remains the preferred, trusted and respected currency of exchange between artist and audience, and is hence integral to record store culture.

What has been the most impressive event hosted by Rough Trade?

There have been thousands in my time alone (I'm a relative newbie, having been on board for only the last 13 years). But for me, Blur's reunion (2009) and Queens of the Stone Age in 2013, both at Rough Trade East, delivered the most spectacular performances.

Unlike traditional venues, our in-store gigs have the sonic quality of a great venue but without the formal seating. The audio and physical intimacy that results is intoxicating! If all goes well, those who experience it feel as if they're at the 'centre of the music universe'.

What role have independent retailers had in the resurgence in vinyl?

A celebration of music is achieved when people of all ages congregate to hang out and share a sense of wonderment, unity and place of belonging. Such is the synergy between music celebration and vinyl – independent record stores are the perfect propagators.

How has vinyl's renewed status affected Rough Trade?

Vinyl is the most respected currency between artist and audience communities, so the resurgence in its popularity has certainly consolidated and increased our relevance, particularly with younger generations. Interestingly, as the world's emerging economies develop their own cultural ecosystems as a means of supporting their fledgling leisure industries, the role model of Rough Trade as a respected authority for uniting artist with audience – where vinyl is the post-digital currency of exchange – ensures we become ever more pertinent, globally recognised and increasingly in demand.

Why did vinyl fade as a format during the time of CDs?

It's only natural for a format to have a life cycle, where anything new overshadows what went before. The rise of the CD in the '80s and '90s coincided with the rise of dance music and hip-hop/rap, both DJ-based cultures that adopted vinyl as their default format. Needless to say, vinyl may have lost some mainstream relevance, but it has found favour with underground musical communities. who kept the medium alive through the thinner years.

Why has vinyl returned?

The LP is the finest, truest, and most informative representation of a recording artist's work, given the breadth of the 'canvas'. Those twelve inches provide a lot of scope to convey concept, imagery, etc. Couple this with the burgeoning demand for authenticity as a counterpoint to the digitisation of our lives, and vinyl becomes a music format at the forefront of the post-digital era retailscape. Digital natives can now afford – for the first time, thanks to the popularity of low cost streaming subscription

services – not just digital music, but also the antidote artefact: the LP.

Vinyl has emerged as one of the first consumer products to prove its post-digital worth in a digitally distracted world. Digital natives are no longer satisfied with music access alone. Having a curated collection of music you own to cherish is now an aspiration for many young music lovers. A rich, eclectic, specialist collection of vinyl is emblematic of the owner's personal identity, ideals, and experiences. The disposable ubiquity of digital products teaches the value of scarcity, and of knowledge as a means to navigate endless choice. Suffice to say, vinyl rewards, educates and conveys you better than most things acquired in life. This will secure its validity for decades to come.

What does the return of vinyl in popularity say about the place and space of music in our lives?

Vinyl demands dedicated listening, so listening habits are shifting to reflect a multi-format-savvy level of comfort, where listening to music in your own home is not just secondary to another activity. Music is returning to the fore of engagement, as a personal and social occasion to absorb, savour, share and cherish.

First vinyl memory?

My first vinyl memory was digging through my mum's record collection, having that 'archaeologist' thrill and the sense of responsibility that comes from handling treasured artefacts. I loved the haptic feedback and precision required in removing a record from its sleeve and playing it as carefully as possible, and the hours spent indoors on rainy days listening to vinyl while I studied. It was never anything underground or 'cool', but all of those albums were essential listening in their own defining way – from Frank Sinatra and Bing Crosby to The Beatles, Simon & Garfunkel, etc.

What was your first vinyl purchase and what did it mean to you?

The first record I bought was Survivor's 'Eye of the Tiger', 7-inch – I was nine years old. It remains a guilty pleasure to this day.

How many records do you have currently?

Too many for our small house!

Crucial release for any audiophile to have because it sounds so much better on vinyl?

All recordings sound better on vinyl, so it's hard to pick out just one or even a few hundred. I'd say invest in good hardware, so you can appreciate the quality of the music as much as possible.

Any other last words of Godfroy wisdom?

1: Love thy eardrums – protect your hearing!
2: Stay curious!

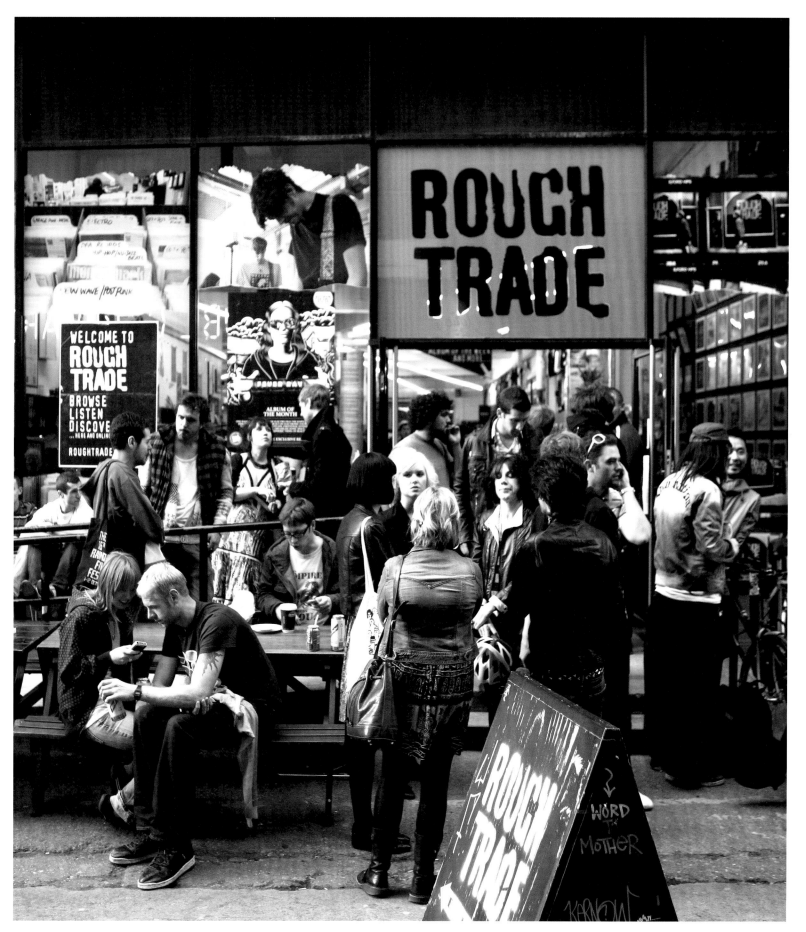

JEFF GOLD

OWNER, RECORDMECCA / AUTHOR

Recordmecca's Jeff Gold has been buying and selling collectable records and music memorabilia for 44 years. Profiled by *Rolling Stone* as one of the five 'top collectors of high-end music memorabilia', he travels the world to search out the finest music collectables. An internationally recognised expert in the field, he is a frequent consultant to the Rock & Roll Hall of Fame, Experience Music Project, record labels and cultural institutions. Gold is also the author of *Total Chaos: The Story of The Stooges*, the first book telling Iggy Pop's story of The Stooges with the singer's own words.

> "Somebody once offered me Darby Crash's [of the Germs] wisdom teeth."

Why did you start Recordmecca?

When I was a teenager, I got into record collecting big time. I was going out looking for rare records at Salvation Armies, used records stores. I saw all kinds of things that I knew were rare but I did not personally care about. I realised if I bought and sold them, I could pay for the stuff I wanted. So I started buying rare records. There was a record market once a month on the Sunday at the Capitol Records parking lot [in Los Angeles]. I would bring the stuff that I had found, sell it and buy what I wanted with the money. This turned into a business pretty quickly. Once or twice a year, I would go to England to sell rare American items, then buy rare English stuff to sell in the States. You could find really great stuff in London at the time. Then I started doing mailing lists. While I was in late high school and college, I was doing this and making a lot of money. It was called The Record Obsession. When I started at the record label, I told my boss at A & M Records, 'I can't afford to work for you at the salary you are going to pay me – unless I can keep my own business.' And he said, 'Sure.' After about nine months, it got to be ridiculous timewise. So I sold my rare record business and got into the record label side whole hog. I did that for nineteen years or so. I was ultimately the Executive Vice President and General Manager of Warner Brothers. But I was always buying records and looking for records. Whenever I would go somewhere on a business trip, that would be a part of it. I kept my connections [in the rare vinyl world] up. When I left Warner Brothers, I had one of those fortuitous things where there was a corporate shake-up. I got blown out with two years left on my contract. I got paid as long as I was unemployed and had no obligation to look for work. I could not take a job from anyone else, but I could do entrepreneur stuff. So I got whole hog right back into the rare record and memorabilia thing. This coincided with the birth of eBay – so I was off to the races.

When you worked at the labels, were you collecting promotional items constantly?

I was actually the one commissioning them.

Oh my goodness, that is the perfect job for you!

I would do all kinds of crazy stuff. For example, Prince originally cancelled the *Black* album, but allowed us to release it in 1994. I said alright, 'We are going to make some really collectable Prince *Black* albums.' So I made 300 white *Black* Albums and 50 black and white *Black* albums, knowing they would be super collectable. Today they are worth thousands of dollars. I know exactly what collectors would want because I am one.

Why will someone pay top dollar for an item that once belonged to an artist?

I am one of those guys who does. It is as close as you will get to the mojo of the artist. I love owning talismanic objects that inspired the people who inspire me.

Craziest thing someone has asked you to source?

Somebody once offered me Darby Crash's [of the Germs] wisdom teeth. I demure at body parts. Someone once wanted me to find them a nude photograph of Jim Morrison; they would pay an unlimited amount for it. Unfortunately, that person passed away. I later actually saw a nude picture of Jim Morrison; I didn't know that it actually existed. Though I try not to get into that sensationalistic stuff.

One of the things I thought was interesting about your business is that you offer financing. Are people starting to treat rare vinyl albums as long-term investment pieces, e.g. like fine art, real estate?

I know that is the case, but I know that some people want stuff that they can't afford immediately. The reason I do well at what I do is because I am my customer. I try to follow the golden rule, and put stuff in the right collections and help people get stuff they are passionate about. If that means paying for stuff over time, I try to figure out a way to help them. I am really into selling the right stuff to the right people because I want people to sell the right stuff to me – things that I am passionate about personally.

Did collectable vinyl ever dip in value during the height of MP3s and downloads?

It is now higher than ever. I think the fair to mid-range stuff really dipped in value. In the CD era, nobody cared about having a copy of David Bowie's *Diamond Dogs*, or records that sold millions – Billy Joel, Fleetwood Mac – they were all 99 cent LPs. But with the resurgence of vinyl, a lot of new people who never had a turntable have a turntable now. A lot of people who had one, then didn't

have one, have gone back to it. They want those classic records from their youth. So the floor level collectables, the original pressings of '70s and '80s classic rock records, which didn't have much value in the '80s and '90s, now do have some value.

The real classic '60s records have more value than ever. About 20 years ago, people really started caring about condition. When I started, it was enough to just have a copy of the record; nobody really cared about upgrading it. But now, there are a lot of people who will pay extreme premiums to get perfect condition copies of something. There are many records, '60s records, where a sealed copy is worth $1,000: if you take your fingernail and you slit the seal – and don't even take the record out of the cover – it is worth $500. If you rip the shrink wrap off, it is worth $400. So there is a lot of competition to get the best of the best of the best. The Internet and eBay have fueled that too; in the 1970s when I was selling records, my audience were people in Los Angeles and readers of *Goldmine* [a record collectors'] magazine. Now my audience, my customer base, is anyone who has a computer. I sold the first item I have ever sold to China recently. I have been waiting for it to happen. It was a Keith Haring signed envelope, weirdly enough. About four years ago, Russia opened up which is, I think, a consequence of Paypal becoming somewhat ubiquitous there. Every week, I would say about half the packages I send are outside of the US. It would never have been possible pre-Internet, not to that degree. I would sell records and memorabilia to Europe, but it had to be that you got a copy of *Goldmine* magazine or that you were on my mailing list.

Piece of vinyl you are personally still on the hunt for?

Happily, I am not. I have been doing this for 45 years; I started collecting records in 1971. Now that is not to say that I do not get stuff regularly that blows me away.

> **"In terms of some specific thing that I have been searching for and not been able to find? I have been able to find it all."**

I did last week. In terms of some specific thing that I have been searching for and not been able to find? I have been able to find it all; 45 years, a computer, a lot of international travel – I have been lucky.

Most prized item in your collection?

Jimi Hendrix is my hero. I have maybe 20 records from Jimi Hendrix's personal record collection, including his copy of *Electric Ladyland*. I bought it from an auction in England that was organised by Kathy Etchingham – she was his girlfriend for many years, and who he lived with in England. Having his copy of the records that inspired him, and his copy of my favourite record is pretty great.

I have two copies of pre-war blues albums that Bob Dylan owned in 1962 – and wrote on the back of. On the liner notes, I can't remember exactly what it says, but it is something to the extent of, 'read and absorbed by Bob Dylan'. The fact that those were the records that inspired him, and the fact that he had been 'Bob Dylan' for about a year and a half by that point, so he is almost trying on the name – I really love that. Those came from Suze Rotolo, who was his girlfriend in the early '60s and is on the cover of *Freewheelin' Bob Dylan*. They were hers, and she sold them at auction as well.

Do you listen to these records, or are they locked away in a bank vault?

They are definitely not in a bank vault. They are framed on the wall in some cases. When I got the Hendrix records, they were covered in fingerprints and schmootz. I was going to clean them, then I thought, wait a minute – that is Jimi Hendrix's fingerprints and schmootz, I am not going to clean these! So I don't listen to them. I have copies of them that I listen to. Some of them are framed in my office, others are filed. One last one: I have an English copy of *The Man Who Sold The World*, my second favourite album by David Bowie. In 1974, I had David Bowie sign it. In 1976, I had Mick Ronson sign it. In 2001, I had Tony Visconti, the bass player, sign it. And this year (2016), I had the final member of the band, Woody Woodmansey sign it. It took me 42 years to complete my set of autographs. That has got to be a world record for completing a set of autographs; 42 years. Some would call it insanity.

Is vinyl going to continue to be popular?

I hope so. It shows no sign of abating. It doesn't seem like a short-term trend – but nothing lasts forever.

MARC WEINSTEIN

CO-FOUNDER, CO-OWNER, AMOEBA MUSIC

Since starting out in 1976 as the tape buyer and display artist at the Record Theater in Buffalo, New York – the world's biggest record store at the time – Marc Weinstein has gone on to be an all-around expert buyer and retailer at music stores throughout the US. In 1990, Marc co-founded Amoeba Music in Berkeley, California. Since its inception, Amoeba has added two locations: San Francisco, on the infamous Haight Street; and Hollywood, California, the world's biggest independent record store, stocking up to 250,000 titles simultaneously. Marc has been making art throughout his life, having received a BFA in painting and been a drummer in many bands, including MX-80, (29 years), 10th Planet with Malcolm Mooney, (24 years), O-Type, (15 years), Pluto, (15 years), Flatmen, Savage Pelicans, National Capricorn, and The Mutants, among many others.

Why did you decide to open a record store in 1990 in Berkeley, California, when there were already ten others?

The destination for records in the Bay Area more than anywhere else was Telegraph Avenue [in Berkeley, California]. That was where everyone was already going for records. Historically, those are the most fun places for record shoppers – those districts where there were a lot of stores. We [Weinstein and co-owner Dave Prinz] believed that the more record stores, the more traffic for everybody.

What was a going to be different about your store and have you accomplished this over the years with Amoeba?

We have made a valiant attempt to do each genre of music justice under one roof. It is such a big subject, there is no way that you could put all the titles out in one store – but we actually tried when we started. That was kind of the ethos over the years. When we created the store in Los Angeles, it had probably one of the biggest inventories ever in any record store. We try to be a lot of small independent record stores under one roof. The idea was to be a one-stop shop – but also to be a place where you could buy and sell music. This was an important part of our formula from the beginning – you could get a price for your stuff to trade in. That has been the essence of our model all of these years: be something for everybody and be the best place to buy and sell. A lot of our best inventory comes from collections and people's homes.

What has been the craziest personal collection you have bought?

There have been many. Most impressive, though, was a collection we bought in suburban Detroit. Sadly, from the parents of a guy who had died

young, in his late 30s. He had a childhood disease, and was physically limited his whole life. His parents had a lot of money, and wanted him to be happy. They said to him, 'Travel around. Do whatever you want.' What he loved to do was to buy records. He went around the world buying them. He loved The Beatles, Bowie, Genesis, a lot of really classic rock stuff. He would go to different countries and buy all of the various pressings of the same records. In other words, for each Led Zeppelin title, he had copies from Peru, Israel – he would just buy records from all over the world – including 7-inches. He had probably at least 500 Beatles 7-inches from all around the planet. That was a collection we bought the year before we opened the Los Angeles [LA] store. We kept it for the purpose of opening the LA store with it. We did the same thing with numerous large collections we bought then. When we opened in LA in 2001, it was probably the best inventory any record store will ever have in history because I know how many amazing collections were in that shop. We had stuff from all over the US when we opened that day. For the first six months we were open, we had so much gold, it was ridiculous. That first day, people were lined up all the way around the entire block [to get into the store].

How did vinyl influence your interest in working in a record store?

I love records as ephemera. I have always been a collector of paper things, especially postcards. I probably own about 30,000 postcards because I love what they represent. These little, fleeting pieces of evidence of a life, of a culture, of a time. Part of the strength of an LP is that it similarly represents a place and a time like nothing else – in the same way that a postcard would, but in a bigger way. It is evidence of a recording session, of someone's aesthetic, of a place in cultural history. When I watch a kid come into the store, and hold

"The record store is the closest thing to a museum for the art of making music."

a Doors record in his hand – he is looking at Jim Morrison, and he is thinking, 'Oh, look, it's a real old Doors record!' It holds so much cultural weight; a lot of people take that for granted. That is part of the reason that so many people collect vinyl. It is so representative of a time and a place that the particular person is interested in. It is the closest they can get to actually 'being there'.

One of the special things about a record store is that they are the closest thing to a museum for the art of making music. We have always looked at it that way, and taken on the responsibility in that manner. What other kind of retail store can you walk in where people have the same kind of love and passion for the 'product'; the guys at the counter, the customers and the staff? It is all centred around the best art that humans can make. Once it is recorded, on a hard copy, it is available for anyone to purchase. The hard copy represents the whole aesthetic of that artist. The artwork, the curation of the music, it is the closest you can get to listening and seeing something the way the artist intended.

Music goes so deep as a form of human expression. It is really like nothing else. Compared to visual art where most of the hardcore audience has a very specific language and way of looking at things, you generally have to be educated a certain way to be able to talk about art. Music is much more for every person to enjoy and talk about in whatever way they want. Visual art holds all of these standards. Once upon a time, I got my degree in visual art and

painting. Soon after I graduated, I realised, 'Shit, I don't really want to do this. Nobody else knows how to talk about art. What is the point of making all of this art and putting it up on the wall if even your closest friends don't really have the vocabulary to discuss it with you?' It is really a very exclusive club compared to music. Being in bands, playing the drums – music is such a communal kind of experience. Especially back in the '70s when I was growing up. I graduated high school in 1975. In those days, everybody had an altar to their music in their living room or bedroom, girls and boys, everybody could talk about what kind of stereo they had, what kind of speakers. They had their records on full display. That was how you identified yourself. Now you can only capture that feeling when you go to a show, and you are all watching an artist you love. Back in the day, you spent a lot of time sitting together and listening to records and experiencing that art together. It was a very powerful experience that is not as common now except maybe at dance clubs where people are immersed in the beat. As far as sitting around and listening to the music for the inspiration and doing it with friends in front of the stereo, it is kind of a long lost experience that was very powerful.

What role have independent retailers had in the resurgence in vinyl?

A huge role – although it depends on what market you are in. There are a lot of major markets that do not have very many independent retailers left. The bigger stores pick up the slack for these deficits. In

our markets, we play a huge role. We sell 1,500 vinyl records every single day at our LA store – 1,000 used and about 500 new. We are pouring that shit out into the world in a big way. Vinyl surpassed CDs about three years ago. Where we used to have about 40 per cent CDs and 20 per cent LPs in our overall sales, it has now flipped – we are at about 20 per cent CDs and 40 per cent vinyl. The vinyl supply is not as easy to come by as CDs once were. So it's a tricky balance. New records sell really well, but they cost a lot to stock, and you cannot return any of them [to the distributor]. It's a lot trickier to make money selling vinyl than it used to be in the CD days. It is frustrating in some ways, but wonderful in others. LPs have always been a huge part of our store. They have never gotten below 20 per cent of our total sales at the slowest. We always sold about 1,000 records a day in the store; we have always been a big outlet for vinyl.

Your first vinyl memory?

It goes back further than I can remember. When I was a born, my dad was a radio DJ. He used to get piles of promos and 7-inches and bring them home if the station was not using them. We had a cool record player. I used to play singles just for fun when I was a kid. I have pictures of myself as a kid on the floor surrounded by all of these 45s. I don't remember any particular instance of my first encounter with vinyl, but I loved records from day one. I don't think I ever bought a record until – I think it's true! - *Are You Experienced?* by Jimi

Hendrix was my very first vinyl purchase. The fact that I was holding it in my hand – it was my first time buying art. This is something that gets me high spiritually and otherwise. It was the buzz of buying a record; for those that really care, there is nothing else like it. You are buying yourself something that is spiritually quenching. Music does not compare to anything else. On one hand, it is this fleeting experience – like, let's say food – it can be very sensual. It comes and goes in a flash. You listen to a record; you eat a meal. You are enjoying it in time.

Would you encourage an artist to release their next project on vinyl?

Absolutely. It is the ultimate way for the fan to have your art. You have complete control over the art, the curation. It's like a hardcover book. You might love Picasso: you can buy a postcard of a Picasso you love, you can buy a nice digital print or lithograph, all the way up. But it is still not that close to the original the way it was supposed to be appreciated. An LP is as close as you are going to get to having the original artefact. If you want to have the ultimate copy of somebody's music, it has got to be an LP, nothing else comes close.

Crucial release that sounds so much better on vinyl?

I tend to think that all rock music sounds better on vinyl. That said, some of the most collectable records out there are classical because such care

was taken in making those recordings back in the late '50s/early '60s. The late mono/early stereo era classical records tend to be the ones most collected by the true audiophiles. People who really want to hear the capability of that technology collect those records because the dimensionality that these guys managed to achieve back in those days often times with one or three microphones, and the technology of the late '50s and early '60s is amazing. I know from talking to collectors anecdotally that it's the stuff that gets audiophiles excited, because that was a time when the quality of records that were being produced was of the absolute highest order. I love vinyl almost exclusively over CDs regardless of whether it theoretically sounds better or not. I'm not a techie guy, but vinyl sounds better no matter what. With jazz and rock, it is really an essential part of the experience.

Any other last words of Weinstein wisdom?

Vinyl is a sort of meditation. When you put a record on, it means that you have to be there to experience it because 20 minutes later, you are going to need to flip it over; it is not an ongoing soundtrack to your life, like when you are jogging, and you have music in your headphones. You are taking the time to actually experience the record in a way that the artist would hope and intend. That is the difference – a huge difference!

Having just been in Japan, I was so impressed that 80 per cent of their market is still hard copies. It was so exciting to suddenly be back in a place where most people still listen to records and CDs. They shop for them like they mean it. And you can go into a discount store, and see a huge stereo department with a whole wall of cartridges, needles, speakers and turntables. Just seeing that stuff – it was like revisiting where I came from. I could not

believe how amazing it was. It was so exciting to see that.

The ethos, the values, the morals that went along with particular artists – they were so much more clearly defined in our day. There were far fewer artists. Each artist represented a philosophy or an aesthetic that had a crowd to go with it. But I think back to the day when individual artists were celebrated in a much bigger way because there were so few of them who could actually make it all the way through the system, and could actually produce records. Often this was tied to how good they were. It's a different era altogether. Now, it has exploded into so many different little parties. There are so many formats, so many varieties, you can pick and choose. You have a lot more options than we did when we were kids. It is really hard for anyone to feel that sense of social coherence that we enjoyed back in our day. I feel bad about that.

My daughter is 18; she loves a lot of great music. But she will never know what it is like to sit with five of her best friends and listen to Pink Floyd. Not that everyone needs that experience – but to me, that was like church. I was never a religious person, but I think a lot of people go to church so they can be with a crowd of people and do something spiritual together – and feel it – *together*. In the '60s and '70s, all of a sudden there was this experience of being able to go out and appreciate another person's music in a way collectively that I think was elevated. It spoke to human potential. It was not about some theoretical god, or some hierarchical, dogmatic programme. It was ultimately inspiring in a way that I do not think too much is anymore. It was such a unique club that we all belonged to when we understood the power of that stuff. Now it's ubiquitous. Everyone has their own little soundtrack to their lives going on through their headphones and their little Pandora.

THANK YOUS

I am deeply, deeply indebted and grateful to the many people who were crucial for the creation of this book. It seriously takes a village, and I am so blessed and lucky to have so many inspiring, generous, beautiful folks in my life.

First of all, a huge, huge thank you to my literary agent, therapist and biggest cheerleader Carrie Kania. I am humbled and in awe of your dedication to your authors, especially me. And to Foxy Kania – *thank you*.

To Francesca Shepard, thank you for encouraging me, believing in me and being there every step of the way.

To Henry Rollins, who gave me hope that this was a book people would want to be a part of, and for being such a generous, kind and down-to-earth human.

To Lars Ulrich for taking a chance on a then unsigned book, for lending his name and credibility to the project. And thank you Brian Bumbery for giving me the chance to do that first interview. You are amazing.

To Tim Burgess, for all of your generosity and thoughtfulness, and for being such a fabulous inspiration.

To Clint Boon, Nick Hornby, Gaz Coombes and Norman Cook for being lovely, supportive and cooler than this little Anglophile from Santa Cruz, California could have hoped for.

Thank you to two of my old friends and mentors who have inspired me for many years, Terry Currier and Marc Weinstein. Your dedication to music, community and culture is aspirational.

'Thank you' does not even come close enough to express how humbled, happy and lucky I feel to have had these gracious, talented folks contribute their time, memories and opinions to making this book happen: Stuart Batsford, Ben Blackwell, Boz Boorer, Fred Brathwaite, Mike Burkett, Sam Coomes, Mike Dixon, Karen Emanual, Alison Fielding, Stephen Godfroy, Jeff Gold, Adam Gonsalves, Steve Hackett, Gavin Hayes, Maxi Jazz, Kill Rock Stars, Michael Kurtz, Luke MacFadden, Gered Mankowitz, David Miller, Martin Mills, Xavier Mosley, Adrian Moulton, Colleen Murphy, Mike Ness, Steve Parke, Mark Rainey, Simon Raymonde, Sean Rutkowski, Portia Sabin, Peter Saville, Andrew Tucker, Colin White, Baron Wolman, Adrian Young and everyone at Bella Union and Third Man Records.

A huge, huge thank you to all the fabulous managers, PR folk, label people and others without whom this book would not have happened: Anglo Management, Rick Bain, Ilene Barg, BB Gun Press, Vanessa Burt, Julie Calland, Jesse Rae Caton, Lucy Chavasse (thank you thank you thank you!), Sharon Chevin, Emma Coquet, Alice Cowling, John (JC) Cutcliffe, Richard Dawes, Katy Ellis, Peter Ford, Scarlett Flynn, Nina Francis, Kiran Gill, Rob Gorham, Brian Gorman, Kirsty Henderson, Dean Hewins aka Boogaloo Dee, Jo Kendall, Heidi May, Mara Meier, Stephanie Nicora, Ben Parrish, Matt Robertson, Drew Roulette, Naval Shadi, Danny Sperling, Sini Timonen, Dave Tomberlin, Shane Trulin, Andrew Tucker, Cyndy Villano, Louisa Worskett and Nina Young.

A huge thank you to all the fine folks at ACC, without whose help this would not have been such a great experience: Mary Albi, Hannah Gooch, Sean Nam and Bryony Porter. Special thanks to publisher James Smith and editor Andrew Whittaker, for believing in this book and seeing it through. Michael Byzewski, thank you for my fabulous cover design. It turned out so gorgeously.

Thank you to my BIMM London family – I love you all!

As for my family of friends – I could not get through life without you. Thank you for believing in me and for being there every step of the way: Wendy and Edward Bickerdike, the Brodie-Wray family, Tami Cady, Calyx Clagg, Sam and Samantha Clegg, Simon Colam, Lynne Collins, Patrick Dominowski, Niamh Downing, Paul Fields, Mary Claire Halvorson, Vaseema Hamilton, Kym Martindale, Mary and Bruce McPherson, Paul Lester, the Mandell Family, Pat Mandell, Kelly Paschal-Hunter, Janet Pucci, Julia Ruzicka, Mark Seaman and Revolutions Brewing Co., Long Sun, Ruth Thomson, Krista Thorne-Yocam, Leslie Van Every, Richard Van Mellaerts, Jo Whitty and all of the fab folks at Sound City Liverpool.

Thank you to my lovely friends at Oregon Music Hall of Fame; your mission to celebrate music heritage and music education inspires me every day.

Most importantly, I owe everything I am to my gorgeous, patient and endlessly supportive husband, James Bickerdike. Thank you for letting me pursue my dreams and allowing me to lead the life I was too afraid to live. Your work ethic pushes me every day to give it just that little bit more. I love you more every day, my sweetheart.

I apologise now if I forget any of you. I thank you too.

IMAGE CREDITS

Cover by Michael Byzewski, Aesthetic Apparatus; page 7, Angela Waye; page 8, KK Gas; pages 14-15, © Sal_GigJunkie; page 18, Jo Hale; page 22, @NickBall; pages 26-27, Salajean / Shutterstock.com; page 31, Jennifer Otter Bickerdike; page 35, Heidi May; page 39, Mat Hayward / Shutterstock.com; page 40, pages 44-45, Cat Stevens; page 46, Chris Poots; page 49, Sebastian Schofield; page 51, Marta Nawrocka; page 53, Charlélie Marangé; page 56, Cristi Kerekes; page 58, C Flanigan; page 62, Twin Design; pages 65 & 69 Rankin; page 71, Alan Snodgrass; page 77, Tina Korhonen; page 81, Renee Xie / Shutterstock.com; page 83, Julian Winslow; page 87, Leandro J./BFA/REX/Shutterstock.com; page 89, kidy / Shutterstock.com; page 90, Tom Rowland; pages 96 & 99, Linda Cooper; page 100, Amanda Edwards; page 105, Mat Hayward / Shutterstock.com; page 106, Duncan Parke; page 109, Radu Bercan / Shutterstock.com; page 111, Peter Saville; page 119, 'Unknown Pleasures' Joy Division, 1978, designed by Peter Saville; page 120, Michael Speed; page 126, Amy T Zielinski; page 132, Miriam Douglas; 136, Brad Trent; page 140, pages 142-143, Independent Record Pressing / Miles Johnson; page 147, David Miller; page 150 & 154, Emma Browne; page 156, Dave Guttridge; page 164, Anna Ferrier; page 169, Twin Design / Shutterstock.com; page 170, pages 174-175 Jamie Goodsell; page 179, Jeremy HARRIS Photographs; page 184, Martin Mills; page 188, © Gered Mankowitz 2017; page 194, Erica Sparlin Dryden; pages 198 & 201, Music Millennium; page 203, Stephen Godfroy; page 207, Elly Godfroy; page 208, Jeff Gold; page 212, Gyvafoto / Shutterstock.com; page 214, Marc Weinstein

Gaz Coombes and
Jennifer Otter Bickerdike

Printed in Slovenia for ACC Editions, an imprint of
ACC Art Books Ltd, Woodbridge, Suffolk IP12 4SD, UK

www.accartbooks.com